CUBISM/FUTURISM

BOOKS BY MAX KOZLOFF

Renderings: Critical Essays on a Century of Modern Art (1968)

Jasper Johns (1969)

Cubism/Futurism (1973)

CUBISM/FUTURISM

MAX KOZLOFF

ICON EDITIONS
HARPER & ROW, PUBLISHERS
NEW YORK, EVANSTON, SAN FRANCISCO, LONDON

This book was first published by Charterhouse Books, Inc., and is here reprinted by arrangement.

TO NIKOLAS

PREFACE

Cubism and Futurism, the flash points that set off modern art in this century, have been discussed summarily in large survey books and studied at great length on their own. In tandem essays here, I juxtapose them because in actual fact they were linked together like uneasy siblings contending for artistic ascendancy. There were sufficient tangents and mutual stimuli in the ricochet of issues between the two movements for many on both sides to have felt for each other the keenest sentiment of familial scorn.

To speak of Cubism and Futurism is to speak of the art of young men, close contemporaries in Paris and Milan, whose development was almost simultaneous and certainly complementary. Highlighting such a relationship, I have confined this book to the most active period of Cubism and Futurism, the half decade before the First World War, and have further restricted comment to their leading personalities. While writing out of each movement's point of view, I have been mindful of the contrast formed by the other. My

intent was to describe not one epoch or sensibility, but an artistic dialogue that emerges, after the Cubist scene is set, in the sections on Futurism. In referring to this dialogue I had two goals. One was to show on what basis the artists rejected as well as explored alternatives in the process of making their pictorial decisions. This entailed a social and political, as well as a psychological, contextualizing of the art involved. The other was to restore to its true, two-track scope the continuous network of innovations that could not have been wrought by Cubism alone.

These, of course, are problems of historical interpretation; but my book would not have seemed justified to me unless it attended to those of language as well. It is a convention of American movies that characters who are represented as uttering French or Navajo express themselves in English. I doubt that painters speaking Cubist or Futurist sixty years ago have been made as conveniently understandable by the magic of modern art criticism. To ordinary spectators today a Cubist subject may look cut to pieces or a Futurist one excessively fidgety, just as they had often seemed when first presented. Many of us have been indoctrinated to edit out these perceptions so that we literally do not have them any more. We talk, instead, of disjunctions or lines of force. My concern has been to reconnect the "naïve" response with the learned one because I suspect that pictorial language operates most deeply in tension between the two. And I even imagine that to regain within ourselves some of the initial shock perpetrated by modern art is not to renew a laughable misunderstanding, but to partake more authentically of the experience we have been offered. That experience, since it oscillates without cease between the familiar and the unfamiliar, the literal and the metaphoric, has no final readability. To Cubism and Futurism we owe the first life-giving portents of this ambiguity in our time.

M. K.
New York City
September 1972

ACKNOWLEDGMENTS

To Dan Wheeler I owe the original idea for this book, although I do not think he would recognize its utterly changed program. Edward Fry, to whom I showed an early fragment of the manuscript, volunteered his knowledgeable enthusiasm. At Charterhouse, my two closest readers assisted my goal in the most spirited and characteristic fashion: Richard Kluger, by egging on whatever interpretative departures I had within me, and Jane Clark, by her real disapproval of my worst writing habits.

For her unremitting efforts and accurate methods in securing photographs and permissions, my warm thanks go out to Marianne Barcellona. I am grateful, too, for the cordial helpfulness of Linda Loving and Richard Took, of the rights and reproductions department at the Museum of Modern Art, New York. Palma Bucarelli, superintendent of the Museums of Rome, graciously furnished me with Futurist material from Italy. Finally, at home, my wife and chief critic, Joyce, gave invaluable encouragement by not thinking I had gone off on the wrong path.

CONTENTS

LIST OF ILLUSTRATIONS

I / CUBISM

1 / CUBISM AS A CRITICAL PROBLEM

Historically, the artistic phenomenon called Cubism began in Paris about six years before World War I. The word *Cubism* was first applied by the critic Louis Vauxcelles—hostilely—to some landscapes of L'Estaque, near Marseilles, exhibited by Georges Braque in 1908. Though Braque's paintings stressed the cubelike presence of rocky hills and houses, such an emphasis was shattered almost immediately thereafter in the work associated with the movement. It is one of the paradoxes of art nomenclature that the name "Cubist" caught on durably and inappropriately only in 1911, after the stereometry that had inspired it had ceased to be a concern of the painters themselves.

Throughout the commentary on the movement there have been ritual complaints about the inadequacy of the label "Cubism," for it rather literally isolated only one fugitive aspect of the artists' practice—a geometric approach to the process of representation. Yet that very literalism was exceptional among the categories imposed upon modern art, a fact that has a

suggestive value in itself. Where the tendency usually was to identify an attitude of mind—for example, Symbolism—or an emotional release—Fauvism or Expressionism—here the focus is on a thing done or being done. "Cubism" became, even if unwittingly, the first idea about art explicitly twentieth century in outlook toward the visual world. Conceivably this was because, in our time, there surged forth the belief that the only universe that counted was man-made. Nature, though still quite mysterious in its invisible workings, existed, it seemed, only to be surmounted and mastered. Indeed, natural history had long before emerged in large measure as the record of what man was either discovering within it or doing to it. Nothing could be more symptomatic of this manipulative incursion than the right angles and straight lines of cubes, as if these could act as monitors of perception and not merely as the attributes of one perceived class of things. Furthermore, it is significant to think of the mathematical meaning of the word *cube:* to take a quantity to the third power. What would it signify and how would they look if represented forms could be imagined, in any figurative sense, as being taken to the third power?

For sheer prestige and pictorial impact, hardly any sensibility in twentieth-century art has compared with Cubism. The paintings it produced have come down to us almost as mystic objects embodying a commanding spirit of formal innovation. For they are the chief artifacts thought by our culture symbolic of the adventurous and propulsive changefulness stamped upon the age by the West. The apparitions in the paintings by Pablo Picasso, Georges Braque, Juan Gris, and Fernand Léger may be dated to one period, but not, presumably, that larger and less tangible display of spatial order to which they allude. Such is the standard view of the Cubist movement.

Quite obviously, though, it begs a number of questions. Everywhere we are encouraged to make our definition of Cubism as broad as possible. Yet the artists themselves made no pretense of contributing to anything but the field of painting. In Futurism, Dadaism, and Constructivism, a concept of art and a program of political action went hand in hand. Going further, Surrealism promoted itself as a prime agent in the liberation of bodily and erotic instinct. All of these movements owed a great deal to Cubism, and all of them, unlike Cubism, exerted considerable energy to challenge given notions about the limits of art. On the contrary, the Cubists restricted themselves to aesthetic pursuits and were disinclined to advance theoretical claims

for their work or even to subscribe to defenses made on their behalf by others. Nevertheless, there is clearly a potency in the word *Cubism* that makes one want it to mean more than the art of a handful of individuals in pre-World War I Paris.

We have a style, or styles, and a taste that can be labeled Cubist, but no method to describe and no ideology. Seurat's divided color presupposed a definite, transmittable syntax. But nothing could be extracted from Braque but fragments and formulae, distributed and configured in various arbitrary ways and capable only of giving a certain Cubist look. This is what makes generalizing about Cubism on the basis of its enormous influence very uncertain. Most of what came afterward is unthinkable without Cubism, but that movement's strength still seems to us in some way bound up with its indifference to any program for legitimate succession, Léger's effective teaching notwithstanding. There must, then, have been implicit in the art of Picasso and Braque a principle of vision more extendable than the terms selected in any one or a cluster of their paintings.

Such an effect could not have been merely the result of a long-lived relationship between originators and orthodox followers. This familiar pattern does not correspond to the fact that Cubism gave rise to the most conflicting programs. Instead of being jeopardized, it thrived on independent, divergent inquiry. (That some scholastic members of the group, Albert Gleizes and Jean Metzinger, eventually thought otherwise is atypical.) We cannot say that competing "isms" of modern art were sectarian or schismatic in their bearing to Cubism. For they were parallel rather than reactive flowerings of an outlook first born in Paris. They coexisted in an atmosphere of spontaneous agreement over the most important aesthetic problems, matched by a set of new and challenging paradigms whose time had come. In this sense, to single out the Cubist paradigms is to indicate structures whose openness revealed continuous formal *potentials*. Yet local impulses and separate personalities, operating under quite different cultural conditions, were, as always, the real determinants of content. And it ought not be forgotten that the period before the war witnessed the first truly international high-speed co-operation between the European avant-gardes, in which they showed together and learned from each other in a critical but open spirit.

Cubism has been given priority in the genesis of this development not only because of the genius of its authors, but because it grew indepen-

dently for three or four years before other interesting ideas entered the field. Neither of these reasons is good enough to explain the ascendancy it enjoyed. Perhaps more relevant is a sense we still have of Cubism as a style that invokes the incomplete and the specifically partial. Not that it created essentially unfinished or unresolved works of art—far from it. But it is a mode whose aesthetic valence is large, meaning that it could be extremely accommodating to all kinds of disjunctive formal combinations and still maintain its identity —indeed, make itself more precise as an idea by exhibiting new capacities for a kind of controlled indetermination. A 1911 Cubist canvas by Braque or Picasso can be elaborately individualized, taut and "right" in every interval, and still be validly considered as notation for other options, other degrees of relatedness within the structure. Somehow their Cubism constantly found the provisional approach and the general statement to be equivalents of each other. Of de Stijl in Holland or Constructivism in Russia this cannot be said, nor does it apply very much to Gris and Léger. Even their most abstract visions are concrete when judged by that brief baiting moment in Cubism, that complex insufficiency that triggered discoveries almost by negative example.

Needless to say, a whole literature has grown up to explain what happened. Some writers have supposed that the Cubist moment emerged out of a new system of ordering marks on the surface of the canvas. If the paintings require an essential reorientation of reading approach, then this says something about what they intended. So, for example, John Berger recently said:

> The Metaphorical model of Cubism is the *diagram:* the diagram being a visible, symbolic representation of invisible processes, forces, structures. A diagram need not eschew certain aspects of appearances: but these too will be treated symbolically as *signs,* not as imitations or re-creations.
>
> The model of the *diagram* differs from that of the *mirror* in that it suggests a concern with what is not self-evident. It differs from the model of the *theater stage* in that it does not have to concentrate upon climaxes but can reveal the continuous. It differs from the model of the *personal account* [the romantic's attempt to make his own experience the equal of an act of nature] in that it aims at a general truth.

Without having to accept all these distinctions, it helps to connect diagrams and Cubism, for it may explain something about the phrasing of images and the terms of the relationship between what the Cubist artist sees and what he paints. Moreover, a diagram, with its signs and conventions, is deciphered quite differently from represented things, though it, too, is a representation, generally, of how something works. Diagrams often function, however, as pedagogical devices, schematisms that propose to clarify a situation. They are very direct, on their own level. A football coach diagrams a play for his team. Picasso's "plays" are a bit more complicated. One is likely to get lost following his directions.

The earliest sympathizers of Cubism were no less desirous of giving a codified rationale to the movement, for it seems to have stimulated an almost legislative faculty among them. They, too, were conscious of the diagrammatic aspects of Cubism, but they were also interested to know what was being diagrammed. Despite the strangeness of the new art, they sought to give it an historical and philosophical pedigree. Jean Metzinger insisted, almost from the beginning, that the Cubists "recognize in the most novel of their own creations the triumph of desires that are centuries old." He reasoned that Cubist painting was not fundamentally different from tradition in imposing thought on nature. Nor was it any less disciplined or logical than the old masters. It diverged from them in its altered and heightened consciousness of itself. And such a consciousness was obliged to emphasize the painting as a particular kind of artifact whose necessities precede a time-honored pictorial illusionism. To Guillaume Apollinaire, more extremely, this meant that the Cubists "are moving toward an entirely new art which will be to painting, as hitherto envisaged, what music is to poetry" (1912).

An odd aspect of contemporary response to Cubism is its insistence on seeing in it a relationship to the anti-naturalistic scaling of Giotto and the other "primitives," because there things are given to us as they are *conceived,* "conception" bringing together and filling in the gaps, rounding out the vistas, of things necessarily seen only in part (Maurice Raynal, 1912). At the same time, Cubism was thought to be consonant with the most modern discoveries in science. Like science, which was increasingly showing that nature, the object of knowledge, was quite dissimilar to the way we experience it, art was now revealing the same about the object of perception.

Cubism freed itself from appearances, we are told, only to uphold

the "sense" behind appearances. The picture could deny or even largely exclude observation of physical images, but images might be said to exist within that picture as reflections of a process of thought. And this process of thought validated the Cubist enterprise because it captured the immutable *idea* of an object, rather than rendering that object by some personal interpretation of its always changing and certainly deceptive appearance. The objection to simple, uncritical retinal experience of the world was that it is incompetent, that it is hobbled by an ordinary inability to *summarize* visual phenomena and their relationships in space and time. Innumerable apologists argued that a Cubist painting was a freely explored and discovered sequence of signs denoting the full range of things' attributes—their mass, volume, texture, shape, weight—as these might be swiveled in the human memory. The Cubist purveyed a pluralistic, generalized, and mobile, rather than a fixed, particular, and static, view of nature because, unlike the operation of the eyes, the activity of the mind vaults over any one place and instant.

The projection of this new view may at first be puzzling, but not arbitrary. On the contrary, once its language was assimilated, the Cubist composition presented a picture of reality far clearer and more complete than any attained in art. Picasso and Braque, for instance, were said to *analyze* their varied impressions, the material proffered in their art being the "equations" between the convergences, tangents, and deflections of objects, for which the nominal subject was but a pretext (Roger Allard, 1912). Their artistic results were intricately condensed because their mental considerations of discontinuous space had to be superimposed within the perimeters of a limited physical field—the picture rectangle. At best, actual viewing gives us a transitory and accidental record of appearances; more often its single limited vantage misinforms us as to their true aspects. Conventional pictorial systems of lighting—chiaroscuro and perspective—only reinforce these deficiencies. The Cubist metaphor, however, kept them all at bay because it constantly and simultaneously mutated points of view. Descent into chaos was prevented by the disciplined marshaling of elements and the achievement of an internal, architectonic order in space—evident Cubist aims that had their own reason for being. Gleizes and Metzinger, in their 1912 treatise on Cubism, spoke of a "superior disequilibrium." They were referring to the sheaves of unexpected contrasts and analogies, the "tempering" or "augmenting" of forms in contact with each other that struck so many observers of the movement. Once binocu-

lar vision is discounted, they said, there fades with it the illusive stability of Euclidian space. Replacing it was the intuitive guidance of painters in whose work "the eye quickly interests the mind in its errors." Fundamental to Gleizes's and Metzinger's thinking was that "the diversity of the relations of line to line must be indefinite; on this condition it incorporates the quality, the unmeasurable sum, of the affinities perceived between what we discern and what pre-exists within us: on this condition a work of art moves us."

Such, very sketchily, was the rhetorical framework into which Cubism was placed by its exegetes. This criticism took upon itself the pioneer task of preparing spectators to comprehend an art whose relative abstraction, as in Picasso's *Female Nude,* 1910 (Fig. 1), was extremely jolting. The more obviously Cubism discarded normal representational and narrative functions the more urgent it was to attach solid, recognizable values to the new style. Such words, therefore, as *renewal, research, pure,* and, above all, *realistic,* often recur in the literature on the movement.

This last word, *realistic,* deserves comment. It served to reject the fluidity of Impressionist perception, at least as a theme of art. But the apologists of Cubism were no less hostile to a main tenet of Symbolism, too: the concept of a work of art as a *decorative* play of colors and shapes, reverberating with allusions to less tangible emotions, sensations, and memories. The theories propagated around Cubism accepted the Symbolist notion of art as a mediation between the raw material of sight, inchoate sensation, and subjective truth beyond sense. But the method of achieving this goal was defined differently by the spokesmen for Cubism and Symbolism. In Symbolism, form was assumed to provide the fluctuating continuum leading from unprocessed sense data to a kind of higher, ideated reality. But in Cubism, pictorial forms were considered systematically meaningful visualizations of an interior knowledge of reality derived by the painter from the complex aggregate of his perceptions. The typical metaphor of Cubist doctrine, therefore, was not of mystical emergence, but of ordered comparison and judgment.

Whatever happened to the viewer before a Cubist painting, it was not of a spiritual order. Nor was it the easy recognition of the weights and textures of the objects, as in the historical realism of Courbet. "To discern a form," wrote Gleizes and Metzinger, "is to verify against a pre-existing idea," whereas there could be no such "idea" to the sense- and body-oriented Courbet. Though each painter would differ in his interpretation, and even

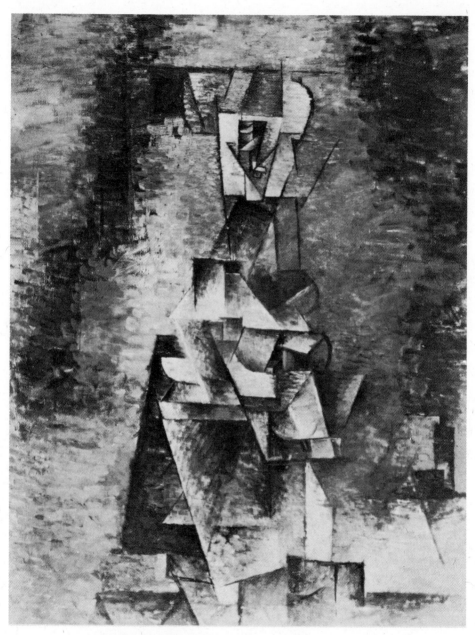

1 / PICASSO: *Female Nude*, 1910. Oil on canvas, 39″ x 30¾″.
The Philadelphia Museum of Art,
the Louise and Walter Arensberg Collection.

choice, of such ideas, and though Cubist forms could not often be matched with specific mental archetypes of objects, this rationalistic explanation of Cubism made intelligible to the viewer an art otherwise severely out of joint with received experience. Deciphering the art becomes a question of proper receptivity and focus on the logical concordance of Cubist signs with our concepts of objects in space, especially those aspects of them not immediately available to sight. This would generate an already known, but hitherto unarticulated, vision of reality. One was bid to understand Cubism almost through a reversal of the realist postulate. The reality that art must approach, and by which art is tested, is located effectively within, rather than outside, the beholder.

If we now turn from the critics to what the artists themselves said about their work, the emphasis on the schematic character of the Cubist reality is seen to change—when it is not outright refuted. In their varied but laconic remarks, generally uttered only *after the war,* a concern with immediate consequences of handling takes priority over any inclusive possibilities of meaning. Gris sounded a typical note when he said: "Until the work of art is completed, he [the artist] must remain ignorant of its appearances as a whole . . . to copy a pre-conceived appearance is like copying the appearance of a model." And Braque's aphorisms of 1917 further deny the dependence of Cubism on schemes extrinsic to painting: "The painter thinks in forms and colors. The aim is not to *reconstitute* an anecdotal fact but to *constitute* a pictorial fact. . . . One does not imitate the appearance; the appearance is the result." Or: "The subject is not the object; it is the new unity, the lyricism which stems entirely from the means employed."

In other words, for both artists, the experience of creating is neither prefigured nor confirmed by ideas gathered through perceptions of the world. The work of art, therefore, is an object that can be seen, not as a translation, but as a given, visually open-ended addition to such ideas. Since it is wrought from the same initial sources as our awareness of beings and objects interacting in space, painting can hardly be "pure." But it can be a *primary* stimulus by means of which we reinterpret those interactions. Picasso followed through this line of reasoning by insisting that "among the several sins that I have been accused of, none is more false than that I have, as the principal objective in my work, the spirit of research. When I paint, my object is to show what I have found and not what I am looking for. . . . We all know

that Art is not truth. Art is a lie that makes us realize truth, at least the truth that is given us to understand. The artist must know how to convince others of the truthfulness of his lies. . . . Through art we express our conception of what nature is not. . . . That those lies are necessary to our mental selves is beyond any doubt, as it is through them that we form our aesthetic view of life."

Picasso insists that Cubism has outright links with the past because all art is fundamentally different from, and even opposed to, nature. More, too, he concludes that our notions of the physical environment are artifacts as well—elements of aesthetic experience. Just as the eye does not mirror the world but fabricates one individual's image of perceived reality, so the artist does not construct the object. He constructs his picture. With Braque's respect for the limits of painting, with Léger's understanding of the artist as a specialist dedicated to isolating his own field (1914), picturemaking becomes virtually an autonomous activity, quite definitely and deliberately inscribing ideal energies and relations. And as this happens, it is difficult, even if it were desirable, for the Cubist artist to separate the absolute from the relative and mind from sense—the one a check on the other—as these divisions are presented in Cubist theory.

It is clear that while the writers on Cubism tended to be too categorical (as is the wont of writers), the artists' exposition inclined toward the opaque. Picasso was no doubt right when he said that they did not start out to invent Cubism, but to be themselves. That is why they later reacted against what had been said of their work, though they were also aware of its historical importance and even affected by the criticism about it. Braque said that "the senses deform, the mind forms." Juxtapose this with Picasso's comparable statement: "when a form is realized it is there to live its own life." But that "life" is surely transposed within us on the same level as all artistic forms that endure. One still wants to know what historical difference was made by the realization of Cubist forms.

The answer to that depends on how one distinguishes the outstanding physical features of Cubism, at least pre-1912 Cubism. Because of its ambiguity of space and its break with illusion, this art may appear essentially disjointed. On the other hand, it clearly harmonizes and integrates notations that share their logic, if not their syntax, with the history of composing in Western and even non-Western art.

This dual possibility is confusing because each component attitude can imply its opposite. Thus, spatial disjunction itself is meaningful only when compared with earlier representational models with which it is still obviously in dialogue. And an emphasis on the abstractness of related forms is a modernist reading of all past art that could not have come into being without presupposing that Cubism itself, as a unique historical event, initiated such a perspective. Cubism was assumed to have rejected the Impressionist ideal of fidelity to the fugitive, yet it held on in many cases to improvised and rapid Impressionist brushwork. Cubism repudiated the exotic subjects and timeless plasmas of Symbolism in favor of depicting an everyday slice of life—but with what enigma! No one can prove Cubism's greater dependence on the "ideas" of objects as compared with perception of them nor untangle the true cause and effect of observation and memory as they operate to distill or to interpret the presences in Cubist art.

To take one example: if the painter is said to blend several disparate vantages of an object into one pictorial amalgam, he cannot be schematizing a consensual idea of that object; he cannot be driving toward clarification or the authority of the "immutable" because his work demonstrates the opposite. Nor can the partiality of his selections be considered, in any philosophical sense, as a reference to a "complete" form. His disconnected images can no more be integrated into familiar shapes than they can be considered as a synthesis of multiple views of those images. His trackless starts and stops, misplaced ends and beginnings, or uncued interims, playing fast with volume, do not provide coherent information about things "as they are" (Jacques Rivière, 1912).

Still, it seems to us appropriate that the painting evoked hypotheses on this general level. For underlying the Cubist world there is, indeed, a metaphysical doubt, a kind of pleasing treachery, that corresponds to our own concourse with sensation. Objects that are foreshortened to the glance are literally truncated in the painting. A shape that seemed large will be shown by the artist to have been encroached upon by its surroundings. We suppress those fleeting misadventures of sight, those gratuitous occlusions, and, above all, those optional judgments of material which Cubism was designed to reveal. They well up softly but no less tangibly because they are represented in art. But there, at least, they are contained, conventionalized, and put on record, whose evidence is the Cubist moment.

CUBISM AND
ITS HERITAGE

Like every other art, Cubism was indebted to precedents, a motley of pictorial impulses and styles from which it made highly selective points of departure. Modern innovation in the arts can often be seen as a judicious sorting out of motifs in the background or environment. They then may be filtered by special predispositions, which may amplify, strip and fine down, distort or caricature them for purposes of which the artists may not always be conscious at the time. By the beginning of our century, the so-called "revolutions" in art may be understood as a succession of avant-gardes treating the accomplishment of their predecessors as so much exploitable, recombinable imagery rather than as continuing world views. That is, though obviously exemplary, important styles and subjects lived on not as residual authority, but as profaned vision.

As a rule, new artistic moves were limited by the range of immediate assumptions, then underwent high-pressure periods of assimilation and

isolation of materials, came to be identified in their ideology, and finally were subject to the same process all over again. Cubism was particularly illustrative in this regard. Upon what issues of earlier art did the artists who were eventually called Cubist focus, and what were their modes of encounter and response?

The Parisian scene from 1899 to 1907 was distinguished as a period of retrospectives. The careers of the great masters of Post-Impressionism, recently passed or passing into history, were being blocked out and celebrated at the Salon des Indépendants and the newly founded Salon d'Automne (1903). From these events two facts become evident. One is that the artistic generation roughly of the 1880s was being honored just as the untried group of 1900–1905 was coming into its own; and the other is that there seems to have been a cultural pause necessary for the consolidating of information. Radical art of high stature was being acknowledged and, in some cases, enshrined. But there may have been apprehension as well as congratulations in the air. An epoch does not commemorate its immediate past in art without some doubt as to its immediate future.

In 1899, Durand-Ruel gave over three rooms of his gallery to a very large show of Neo-Impressionists (Divisionists) and Nabis—the then current representatives of the most advanced art, or at least those most incontrovertibly prominent in the field. Thereafter, Toulouse-Lautrec was given homage in 1902; Manet, Seurat, and Van Gogh were exhibited importantly in 1905; and a great Gauguin retrospective marked off 1906. The next year, 1907, the art of Cézanne was given its most comprehensive due. These presentations were of art going back at least fifteen years—yet, if anything, more alive than ever before to ambitious newcomers.

The Fauves (wild beasts) created a sudden furor in 1905. Matisse, their *chef d'école,* born in 1869, had gone through two bouts with Neo-Impressionism before being joined by Derain and Vlaminck, who had just discovered Van Gogh. In their heritage Gauguin, too, figured grandly. The Fauves may be said to have rioted with these sources. Their frenzied mood urged them to push an earlier emphasis on color purity to an onslaught, where it would be recognized as physical release. This was largely accomplished by playing up chromatic dissonance and painterly gesture, which took on quite an independent force of their own. At the time, there seemed to be an unqualified brutality in Fauvism, an incoherent (because overly loose) clash-

ing and spasmodic flicking and patching of light-showering matter. But if Fauvism appeared to be perpetually climactic, it was not because of any hysteria in the outlook of the painters, but rather because of a hard-headed impatience to make every stroke and choice of hue count in an unrestricted field of maximized energy. Their temper was encouraged by the emotive and anarchic currents in the Post-Impressionists. Yet with Fauvism, it is as if the undertones and secondaries of Gauguin's color areas had been replaced by stinging shreds, blobs, and dabs of pigment; and as if the harmonic and regularized transitions in the divided color of the pointillists had been lifted from freely activated contrasts of jumping tones. There was, then, a thirst for pictorial economy among these artists, a rage to do more with fewer means, that had already been authorized, though for entirely different reasons, by the untouched canvas passages that gave breadth to the spaces in Cézanne's late work.

In subject, the Fauves did not extend themselves beyond the repertoire of the Impressionists, for whose motifs—beach scenes and suburban landscapes, portraits and still lifes—they showed a continued preference (Fig. 2). But these were not treated with that once fond appreciation of the bourgeois mind on holiday. Rather, it is the combination of familiar or homely themes with extreme, otherworldly turbulence of color that produces the characteristic Fauvist wrench. The subjects, with their eroded detail, have little "presence" and are curiously remote and rudimentary, while the heated color and heavy texturing of the picture excite a very immediate emotional response. And although this contrast had been implicit in Post-Impressionism generally, the fierce pastorals of the Fauves externalized it all the more through the raw behavior of troweled or squirted paint, which gave rise to ever-coarser levels of finish. For what seemed to be the childlike, or even aboriginal, climate of Fauvism was spurred on by gathering taste for primitive art—African and Oceanic—among advanced European artists of 1904.

Hitherto, the tribal sculpture of the Negroes and the Polynesians, known in many public collections in Europe, were viewed as artifacts of natural history, studied by ethnographers and anthropologists. More popularly, they were curios or trophies of Western imperialism. That these inadmissible and alien objects were suddenly seen by a few young painters as artistic phenomena of a high order signaled not only a remarkable feat of the imagination, but a need among these artists to find abrasive antidotes to a profound sense of cultural exhaustion around them.

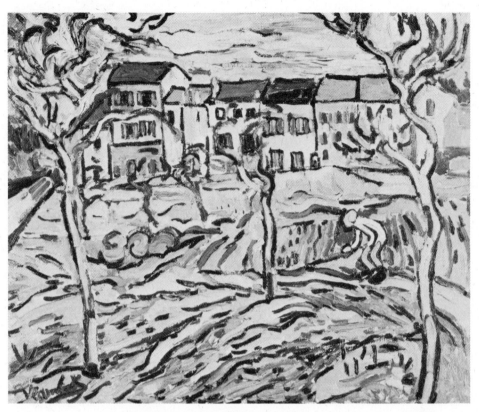

2 / VLAMINCK: *Houses at Chatou,* 1904. Oil on canvas, 32″ x 39⅝″. The Art Institute of Chicago.

For over a half century, Japanese woodcuts had been the self-contained "other source" for Western art. And their flat, surprising value contrasts, negations of depth, and sinuous arabesques yielded various degrees of formal sprucing that were at least as refined as they were bold. To this exotic source was added a new interest in Egyptian ritual art (exhibited prominently by Seurat and Gauguin), whose great attraction was to suggest not a fresh structural imprint, but a world of absolutes and eternities transcending the incoherent frustrations and distracting ephemera of modernity. Against the background of a revival of Catholicism, there was much in the

lives of *fin-de-siècle* masses to provoke confusion, resentment, and pessimism. A vogue for archaic forms and religious myth in art served partly to assuage these bleak moods.

The escape and nostalgia of the Post-Impressionists (Gauguin excepted) had appealed to gods of high, colorful credentials. The extreme cultural development of the civilizations to which they alluded could no more be thought of as an alternative or threat to the West than as barbaric entities. The gods of Africa had no such credentials. To involve oneself with the arts that worshiped them was to raise the level of criticism of the present implied in the iconography of escape. It was suggested that known civilization might be challenged by that savage state in which men were forced to propitiate not mere rulers, but wrathful nature.

Primitivism as a psychological impulse in the West had, since Jean Jacques Rousseau, the function of promulgating a vision of Golden Age or Promised Land—some shining era or place at the beginning of memory where society itself is in mystical and easeful concord with nature. The Fauves and the Cubists lent themselves ambiguously to this dream and yet also subverted it. Meyer Shapiro writes that primitive arts then "acquired the special prestige of the timeless and the instinctive, on the level of spontaneous animal activity, self-contained, unreflective, private, without dates and signatures, without origins or consequences except in the emotions. A devaluation of history, civilized society and external nature lies behind the new passion for primitive art." Just as it is by no means clear that there are fewer personal constraints in primitive societies than in modern industrial ones, so the message of primitivism in modern art lost much of its unthinking optimism. For visual canons of distortion and brazen schematization, inspired by the masks of the Ivory Coast or the statues of Dogon, were introduced into modern painting as modes of astringent irony. Recognition of how elegant some of these masks and fetishes were (Fig. 3) implied not merely a critique of European norms of beauty, but something profound about reversals of taste and thought as well.

The history of the pictorial discovery of African sculpture in Europe is still very confused. By 1904 or 1905, Vlaminck and Derain are said

3 / African mask, Itumba region (border of Gabun and Congo). Wood, 14″ high. The Museum of Modern Art, New York, Abby Aldrich Rockefeller Purchase Fund.

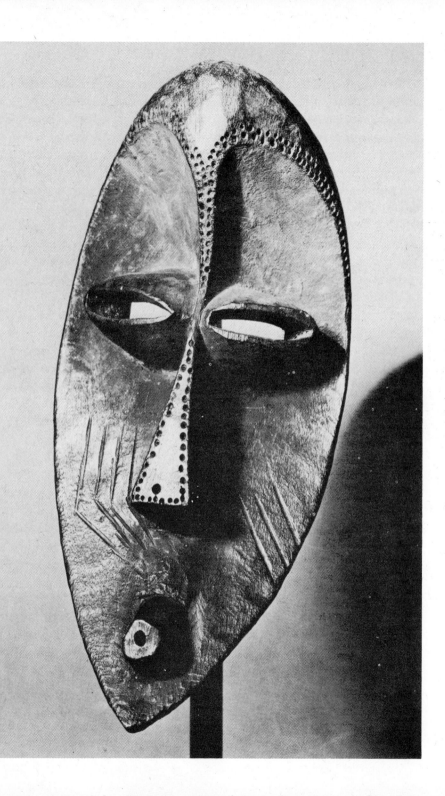

to have collected African pieces. Whether it was through either of these artists, Matisse, or independent encounters at the Trocadéro Museum that Picasso, too, happened upon them, we cannot be sure. Braque, who had been a Fauve, was certainly instrumental in generating enthusiasm for such art and decorated his studio with it. By 1907, all these artists were sharing various insights about them. (Die Brücke painters of Dresden—Kirchner and Schmidt-Rotluff—were also thought to be conversant with African art around this time.)

Its immediate effect on French art is discerned in the totemlike apparitions that are the bathers of Matisse, an aversion to describing space in any particularity (that is, of any historical moment), and the adoption of over-insistent contour markings—signlike schemata—to delineate meetings of planes or changes of volume, as in Picasso's nudes of 1907–1908, their faces now masks. And all this occurred within a context that played down the symbolic as compared with the decorative value of the originals. Furthermore, the ritually hierarchic proportions in African art were recast into an adverse comment on those of the West. (Of course, a new system of proportions and scale could, and did, reverberate meaningfully in its own right through the figurations of Cubist art.)

Yet, how short-lived was this unromantic, primitivizing tendency of 1907. The next year actually saw it drop out as a literal pictorial reference. Only Picasso continued to make of it a key element and not solely a passing stylistic feature or a fund of direct quote within his production. For him, the African wooden sculpture looked "rational" because it incarnated rather than simply represented its subject (Fig.3). From his absorbtion of its principles dates his lifelong belief in the incantatory foundations of art. He grasped, too, that African sculpture was the vehicle for the mimicry not of things or creatures, but of a collective emotion. It is fundamental to an understanding of Cubism that in Picasso one views an artist who sees kinship or bonding patterns among arts of the most widely divergent cultures and eras and who creates the moment when the formalized language for which he strives can find interchangeable derivations in Catalan Romanesque, Etruscan, ancient Iberian, Cycladic, Mesopotamian, or West African arts. He accepts and rehabilitates the prehistoric, the retrograde, the archaic, the primitive, and the naïve; he is sensitized to them all. No clash or contradiction exists among

them. Partially this was because he was not accountable to any of their belief systems, but it was also because he apprehended in them arts whose aesthetic value was authentically commanded by a spiritual necessity. Even more, in their presence he made the profound discovery that art had a signifying function before it had a representational value. It is already too much to say that Post-Impressionism revived ancient arts—at most, indirect allusions to them convey certain desired moods and tones. With African sculpture, and then suddenly with the crafts of countless obscure cultures, there could be retrieval but no revival. Prewar European intellectuals did not look on primitive art for the charm of a distant civilization; they saw in it the heat of human instinct.

In the environment of the Cubists, there was one outsider, Henri Rousseau, upon whom they conferred a special honor. (There must be poetic justice in the fact that a man who earned his living as a customs clerk became the unannounced mascot of Cubism.) Rousseau was a veteran folk painter, a self-taught artist, deeply conservative—he wanted to be a successful academic —who anticipated many of the spatial innovations of the Cubists through an invincible lack of confidence. His craze to guarantee the existence of every jungle leaf, to keep tabs on the single blades of grass and branches, to make every filament of nature unimpeachably clear, worked forcefully against appearances. His stiff landscapes were unearthly because of their stage-whispering literalism (Fig. 4). The things in them seemed too countable, their light painted in, hyper-gradated, and their brittle, thin planes accommodated only one bearing of the image—frontal or profile—at a time. Protesting too much, full of unsurmounted difficulties (representational, not necessarily artistic), Rousseau's work was unaffected by the history of art yet had centuries of naïve tradition behind it—of which he was also unaware. It could have been no more than candor that led Rousseau to confide at the great drunken banquet given for him by Picasso in 1908 that the two of them were the greatest painters of the age—he, Rousseau, in the modern manner, and Picasso in the Egyptian one!

Important issues were involved in the Cubists' engagement with noncontemporary modes. If the great sacred styles were demystified, their demons might yet live again in surrogate form. Simultaneous validation and wholesale leveling of many sources could make possible new thresholds of feeling and pictorial invention. But it was in their response to Cézanne that

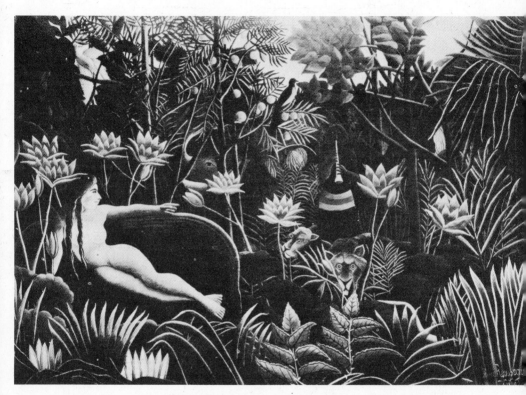

4 / ROUSSEAU: *The Dream,* 1910. Oil on canvas, 80½″ x 117½″.
The Museum of Modern Art, New York,
gift of Nelson A. Rockefeller.

the Cubists would *discover* their true faith—and almost cease, for a while, to be secular men of the world. Primitive art could teach them valuable lessons in expressiveness, manner, and vocabulary; Cézanne gave them something much more: he gave them the semantics of perception.

Still, these matters were related, even if the concern with the primitive had to do with the will to disestablish and transform visual schemes and the Cézanne resurgence with basic questions about their nature. It might be said of the primitives that they inspired the Cubists with assurance; of Cézanne, that he goaded them with uncertainty. Primitive arts nurtured the iconic sense of the Cubists. Cézanne infused in them a distrust of any ready-made answer to the problem of transferring sensations to canvas. In assimilating primitive traditions, the Cubists were behaving as people of culture, or at least were performing a cultural mission: they were linking disparate old ideas and values in new ways. But in Cézanne they found immense loyalty to grand European art—Courbet, Delacroix, Poussin, the Venetian Renaissance —yet a loyalty that could only be realized in the shedding of received culture and its formulae. It fell to the Cubists to intuit parallels between the artist who could not assume the principles of his masters, and the primitives who saw few purposes beyond those they had been so narrowly taught. Between these views—arising from opposite psychological sources—there was an excruciating tension.

How significant that when Picasso spoke of Cézanne, it was not to comment on a matter of technique or form: "It's not what the artist *does* that counts, but what he is. . . . What forces our interest is Cézanne's anxiety —that's Cézanne's lesson. . . ."

Cézanne's character and career show certain similarities with Rousseau's. Both roughly of the same generation (Cézanne was born in 1839; Rousseau, 1844), the two men, fanatically religious about the act of painting, hermetic in personality, suffered extreme abuse from the outside world on the score of their seriousness and competence. They were vilified as artists who did not know how to hold a brush. There was about them, too, an incapacity to deal genuinely with fellow human beings, a morbid self-image of failure, and a reputation for immaturity and instability that seemed to explain the compensatingly reclusive and inflexible habits of the lives they led.

By the 1890s, however, Cézanne, who had sympathized but had not been identified with Impressionism, was established in avant-garde circles

as a great independent master. Nominally, he wanted to reinstitute aspects of substance and solidity divested from objects by the Impressionists, who had concentrated on the phenomena of colored light with which they were perceived. But he would not bring this program about by means of modeling or perspective, categorical devices that did not accord with his experience of nature. Closed contour, for him, was circumlocution, and distinctness of shape an exigency for painters—if contrasted with emerging perception. For multiple sense data "vibrate" as information is gathered from them, and it is an arbitrary convenience to say at which specific point the definitive volume of this object or the extent of that condition *in space* has been determined. So Cézanne's small color hatchings would leave off, even as they overlapped and connected at myriad junctions, not because he wanted to suggest the transience of phenomena, as in Impressionism, but because he wanted to graph the very fluctuations of seeing. One had to ask how those fluctuations, already condensed and evened out in normal vision, could ever be vivified in paint, a medium that necessarily arrests and stereotypes sensations still further.

Intimidated the rest of his life by this question, the fanatical observer Cézanne could only delude himself by imagining he was faithful to appearances. Hardly ever after his youth, it is true, did he paint from his imagination or forego a physical view of the motif. But he saw so many forces of construction radiating out from that view, in all the tributaries of their incident, he tallied so many subtle alternatives among them, that one cannot say that his art required a minimal transparency of representation or that the logic of admitting that some personal view of a tree, mountain, or apple was what counted. One rarely feels that he was interested in articulating the features of what lay "out there" in the landscape for its own sake. But one is thoroughly impressed by his obsession with sorting and ordering the varied functions of strokes, sometimes on the verge of becoming signs, into rhythmically coherent sequences within a field evolved out of an idea of the motif's primal structure and internal forces.

That is why his canvases frequently seem occupied with activities genetically prior to any transcription of a motif. The energy of his attention was concentrated on the synapses of stubby touches that take into themselves all swellings of color and all reserves of density. The things he painted (though this applies less to his still lifes and more to his landscapes) become husks or shells, backing out from the internal brushwork yet never aggrandiz-

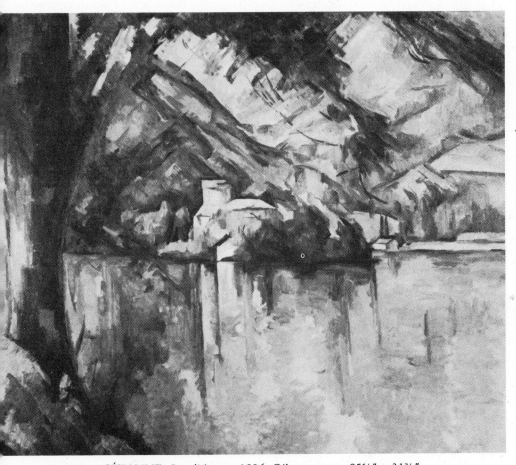

5 / CÉZANNE: *Lac d'Annecy,* 1896. Oil on canvas, 25⅝″ x 31⅞″.
The University of London,
Courtauld Institute Galleries.

ing in size or losing contact with their centers. They are somewhat approximate in shape, yet very exact in their swayings among themselves, as if slowly divining their spheres of separate and mutual influence. The roughened visions that resulted, with their all-over stipple textures and toothed edges, look quite out of countenance with the surfaces, if not the masses observed. Cézanne's "nature," wrote Maurice Merleau-Ponty, "is stripped of the attributes which make it ready for animistic communion: there is no wind in the landscape, no movement on the Lac d'Annecy (Fig. 5). . . . It is an unfamiliar world in which one is uncomfortable and which forbids all human effusiveness. If one looks at the work of other painters after seeing Cézanne's paintings, one feels somehow relaxed, just as conversations resumed after a period of mourning mask the absolute change and give back to the survivors their solidity."

All this resulted from the passionate objectivity of Cézanne. But it was an objectivity that could not take at face value the fixed point of view or the isolated moment of perception. In order to keep at bay the sensate chaos that might ensue from his refusal to describe specific location or boundaries, Cézanne would "color-modulate" at length. The thickening and thinning of his blue orchestrated space are essentially inflections of optical passages, paths of view more fluent than the stunting volumes they pass over and leave behind. If he did not see why he had to choose one set of data or attributes in nature over any other, then he had to develop a grammar of painting that would do them all metaphorical justice—omni-suggestive marks or units that would weld the scene into a convincing totality. The parts related are frankly acknowledged as paint, which, thereafter, seems to participate equally in the air, light, color, texture, volume, and substance of things but with the result of not seeming to finish with any of them. Cézanne's style gives off its most intense power of material envelopment when, late in his life, his skittishness dilates in the multiple echoes of forms that seem far more synthesized than abbreviated.

For the hypothetical quality of Cézanne's approach led to its comprehensive dualism. "Drawing and color," he declared, "are by no means two different things. As you paint, you draw. The more harmoniously colors are combined, the more clearly outlines stand out. When color is at its richest, form is at its fullest." (Gleizes and Metzinger seem to have been thinking of this statement when they wrote: "Every inflection of form is accompanied by

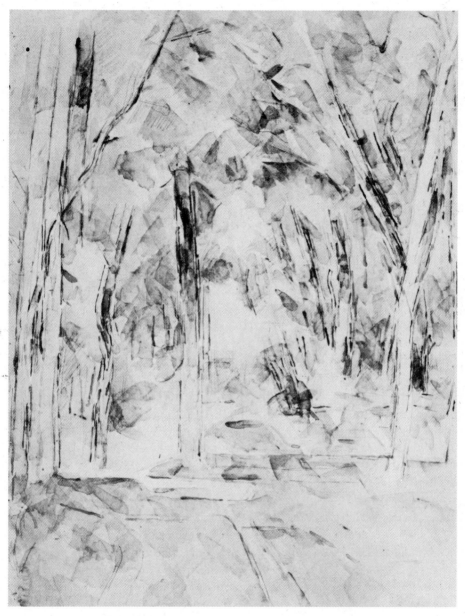

6 / CÉZANNE: *Trees Forming an Arch,* 1904–1905. Watercolor on paper, 23¼″ x 18¼″.
Mr. and Mrs. Henry Pearlman, New York.

a modification of colour, and every modification of colour gives birth to a form.") The same kind of reasoning informed Cézanne's attitude toward depth and foreshortening. Objects frequently seem to be dropping beneath or levitating above the vantage from which, at some other level, they had started out. Or they may be discontinued when they are only partially over-lapped, or they may seem pasted on to each other or stacked vertically when yards or miles appear to separate them. Rousseau would resort to some blatant, charming alibi whenever he got into such a spot, leave out or cover over material which would confuse him and the viewer, let alone interfere with his patterning. But for Cézanne, all the increments of depth have to be consciously disposed on a two-dimensional, flat surface and are obliged to answer to its extensions. He could have said, "Every incursion into space fosters a tautening on the picture plane." It is not as deliberate ambiguity or as pictorial vacillation that such features of Cézanne's world become evident. The light that emanates through his forms with increasing force in his late work illuminates the conscious adjustments he made in paint in order to project the spontaneous amplitude of his vision.

In his late watercolor *Trees Forming an Arch* (Fig. 6), delicately applied brushstrokes of blue, green, and ocher appear to represent an inter-mediate stage between pigment on a surface and the landscape features of the scene, opened by many blank areas. The way the faint strokes transparently overlap each other, tinted patches abutting and boggling over the page, suggests that matter has been pressed out of the vegetation, leaving only vaguely trembling and flouroscoped traces of the leafy canopy in space. In-determinate and disconnective, these blocky marks are the only agents that follow the foliage in depth, and yet they themselves are sensory vestiges not of plant forms, but of the courses these forms may be thought to take in bending within the line of sight. Picasso said that "if you take a [watercolor] by Cézanne, as soon as he begins to make a stroke, the painting is already there." Cézanne, in other words, could signal ahead his assumptions by the barest gestures. At another time Picasso noted, "In the old days pictures went forward toward completion by stages. . . . A picture used to be a sum of additions. In my case a picture is a sum of destructions. . . . In the end, though, nothing is lost." Had he lived, Cézanne might well have been horrified by Cubism, yet it was to him that the movement, as we will see, was most indebted.

THE DEVELOPMENT OF CUBISM AS AN AVANT-GARDE MOVEMENT

Pablo Picasso, born in 1881 in Málaga, the son of a provincial art teacher, was raised in Barcelona. The stories told of his earliest doings in art—and they go back to his childhood—endow him with an almost fabled precocity, like those of the Renaissance masters who astonished their teachers when still apprentices. He passed in a day a one-month entrance examination at the Barcelona academy. Possessed of enormous physical energy, adaptive powers, and artistic resources, he turned his back on the academic success he might easily have attained and threw himself into the cabaret life of his secessionist, anarchist, and always broilsome city.

That the formative development of Picasso is invariably spoken of in connection with anarchist violence in Barcelona amounts, by now, to a cliché. But his rebellious temperament must surely have been affected by a lawlessness that mounted so rapidly that two thousand bombs went off in the city's streets between 1907 and 1908. A comparable ferment existed in its

intellectual life. From the credo of one of its writers, Santiago Rusiñol, one reads: "to tear out from human life, not direct scenes, not vulgar phrases, but brilliant visions, unbridled, paroxysmal; . . . to strive at the tragic by frequenting the mysterious . . . giving to the cataclysms of the soul and to the anxieties of the world an expression excited by terror . . ." But although it was the most industrialized city in Spain as well as the most artistically progressive one, Barcelona consumed, rather than produced, new aesthetic ideas (with the exception of the remarkable architect, Antonio Gaudí). Picasso, with increasing restlessness, craved a wider cultural context in which to expand. By 1904, though marked indelibly by his Spanish background, he had settled definitely in Paris, a permanent exile from his homeland.

Paris absorbed a wider variety of artists, offering them, if they wished, the information most vital to carry on its traditions. Those with whom Picasso fraternized worked near or lived in a dilapidated Montmartre tenement nicknamed the *Bateau-Lavoir* and described by Alfred Barr as an "ark of talent." Gris was to live there and so did the Fauve Van Dongen. The poets Reverdy and Salmon were neighbors, and not far away were to be found their colleagues Max Jacob and Guillaume Apollinaire. To gather with writers had been, and continued to be, a necessity to Picasso and, later, to the Cubists. This impoverished young intelligentsia would emerge from its underground status in a few years, thanks mostly to the tireless campaigns of Apollinaire. Yet an exceptionally grim period, from a material point of view, still stretched ahead of them. Picasso very gradually came out of it when Ambroise Vollard, the dealer of Cézanne, took a liking to the works of his Rose Period. But he was more decisively patronized by Gertrude Stein, D.-H. Kahnweiler, and the Russian collector Sergei Shchukhin, all, in various ways, renegades from their class and protagonists of an experimental and, for a long while, specifically non-French taste. In an act that could only have seemed perverse, even to Picasso's friends, Kahnweiler began to represent the art of the young man who had just completed an outrageous large canvas, *Les Demoiselles d'Avignon* (Fig. 7).

But that painting had never been acknowledged as finished. Its crucial formal importance in the history of art (though it was not shown publicly until 1937) is bound up not merely with its primitive imagery, but with the way Picasso used such imagery to equivocate on the issue of pictorial volumes. For he seems to be "carving" in paint in the same way that his

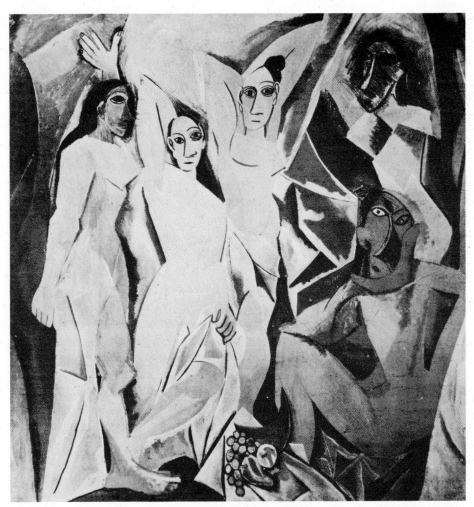

7 / PICASSO: *Les Demoiselles d'Avignon,* 1907. Oil on canvas, 96″ x 92″.
The Museum of Modern Art, New York,
acquired through the Lillie P. Bliss Bequest.

African sources were shaped in wood. In painting, this permitted him to expunge modeling, which was a rationalized technique for gauging a curve in volume as revealed by light. At the same time, he symbolically amplified the idea of three dimensions, either by suggesting the incising and cutting characteristic of Ivory Coast sculpture or by the radical twist of an axis, as in the lower-right squatting nude of the *Demoiselles*, whose head and back simultaneously face us. (A comparable device was the placing of a front view eye on a profile head, as in the standing woman at the left.) Picasso noticed that every change in plane articulated by African sculpture could be evidenced by line. And it is line that abbreviates such changes in dimension or movement, though they are, of course, by no means followed through as representations of existing volumes or gestures. If this kind of powerful, yet sly, tension marks the canvas as imminently Cubist, so, too, does its unresolved combination of different styles.

The picture is apparently wrought out of the most abrupt of reversals of program and left deliberately, perhaps hopelessly, in a state where they might be thought to accuse each other of pictorial disunity. Originally, in an early study, the artist had conceived as a central figure a sailor whose entourage of nudes is being visited by a man possibly carrying a skull in from the left—the whole, as Alfred Barr suggested, a kind of *memento mori*. Perhaps Picasso thought these embroideries too disingenuous or simply too narrative. To have excluded them from the final version shows, in any event, as much a reversal of intent as the sudden, thoroughly discordant inclusion of the masks on the right. Yet these were modifications that occurred in some kind of reasonable, second-guessing evolution. Notwithstanding their disruptive consequences, drawings executed by Picasso himself indicate that they were the result of a constant editing of placement and parsing of forms.

Accounts of his working procedure and the presence of innumerable drawings reveal that Picasso did not conceive of painting as work that could be carried through successive phases on the basis of a pre-established plan. We do not exactly feel that what was covered by paint in *Les Demoiselles d'Avignon* enjoyed as much importance in Picasso's mind as that which we see now. But the work conveys, as strongly as it can, an obsession with metamorphoses for their own sake. The question of choosing among them became an exigency imposed by finite painting. From now on he would be caught up with the exchange and trade-off of pictorial appearances, an operation in

which he had such structural confidence that he can be said to elaborate, but not to develop, his pictures. "Whenever I had something to say," said Picasso much later, "I have said it in the manner in which I have felt it ought to be said. Different motives inevitably require different methods of expression. This does not imply either evolution or progress, but the idea one wants to express and the means to express that idea." An empirical, protean, brusque personality, Picasso held no allegiance to a particular style beyond the most efficient exhaustion of its possibilities. Yet his faithfulness to his individual moments of perception was something that could be apprehended but never explained. No imaginative impulse could have been more germane to Cubism than this, though its eruptive and recycling tendencies have also shown Cubism to be an untypically evolutionary movement in Picasso's career.

Picasso's multiple commitments did not preclude intensity of vision, but they did imply a result-oriented activity that could have no one stylistic terminus or climax. Cubism for Braque, on the other hand, was a means he created for bringing painting "within the range of my gifts." Very characteristic is his thought: "In art progress consists not in extension but in the knowledge of its limits. The limits of the means employed determine the style, engender the new form and impel to creation." The morality of Picasso's almost exact contemporary, Braque, consisted in knowing and respecting the medium at hand and recognizing a special decorum in the sensuous properties of materials. Stemming from a Le Havre family in the painting and decorating business, he always cherished the probity of artisanship, whether it be humbly commercial or oil on canvas. Something of his vitality is suggested by the fact that he was an amateur boxer and accordion player. Already he had participated very creditably in the Fauve movement. It was not, though, until his contact with Picasso, ensuing in a close friendship from the moment of the *Demoiselles,* that his path was opened to him.

The history of early Cubism—or as some writers call it, the post-Cézanne phase of advanced European painting—is the story of the alliance of these two men. After an awkward postscript of his own to the Picasso brothel scene, Braque departed for southern France, Cézanne's country, where, at L'Estaque, he painted a number of landscapes. For his part, Picasso left for a Catalonian town, Horta de San Juan, in 1909, to be similarly engaged. It was as if they were picking up the lessons of Cézanne, filtered through the sensibility that had formed the *Demoiselles.* The paintings of villages and trees

8 / BRAQUE: *Houses at l'Estaque,* 1908. Oil on canvas, 28¾" x 23⅜".
The Kunstmuseum, Bern,
the Hermann and Margrit Rupf Collection.

that followed were distinguished by an apparent overall stability and little perceptual logic. Meetings of planes tend to be magnified, and bald, stereometric volumes are stacked upward in a close space rhythmically tufted with foliage, as in Braque's *Houses at L'Estaque* (Fig. 8). But these planes, executed in thinned washes of pale greens, ochers, and brown-grays, are lighted irrationally by tints that could have no natural source. Details of Cézanne landscapes seem to have been blown up and then "carved" out of a resistant, but lightweight, substance. One can measure the explicit cubic qualities of the forms, but one cannot anchor or relate them in an environnent that, by implication, they refuse to define. Shadows slide off the roof or crease into furrows that lose themselves from sight. Many internal or foreshortened contours bleach out. A truculent, rugged energy is injected into the airless landscape, gluing near and far without sacrificing a focus on the projection of geometric solids.

To splay and flap these large wedges became the drive of Cubist painting in the next two years. The impression given by Braque's *Still Life with Violin and Pitcher* of 1909-1910 (Fig. 9) is one of objects cracking open and jutting through successive walls of matter, like so many icebreakers plowing a congealed pictorial space. Reciprocally, the identities of images are almost battered out of the field as crevices of shadow operate to indent or cut masses rather more than to separate them. Pervasive is the sense of a tumbling cataract of activity under whose buffeting the still life begins to wrench apart so that a series of jagged dislocations is established. Formerly, in his landscapes, Braque had been at work impacting discrete forms, connecting or disconnecting them by a drawing still ordered by perspective and still dependent on the motif, no matter how schematized. But in the chewed-up terrain of this painting, it is as if he had to reintroduce by means of their most characteristic attributes the sense of objects lost early in a tumult of facets. The space is well on its way to becoming a complete invention, defined by a chiaroscuro that responds to every dent and cut of contour as if it were an occasion for contrast rather than a means to articulate shape and roundness. It is likely that Cézanne would not have countenanced this reversal of means and ends, particularly insofar as it is materialized by shading and drawing. But Braque's greater tolerance for ambiguity can also be seen as an intellectual extension of Cézannian passage work.

The traffic of his elements registers endless collisions symbolized

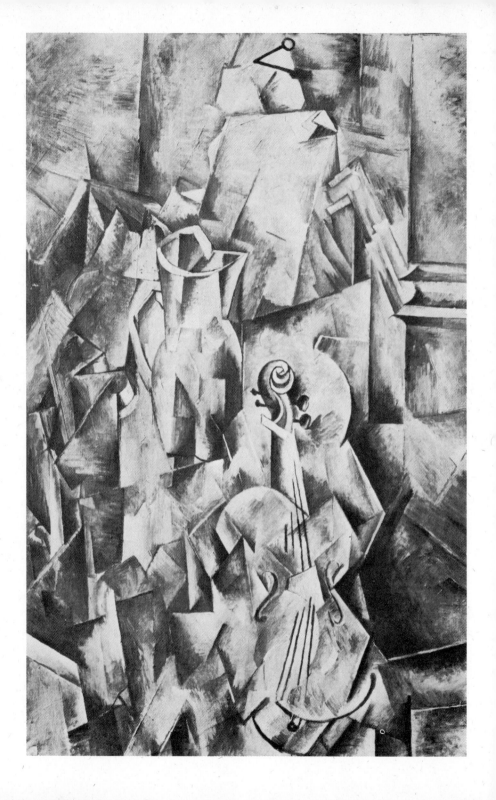

by pokes out of a still hard, solid mass. They had resulted from his desire to internalize the intersections that had occurred only along the edges of the house forms of his landscapes the year before. But now the artist had a circulation problem, and to create more room for his facets within the restricted, shallow space of the frame he, like Picasso, was to "fluoroscope" his image, producing in the act a curious light from within that became the watermark of Cubism, 1911.

Yet the Cubist artist has booby-trapped the seriousness with which we may greet this turn of events. Near the top of his composition, he shows a dog-eared fold that throws a shadow leftward, as if illuminated from the right, while just above, at the apex of the still life, he paints a *trompe-l'oeil* nail, driven into what would have been pure pictorial space (while also, apparently, projecting into ours) that nonetheless casts a shadow to the right, implying a light source from the left. With diagrammatic clarity, Braque cancels one reading of shadow and substance with another, while underneath he presents the inextricable mingling of the two. But even more significant than this externalizing of his own process, the realistic nail seems to discredit the hard-won metaphors of his style by removing them to the status of mere marks on a cloth, though they are no more or less so, actually, than the nail itself. In his preceding works, there had been a strong urge to impose a conceptual order on multiple sense data. Now that control has suddenly, if tactfully, been infiltrated by self-consciousness. Braque's conceit of the nail reveals a knowledge of art's limits—a tuning in on the artifice of his own goals. It is also a liberatingly ironic act of the Cubist imagination.

What is remarkable about the development of Cubism thus far is a dynamic seizure of the consequence of each step, accompanied by increasing reminders of its fictive status, approached very empirically, effected quite poetically. Picasso and Braque could only re-establish their credibility in the most highhanded and outlandish way. But by 1910, the presence of two other personalities, as divergent as they were singularly brilliant, was to be felt in the Cubist enclave.

Juan Gris (1887–1927) and Fernand Léger (1881–1955) had most in common the fact that they were devoted to realizing their perceptions through system. Gris, who came to Paris from Madrid in 1906, supported himself as a commercial illustrator until befriended by Picasso and the dealer

9 / BRAQUE: *Still Life with Violin and Pitcher,* 1909–1910.
Oil on canvas, 46" x 29".
The Öffentliche Kunstsammlung, Basel.

Kahnweiler. This Spanish painter was diffident and impecunious, easily depressed and fanatically painstaking. Additionally, he was the only "hard core" Cubist painter to discourse on the philosophical aspects of his art. Born José Gonzalez, his change of name indicates something about his monastic self-image. Léger, son of a Norman cattle breeder, studied architecture, served in the Engineer Corps of the French army, and for a time did retouching for a photographer. He loved Charlie Chaplin movies and locomotives. He was, in short, an enthusiast about the twentieth century. According to Kahnweiler, Gris occasionally relaxed from painting, during the twenties, by participating in the kind of séances where tables were supposedly turned—an apt hobby for a Cubist. Léger, in the same period, produced a film, *Ballet mécanique,* and extended his art into murals. Both artists, despite these differences of personality, tended to proceed as painters by means of very firm underlying structures. And these structures appear to set up a force that cocks images against illusionist space instead of situating them within it.

In Gris's *Still Life,* 1911 (Fig. 10), parallel slants of an almost lunar light rake flat across vessels whose verticality seems all the more intensified by contrast. Thick, dark paint appears to collect on the serrated edges of these forms and to highlight the lips of a glass, bottle and pitcher. Logical in its even modulations, frontal in its disposition of shapes, the painting nevertheless threatens to dislocate each observed object into an overall diamond or checkerboard pattern—the favorite configurations out of which, in later years, the artist's lights would flash.

Léger, too, felt that he must make every dissonant exchange of forms count, that this exchange be given the utmost, gutteral visibility. He had a horror of discreet art. Unlike Gris, he at first responded to the pressure of Cubism without wanting to go so far in draining the pool of represented space as Braque and Picasso had. Involved with the more billowy aspects of the world—smoke and crowds—he maintained a hollowed-out depth against which he wanted to contrast the new geometric shapes. By 1913, in his burly *Contrast of Forms* series (Fig. 11), he discovered a way to reduce his description of volumes while heightening the agitation which makes his turning drums slip out of gear. Color patches—pure reds, blues, oranges, yellows—angle bumptiously against his curves in a dialogue upon the sharp white canvas more abstract than any ever attained in Cubism.

10 / GRIS: *Still Life,* 1911. Oil on canvas, 23½" x 19¾".
The Museum of Modern Art, New York,
acquired through the Lillie P. Bliss Bequest.

11 / LÉGER: *Contrast of Forms,* 1913. Oil on burlap, 38½" x 51⅜".
The Philadelphia Museum of Art,
the Louise and Walter Arensberg Collection.

Nothing illuminates his later change of style better than his well-known statement (made during the war, when he was a soldier): "I was dazzled by the breech of a seventy-five-millimeter gun which was standing uncovered in the sunlight: the magic of light on white metal." From then on Léger militantly espoused the cause of propellers, ball bearings, cam shafts,

12 / LÉGER: *Les Disques,* 1918. Oil on canvas, 94½″ x 70⅞″.
The Musée d'Art Moderne de la Ville de Paris.
Photograph by Bulloz, Paris.

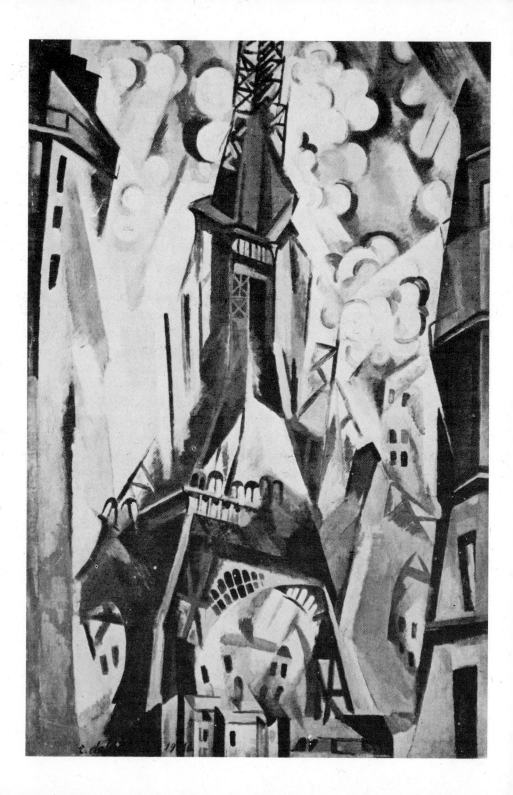

discs, and bridgeworks, polished in their metallic hardness or flattened in posteresque arrangements (Fig. 12). All trace of personal nuance and "artistic" brushwork vanishes in his zeal for picturing the manufactured and mass-produced. For him, the city is a vernacular, uninhabited *now*, a frozen industrial landscape in vital bad taste. It is composed of still lifes scanned and concentrated in an imaginary jump-cut space (resembling the long shots and close-ups of the movies) and materialized, finally, in the guise of advertising and road signs.

Léger's public style and epic generalizations were rooted to the present. But for Albert Gleizes, Jean Metzinger, Robert Delaunay, and Roger de la Fresnaye, the Eiffel Tower (Fig. 13) or Louis Blériot's primitive monoplane—outstanding artifacts of modern technology—stood for a continuous, timeless order of human aspiration. Picasso and Braque had ceased to show after 1909, and almost their only acknowledgment of modern technology was a brief habit of calling each other "Orville" and "Wilbur," in bantering reference to the Wright brothers. But these other men were socially conscious, symbolistically oriented theoreticians and Salon painters, anxious to reach a large public. Typically, they organized together for collective efforts, such as Gleizes's failed Communist commune, the Abbaye de Créteil of 1906, Salle 41 of the Salon d'Automne, 1911 (at which they gained control of the hanging committee), and the most prominent event of them all, the 1912 *Section d'Or* exhibition, where Cubism mobbed the avant-garde with over 185 works by thirty-two painters. Clan meetings were held in the house of one of their members, Jacques Villon, in the Paris suburb Puteaux. Critics, poets, and collectors were encouraged to press their cause. These Cubists, along with the Italian Futurists, with whom they joined in polemical battle, ushered in the age of aesthetic manifestoes. Throughout Europe there appeared belligerent house organs championing various new styles: the magazines *Der Sturm, Commoedia Illustré, Montjoie!, Blast, Lacerba.* As for the Puteaux group, it was symptomatic of their desire to convert Cubism into an art of considered judgment, even mathematical harmony, that they took for their emblem the Golden Section, a visual proportion known to the Egyptians, in which the smaller section of a painting is to the larger one as the larger one

13 / DELAUNAY: *Eiffel Tower,* 1910–1911, Oil on canvas, 77" x 50¾".
The Kunstmuseum, Basel,
the Emanuel Hoffman Collection.

is to the whole. Fused with a taste for allegorical themes—harvesting, the conquest of the air, the three graces incarnating the spirit of Paris—their rationalistic bias indicates the retrospective character of that phase of Cubism that had come to the most immediate public attention. With uneven results, the Puteaux Cubists insisted on the assimilation of the past into a view of the modern by marking their fragmented style with references to the French Grand Manner. For French artistic and intellectual supremacy was assumed, an opinion in accord with the declamatory style and grandiose dimensions of much of *Section d'Or* Cubism. World War I, in an off-handed consequence, temporarily shattered such beliefs as well as wrecked the social bonds and dispersed the public constituency of a movement that could never be pieced together again.

4 / *MA JOLIE* AND COMPANY

In 1911, no legible subject guides the eye in a Cubist composition. No distinct possibilities of comparison between pictorial and natural substance can be taken for granted in the problematical space evoked in that year's paintings by Picasso or Braque. Examine, for instance, the Spaniard's *Ma Jolie* (Fig. 14).

The luminosity it effects seems upset in its tonal values. They shade into darks where one anticipates lights and, sometimes, the reverse. Or is it that one no longer knows whether modeling, with its sane distribution of shadows, is in effect? This phenomenal light penetrates as much as it illuminates. The analogy it invokes of an unearthly energy (materialized in very earthy brown tones) "getting into" things has no mere natural explanation. The innards of the subject are exposed in what looks to be architectural forms, as if their covering had been made transparent. But we do not know that any such "covering" has been even implied. The picture can be spoken

45 /

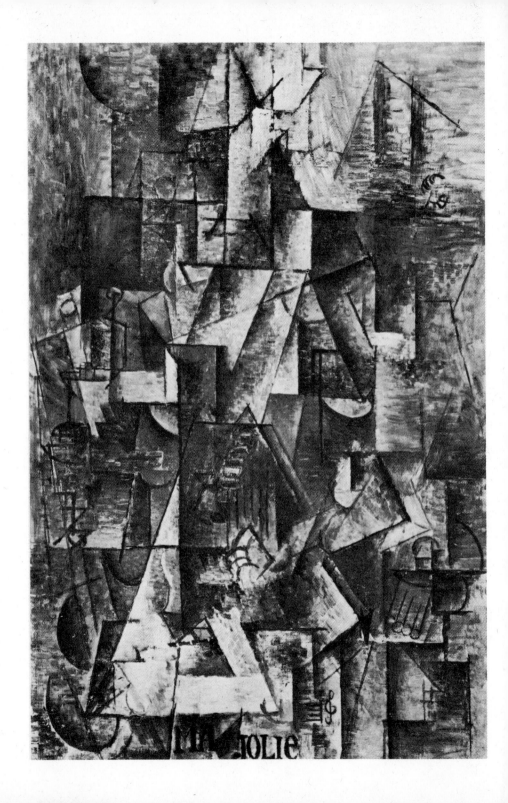

of only very approximately as an anatomical structure—a kind of complicated armature imperfectly made visible by a built-in pictorial X ray.

Nothing is more evident in the *Ma Jolie* than the striking difference between the rate at which we perceive and the time it takes us to recognize the image. With Impressionism, say, the viewer sees and identifies objects and conditions within the same physiological pulse. It is important that the coherence of the picture depends upon the revelation of one temporal instant. With *Ma Jolie*, what is seen and how it is interpreted are experiences that have been drastically pried apart and proceed at differing, umpredictable paces. That darkened vertical form in the center of the canvas, for example: what is it in itself and to anything else surrounding it or moving over it? Not only are such questions prompted by the complexity of the forms, but also by their behavior and function. Such a state of affairs is, of course, nothing new in itself. But to be obliged to tell how forms relate to an idea or an appearance, to distinguish which are conventionalized and which are without any known identity, all this initiates a progressively slower, compounded, and denser process of cognition—and an unprecedented challenge.

By no means, however, does it produce a thankless and unintelligible experience. For one thing, a painting like *Ma Jolie* strikes us as very tautly ordered. This order is carried so far that the imagery does not fall or find itself set into a created space, but becomes a product of that space. What is more, we do not get the impression that a particular class of forms is imposed upon a figure or object and that if only we tame or compute the forms we could fish out the figure, as if it were some coquettish creature lurking derelict beneath the shadows of a pictorial style. On the contrary, the image precipitates *through* the forms and is indissoluble from them. This painting assumes a homogeneous, mutually adapting sequence of broken shapes and lines, consistent in appearance but varied in connotation. The spectator is bid to study how parts are put together and, on that basis, to intuit the vague presence of a subject. To analyze the composition means to discover and sequence cues of that subject.

One can perhaps start talking of *Ma Jolie* as a vertically built-up linear grid, interrupted and intersected by flangelike diagonal structures that seem laminated in a roughened chiaroscuro of ochers, umbers, and grays.

14 / PICASSO: *Ma Jolie*, 1911. Oil on canvas, 39¾" x 25¾"
The Museum of Modern Art, New York,
acquired through the Lillie P. Bliss Bequest.

Arcs, spindles, shafts, and trapezoids, implying but never delineating volumes, are fretted, with their many cutting edges, into the light-sensitized environment. Visually, they compete with the little pipelike forms (the tassel under a chair's arm?), the guitar hole and strings, the inscribed words "Ma Jolie" (my pretty one), a treble clef, and a wine glass, sprinkled in an oval path around the mass. However much these features may shift in and out of focus, the mass itself is even more grudgingly defined—for it is only by virtue of its proportions, alluding remotely to those of head, shoulders, elbow, and torso, that one comes to think of it as a figure. Is this, then, a "portrait" of a woman reduced to a set of pictographic signs? Or have these geometric planes and scaffolded marks taken on an animistic life? To oscillate between such possible conditions, *Ma Jolie* assigns itself with an exceptional grandeur.

For it is rare that Cubist canvases, even with the same hard-to-read vocabulary and dense overlapping, resolve themselves with such emotional neutrality. A sly caricatural attitude or personal response to a theme often has its way with these austere forms. Picasso's *L'Aficionado* (Fig. 15), executed about six months later than *Ma Jolie,* in the summer of 1912, shows that his feeling is neither restricted nor even compromised by such forms. Jammed rigidly against each other, as if shoring up the bisecting axis of the painting, plates and louvers seem to pleat together a mass that is snipped above center by a cutaway formal white collar and decorated by a little bow mustache pirouetting above the left of a schematic mouth. A pompous dickey taking its place beneath the collar, a carafe blocked out in the lower right, the words "Le Torrero" capped here by a guitar hole and strings, the letters "O F," and the name "Nimes" flanking a top hat: all these weave together, with derisive effect, references to a "stuffed shirt" and the bull ring. Here, too, the space and the character of the imagery are mutually informing. Cardboardlike planes notching into and seeming to buckle each other are revealed by a powerful light etching their shallow overlays. The formality of Picasso's composition is turned against, even as it grows out of, its subject. But the humorous overtones of this situation are darkened by associations with the ritual fatality of the *corrida.*

Braque, as well, shares some of this sardonic feeling and certainly a parallel structuring of elements (although put to work for different ends) in his slightly earlier *Le Portugais* (Fig. 16). This canvas, freckled all over with little brown and gray brushstrokes, punctuated by linear facets, is nothing

15 / PICASSO: *L'Aficionado,* 1912. Oil on canvas, 53⅛″ x 32½″.
The Öffentliche Kunstsammlung, Basel.

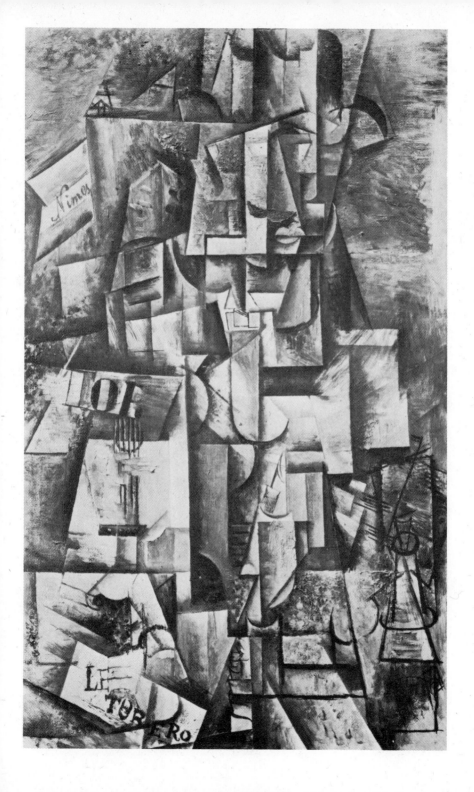

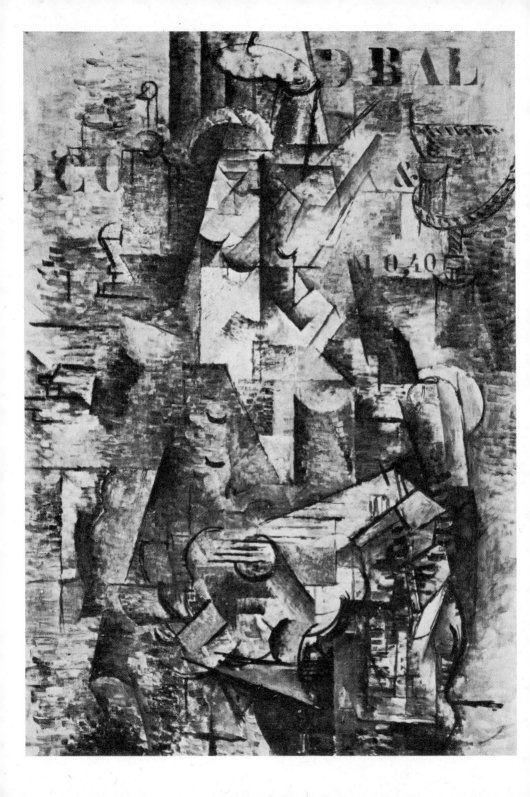

more than a series of partly broken, smoky transitions shaping themselves insubstantially into a guitar and still life, above which rises a figure (the subject is a musician). With its myriad touches, the staccato textural life of the surface seems to imitate Braque's drawing as well as tease and override its edges. It cannot be said, however, that deep space any more than flatness is suggested by this tactility. The webbing of the strokes in any passage is so emphatic that it destroys illusion while it also parodies modeling. Space doesn't go "anywhere"; it doesn't fill up the slanted intervals of the design, which are increasingly covered by various dappled shades of paint. Almost as if to spite this limbo, certain small upturned crescents—eyes, mustached mouth, even button shadows—crescents to which many of the dabs more subtly conform, smile out at us, grin with a kind of determined mischief.

For all their calculated structure and their puritanical color, these canvases are flighty in stroke and evasive in depicted space. "At the time," said Picasso, in 1971, to William Rubin of the Museum of Modern Art, "everyone talked about how much reality there was in Cubism. But they didn't really understand. It's not a reality you can take in your hand. It's more like a perfume—in front of you, behind you, to the sides. The scent is everywhere, but you don't quite know where it comes from." In fact, nothing can be claimed a priori about the dimensions or the nature of this space, which is precisely what is so unusual about it. We can accept the received idea that Braque and Picasso broke with the long-lived Renaissance notion of the painting as a window, framing a perspectively marked-off cavity of the outer world. But the Cubists apparently did not reject this system in order to assert its opposite—a concept of the painting as a façade where forms theoretically relate to each other only on the vertical plane. For the Cubist artists, rather, the field of creation lay between these two poles, so that allusive space became an endlessly conjectural pliancy fending to define itself. Such space, whether for the moment hollowed, warped, steam-rollered, or sometimes coexisting in all these states, contends with the preconception that depth is continuously perceived in nature.

That is why we have so much difficulty "locating" ourselves within any of these canvases. One has no choice but to "jump" in, each passage being as arbitrarily valid a starting point as the next. No more orientation exists than the tendency of forms to concentrate around the center vertical axis and to drift away toward the perimeters. Aside from this scheme,

16 / BRAQUE: *Le Portugais*, 1911. Oil on canvas, 46" x 32⅛". The Öffentliche Kunstsammlung, Basel.

however, to proceed further into the picture is to encounter a series of baffles, splices, and filters that merely inflect each other insubstantially with a tension from which there is no escape. In these circumstances it is impossible to imagine that the suddenly portable volumes and stabilities reveal any distortion of nature as we know it. For that to happen, as in Picasso's _Nude_, 1910 (Fig. 1), departures from the integrity of an image had to make themselves felt. From the representational point of view, though, 1911 Cubism is never "accurate" enough to look distorted. The recurrent dismantling of shapes and symbols, relayed across the surface and assigned new positions, constitutes an overall tissue of dislocation.

It is, then, necessary to adjust to a great deal of intentional "noise" in this art—that is, energy or information that seems to be in the wrong place. But while the reshuffling of token appearances may disrupt our knowledge of where things are, it affirms the visual homogeneity of the picture zone— its dovetailings and asymmetrical enjambments. In the Cubist priorities of seeing, for instance, movement is rarely of an event or action depicted, but a qualification of the handling. The desire to view many conceivable unfoldings of a thing superimposed in the same space, or the need to connect or bridge objects nominally separate exhilarates all transitions. It is the finagling of a cardsharp or conjuror—fast, purposeful, and deceptive in its executions —and it is no accident that the card game, once a symbol of rural leisure in Cézanne, was to become a prominent emblem of the Cubist sleight of hand.

Often, one feels as if brought up close to the riffling of the deck —an intimate experience in which the eye is dazzled by many separate images that rush subliminally in and out of sight. In Cubist painting, this effect may lead to asking questions about the relations and their meanings of part to whole. What happens to scale? Do little shapes generally amalgamate or fit into large ones; do they become part of the overall whole? Despite the presence of geometric figures—or often, rather, their echoes—it is very hard to talk about shape in canvases like _Le Portugais_. And without an idea of shape, it is impossible to judge the depicted size of objects as they adjoin each other. Not only does this art, for the first time, do away with a standard that allows us to imagine whether images are cast smaller or larger than those in life, but it doesn't convey the idea that anything within its sphere of vision is complete. Fragments, episodes, details—these may imply an amplitude latent in, but never delivered by, the painting.

Instead, one has the finality of the picture itself as the only index of scaling internal events, so that scale is quite literal rather than virtual. In Cubism, an image is not diminished, scaled down because of its supposed distance from the retina; it is small because there may be larger forms nearby with which it must contrast. We are not mentally permitted to "return" anything to its size as known because the picture has already given us its actual size. This procedure is so unexpected because it is so candid.

We are entitled to ask what effect this literal scale has on the subject of the Cubist painting. It is known that much the same vocabulary and syntax are used in Cubism when presenting landscape or architecture, still life, and the human figure. Even though each of these genres ordinarily requires differing treatments of space, within Cubism they appear to collapse into one still-life paradigm. Though it is an apparent landscape, Picasso's *Pointe de la Cité* (Fig. 17) shows a typical Cubist antipathy for plunging or angled depth. The artist prefers an immediately touchable up-front imagery, intimate in the way a landscape rarely is. For literal scale demands such intimacy, in which objects almost want to jut out from the plane and are in scale with nothing but themselves. Curiously enough, the more that representational premises are de-emphasized in an art, the more direct the physical being of its forms tends to be. Here they begin to have a point-blank and continuous relationship with the space of the spectator.

Enclosed in an otherwise abstracted realm, lettering, whether stenciled, printed, or written, underlines the concreteness of such a development. It is easy also to appreciate the narrative possibilities introduced by lettering. The painting seems to whisper of news, signs, and events that give some personalized, extended context to the subject. The latter, if it is not located in a specific place, comes to be situated in history and thought—that is, it is infused with biographical hints. No matter if the information given is piecemeal and the notations stutter, starting out from the middle of isolated words. This kind of verbal incompletion accords with the fragmented quality of the imagery. Although one reads print linearly, Cubist lettering partakes of the same staggered order as the forms in Cubist painting. On their own level, these inscriptions spell out the fact that many visual sequences in the picture have been tampered with. But such lettering is no more obscurantist than it is redundant. What may appear on a title sheet of a song, a poster, or a newspaper masthead triggers many differing kinds of expectation that, no-

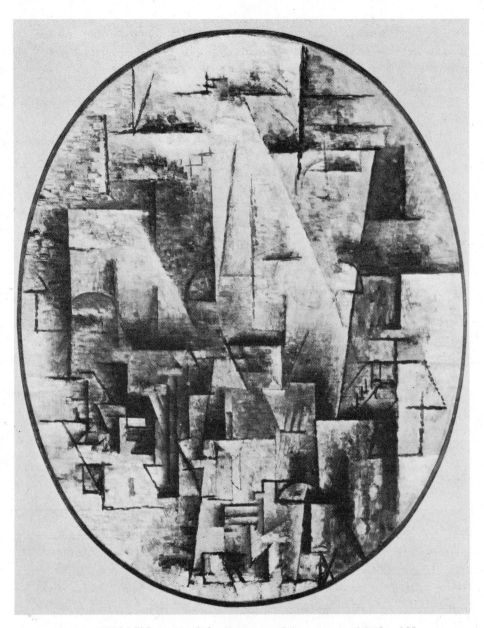

17 / PICASSO: *Pointe de la Cité*, 1911. Oil on canvas, 35½″ x 28″.
Norton Simon, Inc.,
Museum of Art, Los Angeles.

ticed in passing, contribute to our everyday linguistic environment. Picasso and Braque refer most frequently to forms of popular music—"bal," "valse" —and to newspapers, some of whose names—*Le Figaro, Gil Blas*—have musical associations. Occasionally, it seems as if the inscriptions are themselves like musical notes or accents, suspended in stafflike entanglements that make up the imagery.

Yet print structurally resembles much in Cubist form itself, being almost an extreme outcome into legibility of the pictographic status to which Picasso and Braque have reduced their subjects. Here the analogues between word and image are carried far, but not so far that the artist will sacrifice the decorative and contrast values of verbal symbols within his pictorial atmosphere. Introduced tactfully into the composition, words behave like motifs as well as material that can be read. For instance, the composer's boldface name in Braque's *Homage to J. S. Bach* (Fig. 18) graphically condenses and alludes to the "B," "H," and "S" figurations more covertly at work within the painting.

Of course, we have acknowledged lettering on painting long before Cubism, in the guise of the artist's signature—Henri Rousseau's, for example, was always proudly noticeable. Significant now is not merely the removal of the upper-case names or words into staging areas more visible than a corner, but the integral functioning of these names within the matter of the picture. It says a great deal about the enormous changes wrought in art by Cubism that lettering, something *written* on the surface, has been accepted as part of the metaphorical vocabulary of the painter. A signature, too, is written. But we never inquire as to what it does to the representation above precisely because it is a signature, something obviously there but "apart" from what is shown. A signature is merely a peripheral fact, whereas we are concerned with the on-center fiction of the work as a whole. It is startling to see fact and fiction now get on with each other so amiably. For the Cubists put intense pressure to bear on our habit of regarding the picture plane as a metaphoric transparency. They would call attention to the physical being of that plane by printing on it. And they were perfectly aware, even desirous, that this would introduce spatial contradictions. Braque said that letters "were forms which being themselves flat were not in space, therefore, by contrast, their presence in the picture made it possible to distinguish between those objects which were in space and those which were not." This comment is not helpful insofar

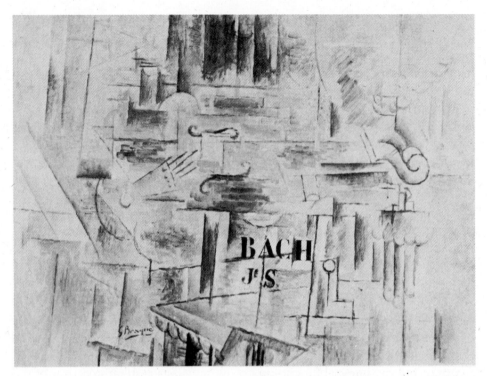

18 / BRAQUE: *Homage to J. S. Bach,* 1912. Oil on canvas, 21¼" x 28¾". Sidney Janis, New York.

as we realize that none of the objects alluded to by the picture is in actual space. And Braque did not here take into account the fact that the lettering on a poster and on a newspaper are ordinarily seen at quite different distances from the eye, the "thereness" and "hereness" of which are discounted by Cubism. Whenever letters appear in the Cubist context, the surface seems to pull up its illusionism to meet them, and little, indeterminate, starched precincts spread out within the shaded maze. Since any line drawn *on* a canvas would normally have this effect, the distinction of letters must be in the fact that they are never representational. They are what they are—accepted symbols—and, therefore, can only be "put" on an incontrovertibly physical ground. Varying the play of artistic forces, script acts simultaneously as a unifying and a differentiating element within the Cubist matrix.

It was exactly this double-functioning nature of the Cubist approach that became the issue of perhaps the most perceptive article written by any of its critics, Jacques Rivière ("Present Tendencies in Painting," 1912). Rivière assumes, in the light of Cézanne, that "sight is a successive sense; we have to combine many of its perceptions before we can know a single object well. But the painted image is fixed. . . ." Perspective and lighting, he then goes on to say, are accidents, altering the forms of objects, indicating not their situation, but only that of the spectator. To correct this overly limited view, the Cubist employs a more equitable distribution of contrasts, showing "slopes supported on one another in a gentle solidarity. . . . Where one object is in front of others, this fact will be shown by the fringes of shadow with which its contour will be edged; its form will detach itself from the others not as a simple profile on a screen, but because the strokes delimiting it will be flanges, and because from them shadows will flow towards the background, as the waters of a river fall regularly from a dam."

Having made these suggestive analyses, Rivière's text collapses in its internal sympathy for the Cubists, and he levels against them the insistent complaint that their art is overdone, self-parodistic, and confusing. They show too many faces of the object, "give [it] the appearance of an unfolded map and destroy its volume. . . ." Moreover, everything is equivalent for these painters; they do not select or subordinate elements. And finally, he accuses them of giving depth as much solidity as objects: "To each object they add the distance which separates it from neighbouring objects, in the form of planes as resistant as its own; and in this way they show it prolonged in all directions and armed with incomprehensible fins. . . . The purpose of the painter's efforts to express depth is only to distinguish objects one from another, only to mark their independence in the third dimension. But if he gives to what separates them the same appearance as he gives to each of them, he ceases to represent their separation and tends, on the contrary, to confuse them, to weld them into an inexplicable continuum."

Rivière demanded of Cubism's contourless drawing and volumeless modeling a clarity that was not its purpose to give. His eye could not adjust to Cubist appearances. Where its enemies derided Cubism for its reductions, he criticized its superfluities. His conclusions do not prevail today, but this does not diminish the finesse of his observations. The thicks and thins of the Cubism he discussed were an evident problem to the painters themselves.

Usually called *analytic* because it made dissection of objects its apparent ideal, and sometimes dubbed hermetic because it seemed to seal in these dissections with an especially cryptic formal language, this phase of Cubism initiated a dialogue between surface and depth on deliberately unstable terms. The willfulness of this dialogue, which Rivière could no longer follow, was reinforced by lettering. The latter worked against the omniscient shallow recessions of Cubism, yet was never permitted to gain the upper hand among them. Nothing less than the legibility of Cubist space was at stake. And now, in collage, that pressured, volatile space was to be relaxed and anchored by a device that made a shambles of pictorial illusion.

PAPIERS COLLÉS
AND COLLAGE

Those who have written on Cubism speak of 1912 as a crisis year for the movement. Several issues bind themselves together in the common view of this crisis. On the simplest level, Picasso and Braque are said to have felt that they had carried their work to the extreme reach of complexity, and now, in corrective recoil, were setting out to clarify their vision and to reconstitute the integrity of objects lost in the dispersals of analytic Cubism.

But this judgment depends on the way simplicity and complexity are defined. If their aim had been to revert, in some manner, to primary information about objects, it was not accomplished by disjoinings even more flagrant than those of 1909–1911. The established term for the style they evolved thereafter is "Synthetic Cubism." But to use the word "synthetic" to describe those definitive separations of parts from wholes that appeared in the next three and a half years is to misrepresent the processes involved. First of all, artists obviously synthesize forms as much as they analyze them, the

decisions they make engaging the two operations concurrently. Second, objects in 1912–1914 Cubism are particularized—given heterogeneous and conflicting tactile and chromatic identities that do not seem at all in accord with the generalizations one would think necessary to a "synthetic" approach. By such criteria, 1911 Cubism, because it was more homogeneous, must surely be thought to be more synthetic than what succeeded it.

One of the major changes occurring in the later period is structural. At certain passages, substance fills in and becomes enclosed by drawn or implied edges, whereas they would have been shaded off earlier. And it is precisely this shading that begins to evaporate when the painter opens up or leaves unmarked spaces between these delimited masses. The basic pictorial vocabulary of Cubism is continued—if anything, made even more schematized and spare in its definition—but Cubism itself becomes an art of prominent, self-contained contrasts rather than small, broken transitions. The artists had increased the size of their elements relative to the frame, while declaring specifically how they do or do not support and prop each other. Images inevitably are radically taken apart, their aspects discordantly mixed. Cubist designs on the object are greater than ever before. In this sense, post-1912 Cubism is far *more* analytic than the Cubism preceding it. There can be no question of a retreat to the constitution of appearances. But if they are less credible in this new work, they are readily grouped by the eye, no longer obliged to make myriad, tiny scans. With its simplified patterns, fewer superimpositions, and reduced armature, the logic of the picture asserts itself as a decorative ensemble. The earlier obstructions or delays in maximum visual impact are cut away. All connections or disconnections emphasize themselves —are precisely what the art is made of. And the result is that one is immediately enabled to get on to the conceptual demands of the work, demands that have suddenly grown in proportion to the high specificity of the formal means. If this visual directness is *not* understood as clarification, then the phrase "Synthetic Cubism" may stand as a rough allusion to the *effect* of the new painting.

While figurations introduced by the revamping of late 1912 showed one escape from the crisis, the accompanying space revealed another. By putting pictorial recession off limits, the artists were obliged to back up their forms, terminating the space precisely on that plane that literally receives the marks and the material of the image. If dimension ends there, then, for

practical purposes, it must "commence" almost or right up to where it stops
—or else painting, lifting its restrictions on 3-D, becomes a form of bas-relief.
What is usually described at face value as a flattening of depicted space in late
1912 Cubism infers, indeed, new thinking related to sculpture.

Much of the work before had tended toward monochrome so as
not to interfere with a groping into depth by tones. Abruptly a great deal of
color, sometimes delicate but often saturated, comes back into Cubism. This
bouquet of blues, pinks, greens, ochers, and whites color-codes the various
forms, keeps them apart on a one-to-one basis. It also helps to determine
which areas lay on top or beneath other areas, precisely because the overlaps
are generally of single, unmixed colors. A reversal of artistic policy has taken
place. Pre-1912 Cubism hinted of modeling (when it did) in much the same
fashion, though on much shorter terms, as Western painting overall. But there
then ensues a change in Cubism in which the forms are quite avowedly where
they are, unmodeled, yet exist in a stratum edging almost as much in our space
as in the picture's. Just as there has been a decline in sculptural illusion, there
has been an increase in sculptural presence. *literally* *Lie modelling*

Picasso, in fact, has given us two pieces of sculpture that physically
enact the change. In his 1909 bronze *Woman's Head* (Fig. 19), he seeks to
manifest the discontinuity of all planes and yet to force them to hold, as an
aggregate, the full volume of the head. Powerful, if awkward, with an exag-
gerated motility, the piece topographs pronounced facet meetings whose
solidity, for once, is eked out in matter rather than blurred by the solvent of
paint. By early 1912, Picasso executed a sheet-metal and wire *Guitar* (Fig.
20), much as if its frontal shapes had been snipped from a painting. The
surfaces of the first sculpture bear down or out from the core, which now
merely sustains weight and gives density but does not orient the externally
convulsive deformations of the head. In the constructed guitar composition,
there are no distinctions between inner and outer volumes. Volumes, in fact,
are difficult to speak of because we have only flats disposed parallel to each
other and frontal to us, with varyingly shallow spaces between them. Al-
though both works derive from Cubist painting at two different stages of its
development, the head translates easily into a modeled-sculptural effect of the
round, while the *Guitar,* more conservatively, adheres to painting syntax,
unfolding out from its base, as if it were a bellows from a camera, here cut
away and there flapped down. But this spatial conservatism strikes an entirely

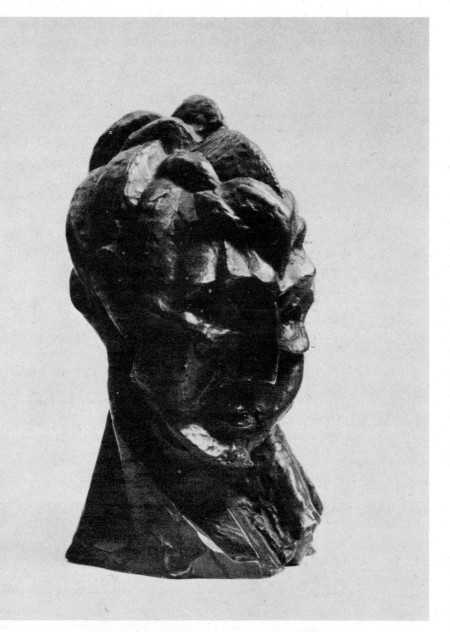

19 / PICASSO: *Woman's Head,* 1909. Bronze, 16¼″ high.
The Museum of Modern Art, New York.

new note in sculpture. For the activities and the pressures that have brought the piece together did not presupppose any working upon or modulating out of a given mass, but an assembling of separate shapes, without necessarily common origin, that are fitted to *make up* an image.

Cubist painting after that uses this process of making up and fitting together. If painting traditionally involves the moving of hands, and the covering of a surface, such activity declares itself within a specifically privileged field. Every fictional thing occurring there was invented, not in the sense that prototypes were lacking, but in that it did not physically exist before. This would be obviously true of lettering as well. But what of lettering or print on newspapers, brought to and stuck on the field? When Cubists did this, the fictional intactness of painting was violated. The artist could claim to have shaped and placed these "readings" (called *papiers collés*—pasted papers), but he could not assert that he had ever been responsible for bringing them forth into the world. The picture in which these pasted papers appear, therefore, is a setup of displaced—essentially mechanically reproduced—materials.

Numerous greeting cards, valentines, and folk artifacts had earlier used similar combinations of things for playful or decorative effect. Picasso and Braque, however, were the first (Braque leading in 1912) to elevate this dainty pastime into the culture of art and to consciously deploy its once lightsome oppositions as a form of serious paradox. Soon there was included in their work a vast gamut of extraneous objects: tickets, programs, wallpapers, book illustrations, cloth, corrugated cardboard, sand, calling cards, advertisements, etc., all of them suddenly legitimized components of art imagery. The term denoting the use of these and any other materials alien to paint in a pictorial context is *collage,* a French slang expression for two people living (i.e., pasted) together. To complicate the matter still further, the artists sometimes juxtaposed this imagery with brown-paint passages raked by a special decorator's comb to imitate wood graining and/or papers printed to look like wood.

Collage, then, was a short-cut way of picturemaking—a method of possessing many images without resorting to the representational apparatus at all or by treating representations as things in themselves (and, therefore, ✳ highlighting their different substances). Yet these "short cuts" consisted not merely in contracting the span of physical work involved, but of shifting

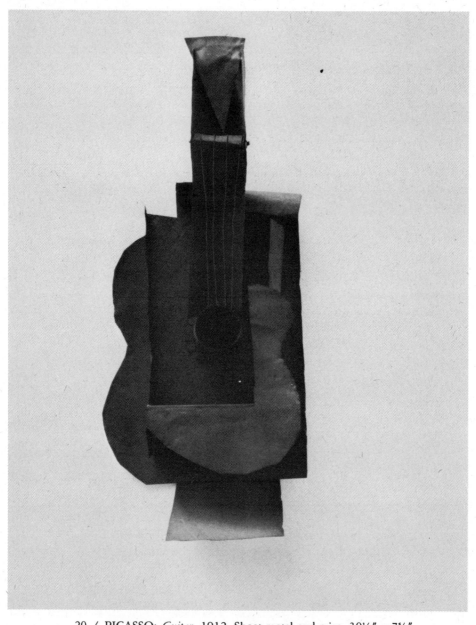

20 / PICASSO: *Guitar*, 1912. Sheet metal and wire, 30½″ x 7⅝″.
The Museum of Modern Art, New York,
gift of the artist.

responsibility for the life of the picture more directly on to the combining, rather than the executional, skills of the artist. All along in Cubism there had been a kind of chastisement of pictorial handling and progressively minimizing definitions of craft. These tendencies went hand in hand with a very sober view of style as embodiment of personal impulse, a preference for restricting autographic potentials of the picture, and a distaste for any display of temperament. In this sense, collage, with its prefabricated ingredients and second-hand references, was a natural outcome of the anti-expressionist mood of the artists. Their detachment as artists illuminates the liberality with which they opened the bodily limits of permissable subject and form. Just as, before 1912, they could deliberately misconstrue the figure as a sequence of cryptic fragments, so, thereafter, they asserted the hybrid and gratuitious nature of their own processes, as demonstrated by the clash of pictorial and non-pictorial fragments within the collage composition. This strategy of accommodation to literal artifacts from the outer world was sanctioned by a pride in the viability and integrity of their conception. Their aesthetic goals were such as to be enhanced by the adulteration of their field by non-aesthetic materials. It is debatable whether the "synthetic" mode held in suspension, or was an outcome of, collage. The one is unthinkable without the other in the non-illusionist framework provided after 1912.

Collage and *papiers collés* dominate Cubism in 1913; the lessons learned from it filter back into "pure" painting slowly thereafter. One of the immediate consequences of the new method was a reading of the picture area as a kind of suddenly "neutralized" ground. Previously in Western art, to do something to the ground—that is, the picture surface—was to bring it instantly into complicity with the world taking shape on that canvas. The progressively inflected surface germinated the space in which that "taking shape" occurred. There is no such simultaneous interaction in the relatedness of image and ground in Cubist collage. There, the paper or the canvas functions as a support that takes onto itself various kinds of matter and may, eventually, look interestingly divided, patched, or ruled. It can be endowed with a specific gravitational power, but it is, at the same time, deactivated to literal status—made to behave as a staging or storage area. The intervals into which it is broken up are purely visual, while, contrarily, the whole they comprise is significant as a repository for information, like the page on which this is printed.

In either instance, the base of collage is non-referential despite the particularity of the real materials and the schematically drawn objects that have been superimposed (by pasting) upon it. To compare this aspect of the mode with the then contemporary abstractions of Kupka or Kandinsky, Delaunay or Mondrian, is to realize that, purged of identifiable imagery as they are, these abstract works still belong to other worlds whose dimensions are distinguished from those of the physical support. Hitherto, the query carried through by Braque and Picasso might be summarized "what if?"— if one thing is done, how will it affect or alter the existence of another thing (assuming that the "things done" are formal activities always under the control of the artist). Presently, as in Picasso's *Still Life with Violin and Fruit,* 1913 (Fig. 21), the earlier premise "what if?" is rapidly joined by something like the propositional "let it be"—let it be that the work of art asserts itself as an outright rather than a covert artifice; let it claim only a single catchment area instead of a set of allusive references to a sphere of existence beyond the picture.

But that single area has suddenly become very uncertain. For in the Cubist collage the artist argues that there can be no intact pictorial view of reality, seen or imagined. There are merely propositions about reality— that is, self-conscious proposals of things related or associated with each other on different levels. Cézanne wanted to homogenize all the varying features of the world with his set-piece strokes. In 1907, Picasso could subject the widest array of cultures to his modern grasp of savage instinct. By 1913, however, he understood not only that popular or commercial media had their place in his domain, but that the data he desired to synthesize could only be held firm by acknowledging the spatial and tactile discrepancies among them and by making his art a play on those discrepancies. The color-engraved illustrations of the pears, the charcoal-outlined tuning keys at the knob end of the violin, and the simulated textures of the wood in Picasso's *Still Life with Violin and Fruit* can relate to each other only through the graces of a sensibility that confesses the disconnectedness of all sensation. For the counter-proposal of collage, as remarked by Nicholas Wadley, is that "the medium provides its own reality. Various sorts of imitation of a motif are replaced by a sort of painting in which the means *are* the motif. The different materials not only determine the form, but also the subject matter of the painting." Thus, the incursion of cheap, ephemeral, or prosaic items within the field is only a

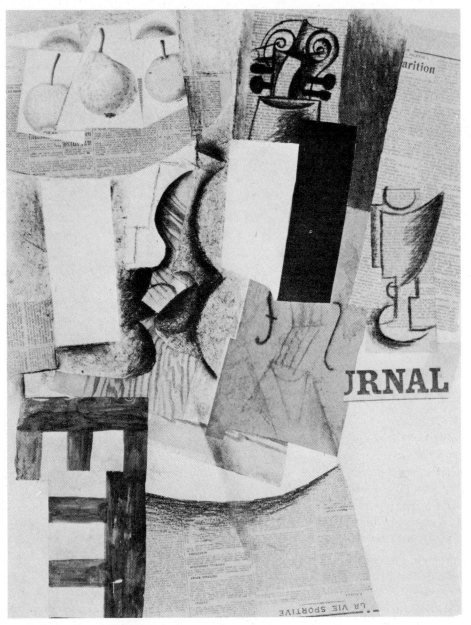

21 / PICASSO: *Still Life with Violin and Fruit,* 1913. Collage with colored
paper and charcoal, 25½″ x 19½″.
The Philadelphia Museum of Art,
the A. E. Gallatin Collection.

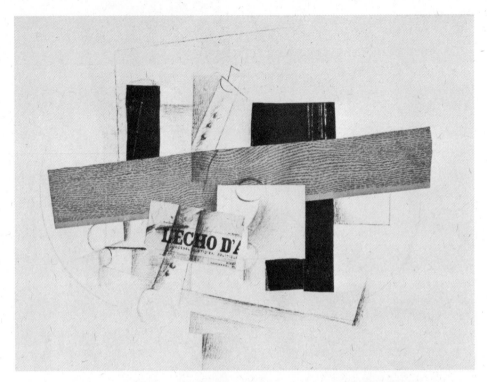

22 / BRAQUE: *The Clarinet*, 1913. Mixed-media collage, 37½" x 47⅜". Private collection, New York.

nominal stepping out of character. The more they misbehave as subjects, the more evident that they have been aesthetically charged as form.

With the exception of a few heads by Picasso, most Cubist collages are explicit still lifes. Because they are pasted on a flat plane, the table top or drawer scatter they juxtapose is upended, parallel to the wall, though it is not necessarily meant to be read as if looked down upon from above. Very often, plan, front, and side views fold transparently into each other. The earliest *papiers collés* are charcoal, and sometimes pencil, drawings varied with colored cutouts. Braque's *The Clarinet* (Fig. 22) sophisticatedly illustrates the tactics involved. Its diagonally sketched clarinet vanishes behind a long, horizontal band of brown wood-grain paper, reappears on top of a snippet of

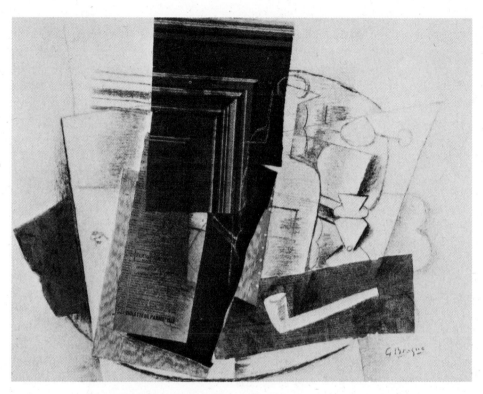

23 / BRAQUE: *Bottle, Glass, and Pipe*, 1913. *Papier collé*, 18⅞″ x 23⅛″.
Lady Nika Hulton, London.

newspaper, "*L'Echo d*" [*Athenes*], only to establish itself below once again on
the base sheet of the drawing. Differing surfaces, therefore, intercept or are
sometimes drawn over with the outlines of an object that can have, as a result,
no one determinable location. Since an image may be grafted on to masses
which elsewhere are shown to conceal it, the elements within a collage
emerge as little pictures in their own right—pictures with their own spatial
environments and styles. Such are the poetics of collage that every time the
artist pretends to ignore these discrepancies, he deliberately calls attention to
them. His every move is a transgression, exposed in a particularly naked way.
He puts new demands upon himself to assimilate these transgressions to make
them look natural even in their surprise.

Bottle, Glass, and Pipe (Fig. 23) shows Braque complicating these dynamics with virtuoso effect. Unmatched shards of still life in different finishes—from the highly illusionistic paper-wall dado panel, through the diagrammatically linear bottle, to the pipe shape cut away from the browned newspaper—partake of an impossible intimacy. The viewer is arrested by the solid wall molding, a background element, fronting and pushing down from above upon the dematerialized table vessels. In tearing, wrenching, and reversing depth, such a collage does extreme violence to our perceived sense of location. No more reassuring is the fact that, unlike 1911 Cubism, it contradicts that sense in different media as well as by its disjointed subjects. But just as Braque has taken great care to prevent any one of these media or objects from dominating the composition, he has subtly seen to it that another kind of order—the jibing of shapes, masses, and weights—regulates his wayward subject. In the juttings of its rhythm, this work even harmonizes real and imagined scale with special finesse.

It is easy to see how the *papier collé* and collage altered the aesthetic economy of Cubism. In the Braque collage discussed above, the self-contained cross-circuiting of objects into forms is accomplished in one homogenous, ongoing fusion. In collage, real object-forms, previously cut to order, are brought into the picture as foils that imply the mutability not only of perception but of representational modes themselves. It may help to think of this change by means of an analogy with grammar. The terms of a Cubist painting are run together without commas, without any form of punctuation. Pauses are reintroduced in the collage, but everything it manifests is put into parentheses or quotations. The latter may indicate an outright quote or a special meaning given to a familiar word. Collage often functions both ways simultaneously. The aim is to uncover an imaginative bond within diversity. In the above-mentioned Braque, for instance, newspaper, imitation wood graining, and the fake wall paneling play textural and social variations on their common tree origin. And even further, the newsprint and the wood grain are like a positive and negative code of the same stipple motif.

Once such metaphors were developed, the visual integrity of collage as a formal arrangement could accommodate any number of conceptual shocks without being dependent on them or arising out of them. Braque's 1918 *Musical Forms (Guitar and Clarinet)* (Fig. 24) is a still life in which flat color areas tersely slot together to comprise an all-over pasting. Its triads of

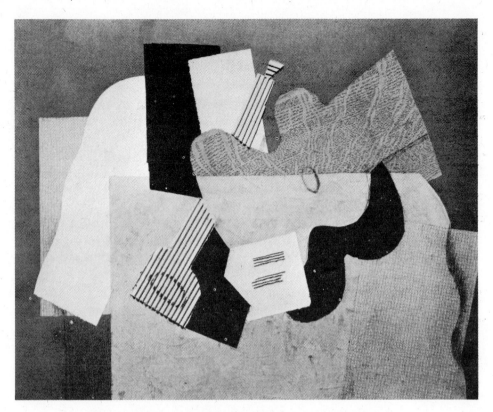

24 / BRAQUE: *Musical Forms (Guitar and Clarinet)*, 1918.
Collage on paper, 30⅜″ x 37⅜″.
The Philadelphia Museum of Art,
the Louise and Walter Arensberg Collection.

white, mahoganies, and brown-beiges, framed by dark blue-gray, read as if in one space. With great pleasure, the eye picks them out as sprocketed units, their outlines sometimes undulant, sometimes angular, but fitting together always with a beautiful ternary justness. Understated, by contrast, are the conceits of having the corrugated cardboard ridges of the clarinet invoke the sound made by the instrument at the same time as they mime the staff on the music paper.

Overall, this "musicality" permits us to move around forms as well as relate decorative colors in a fashion we have not yet seen in Cubist

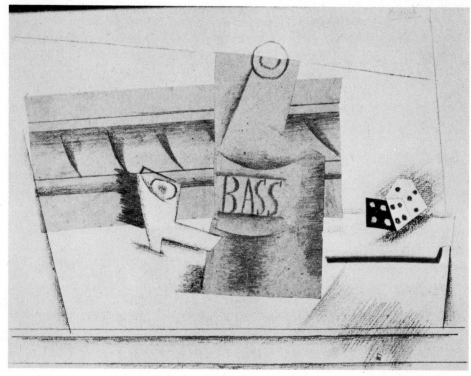

25 / PICASSO: *Pipe, Bottle of Bass, and Dice*, 1913–1914. *Papier collé*,
9½" x 12½".
Private collection, Basel.

art before 1912. An obvious outcome of thinking in discrete shapes, *Musical
Forms* reconstitutes itself in pictorial terms, a painting but for the traction of
its non-pictorial material.

But collage, as stated earlier, could just as naturally eventuate in
another, quite opposite direction: the sculptural. That is, collage implies not
only the replacement but the extension of materials. Braque's corrugations
are already a type of low bas-relief, and his liking for paint mixed with sand
suggests, as he put it, a "tactile" space which appears to connect more with
the spectator's environment than art's. A small collage like Picasso's *Pipe,
Bottle of Bass, and Dice* (Fig. 25), exhibits a stage-flat illusionism reminiscent

of the contemporary stereopticon, so that the oatmeal-paper bottle seems to step in front of the paper page to which it is pasted. Realizing that a piece of paper can have no back or sides, Picasso props it out elliptically with a touch of charcoal shadow and makes it into the literal façade of an object.

Such a deliberately stilted theatrical outcome may have led him to imagine the wooden snack, resting on a little tassled proscenium, which is one of a set of assembled and painted mixed-media objects he created in 1914 (Fig. 26). Though its stage properties are now all in three dimensions, they are painted as if they belonged in a two-dimensional design. With cheek and zest, Picasso delights in building or denying an illusion and then reversing himself as blatantly as he can. In his hands the unity of the technique consists in its lighthearted confession of subterfuge.

26 / PICASSO: *Still Life,* 1914. Relief of painted wood with upholstery fringe
 10″ x 18″ x 3⅝″.
 The Tate Gallery, London.

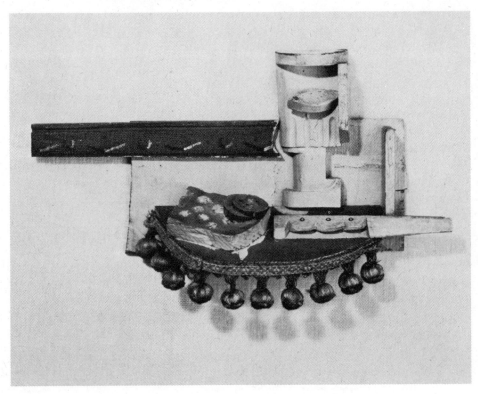

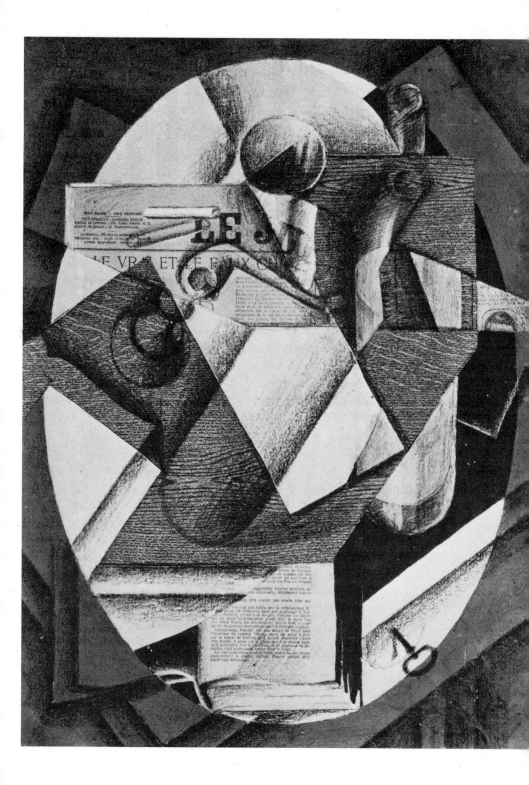

Located lucidly among the pictorial, theatrical, and sculptural destinations of collage, orchestrating its multiple identities where Picasso and Braque seem to be improvising them, are the works of Juan Gris. In his paintings, modeling, fluting, and nuance constantly distill particular object-images out of unspecific volumes, while checker patterns and pastel color work continually to negotiate them back into a decorative surface. Gris operates with details like the foam of a beer head, the fold of a napkin, or a reflection on a glass, many of which have a conspicuous profile, brought out by creases of shadow and trenches of light. In addition, most of his images betray their own history, gently crumpled by circumstance or pressed like leaves in a book. But these qualities are often imparted or outlined by charcoal grain (owing something, possibly, to Seurat) that fades out as if it were filtered, and revealed by a shadow box that tilts sideways or behind the mysteriously fixed forms. This means that however braided with intellectual twists on the play between illusion and plane, Gris's collages are far more physically recessive and etherealized counterparts of Braque's and Picasso's.

It is an indication of the puzzle-making sensibility at work in his art that Gris can allude to his own duplicity in *The Table* (Fig. 27) by the headline "Le vrai et le faux" ("The True and the False"). And even more self-conscious and unstressed is his incorporation of a news item in *Teacups* (Fig. 28) dealing with the laws against, and the effects of, postering on public monuments. Strangely enough, the before-and-after comparison in the photos accompanying the article cannot be extrapolated as an illustration of Gris's attitude toward time. In other Cubist collages, the absence of light implies the absence of reference to time. Gris encourages us to see each twinkle on the rim of a carafe as an event, but he also slices and stores these "events" into the opaque problem-laden fabric of the composition. Instead of marking off one unit from another, he compartmentalizes the scenarios of his collages. The eye wants to tuck his overlays back into the reasonable alignment that may be suggested, to work plausibly but fruitlessly against the grain of his permanent transgressions.

Yet by means of such happy resistances, Gris was to realize the most elaborate unity within a technique dedicated to a partial view of things.

28 / GRIS: *Teacups*, 1914. Collage with oil and charcoal on canvas,
25⅝″ x 36¼″.
The Kunstsammlung Nordrhein-Westfalen, Düsseldorf.

His repertory of themes thoroughly frames the café-concert, outdoor-bistro,
and bohemian-bar still lifes of Cubism as the nocturnes they must originally
have been. If his chalkier colors—the salmons, pinks, and azures—refer back
to the daylight world, many pinpointed and glittering areas, set off by his
wonderful blacks, invoke the night.

6 / CUBISM AND
THE HUMAN COMEDY

The literature on twentieth-century movements in art tends to be safe and repetitious, even though such movements may have aspired to revolutionary goals. Too often the initial defense of a subversive avant garde solidifies into a party line hallowed through generations of textbooks.

To a large extent dependent on the writings of the artists and their contemporaries, historical grooves have been established that make for easy placement of competing "isms." So, the German Expressionists are invariably talked about in terms of their tortured psyches, their orgiastic impulses, and the neurotic, authoritarian, and hypocritical bourgeois order against which they reacted so bitterly in collaboration with a number of estranged poets and playwrights. Or, to take another example, the Russian Constructivists are normally considered exalted, if tragic, players on that stage where the utopian dreams of advanced abstraction and national Marxist revolution momentarily joined forces.

Needless to say, the Cubists, too, had been type-cast long ago. They have come down to us as master picture builders, the creators of a new entity called the *tableau-objet,* or autonomous, self-referring painting, and the prime modifiers of what was to become the abstract language of modern art. The literature follows up this estimate with judgments about the equivocal status of their space, that arena in which idea and perception camouflage each other with high intellectual fervor. It is obviously basic to emphasize the formal labyrinths of Cubist art. Through them the eye is exercised and the mind is challenged. But it is strange how few interpreters have strayed from the outline of these issues, particularly in how they avoid talking about *what* the Cubists painted.

It has been assumed—or, more accurately, implied—that Cubism's vision of space is its real subject, whose ironies and paradoxes are demonstrated by various still-life fragments. But Cubism confronts us with as many figures as still lifes. And before the spectacle of the human body, we cease to be as detached as we are when contemplating images of something to eat or objects to use. Because we are so egocentric in our nervous, muscular, and social identifications with it, the image of the human body can become a remarkable index of meaning in the work of an artist—even one for whom story line and visual illusion are not primary assumptions. In the writings on Cubism, the figure is considered at best as a target upon which has been wreaked certain dislocations, analysis of which is given priority over any view that Cubism may have something to tell us about men and women in their own right. Not merely does such an approach mistake part for whole, but it overlooks two other facts as well. First, this art exhibits quite indigenous, complex responses and feelings toward people. Second, modern art projects succeeding ideas of the human situation as much as it articulates changes of style and form. The importance of Cubism on this level is that it literally shatters every previous notion of man's behavior as represented in visual art.

It cannot be an accident that the one work that almost single-handedly raised the curtain on Cubism is a figure painting. It is also, significantly, a massacre: Picasso's 1907 *Les Demoiselles d'Avignon* (Fig. 29).

In this large group of nudes, conceived as prostitutes, the artist has wrecked all known standards of Western beauty by a willful cleaving of the human form itself. His five females, two crossing their arms behind their

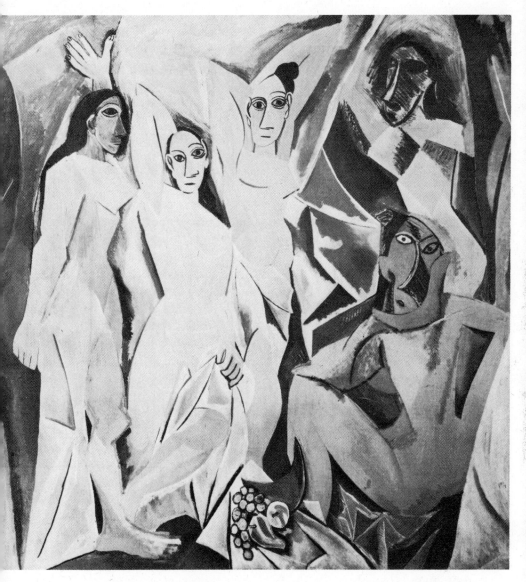

29 / PICASSO: *Les Demoiselles d'Avignon*, 1907. Oil on canvas, 96″ x 92″.
The Museum of Modern Art, New York,
acquired through the Lillie P. Bliss Bequest.

staring heads in a caricature of voluptuous abandon, two with snouted, cross-eyed masks for faces, seem to belong to a new and barbarous race. All elbows, they have been hacked in and out of rose, pink, ocher, and cobalt planes that still retain their cutting edges. What startles is not merely that these women are whores, but that they are a species of bitch-goddess.

This outrageous painting switched the track of Picasso's youthful development, auguring departures for which few of his earlier works had prepared. But, seen as an event within the history of the representation of woman in art, it takes its place as a climax to a mood of deep-flowing rancor.

The immediate ancestors of the *Demoiselles* are a series of compressed, stubby-bodied, large-headed, muscular nudes, in which reminiscences of archaic Greek sculpture and Picasso's own physique are about equally blended. Their type relates also to Cézanne's late bathers in their chunkiness, if not their terra-cotta color, density, and weight. Their vaguely coquettish gestures contrast with the blankness of their setting and the stiffness of their torsos. To look back beyond them is to see Picasso occupying himself with the famous portrayals of the clowns, mountebanks, harlequins, and acrobats of a circus world that he had bohemianized, in obvious concord with his own precarious status as a down-and-out artist, an obscure prestidigitator. (Fig. 30.) It was his device to see their world through the filter of one dominant hue, pink (hence the Rose Period), just as, earlier, he had conceived of an even more declassed environment, that of the old, the infirm, the blind, the poor, and, above all, the lonely, in the chill of a pervasive blue.

All these mournful subjects, idealized in their deprivation, belong to a fantasy that is as much self-pitying as it may be compassionate to others. And, as befits a fantasy, Picasso gives us a sealed-off, self-contained environment, populated by types rather than individuals, whose relationships with each other are extremely elemental and generalized. By and large, only one emotion—bereavement, say, or stoicism—dominates at a time. It is all the more remarkable, then, that Picasso's earliest independent work is that of a painter of society, in the tart manner of Toulouse-Lautrec. There the subjects were bullfights, the Barcelona cafés, and the crowds at the Paris cabarets. His record from roughly 1900 to 1907 shows an artist who moves from a kind of glamorized report of sleazy night life, with an obvious enjoyment of the slumming about, to exceptionally internalized, mood-soaked picturings of

social outcasts, and on, finally, to a weirdly arcadian depiction of nudes, their anatomies rendered hard as if transformed into rock.

Suddenly, with one blow—*Les Demoiselles d'Avignon*—he liquidated not only the illustrational mannerisms of his art, but its self-referring, romantic psychology. In their place is an angular grotesquerie of form—for years he pretended ignorance of its indebtedness to African art—and a calculated indifference of face that is positively defiant. Hitherto, the grave, if pathetic, figures of the Blue and Rose periods had been distracted—or, better, bewitched—by their helplessness. For them, there could be no awareness or communication with the spectator because of an unbridgeable social gulf that left them lost among themselves. All this now dissolves in the bluntness with which the *demoiselles* gape back at us, as they offer bodies that may not even deserve the name human. Apparently they suffer a greater bodily affliction than any of his previous personages; but instead of being possessed or identified by it, these women blatantly exhibit their condition, as if there had been no sudden depreciation of the commodity value of their female form. To be sure, the *Demoiselles* are linked with Picasso's past work on two continuing levels: 1) they are typed in terms of occupation or class and 2) they are more closely associated with intense, continual physical experience than the middle-class city dweller, to whom the opposition of the early subjects is also implicit. The whore is another outcast creature, in Picasso's vein; but rather than being overtly discarded, she is covertly accepted by society.

Still, the functioning metaphors of this picture are entirely different from those of all his preceding effort. A saltimbanque is protected, so to speak, by the artist's tenderness and empathy; a *demoiselle,* someone who hardly needs the artist's support, puts the viewer on the defensive. The more malignant his treatment of her image, the more capable does she seem of taking care of herself in the world, of staring us down, even, and of perplexing us. Shortly after humiliation drops out as a theme of his art, so, too, does representational credibility. We are no longer asked to see the distortions of 1907 in the same spirit as the bony hands and sunken jaws of the miserable. Where once these had been attributes of bodies under stress, their analogues in *Les Demoiselles d'Avignon* are fixed features of particularly belligerent icons. And the impersonal ferociousness with which he takes liberties with these icons—almost as if justified because they are now objects of hatred—become the first prophetic liberties of twentieth-century art.

30 / PICASSO: *Two Acrobats with a Dog,* 1905. Gouache on cardboard, 41½″ x 29½″.
Mr. and Mrs. William A. M. Burden, New York.

It should be clear that they also reveal a strain of aggression in one man's feelings toward women. "We used to make a lot of jokes about that painting," he said in 1933. "One of the women was Max's [Max Jacob's] grandmother. Fernande [Picasso's mistress at the time] was another one, and Marie Laurencin another—all in a brothel in Avignon." It is easy to disregard this jest at the expense of the women in his circle as a studio flippancy. But it is also true that for over forty years, other male artists had grappled with the female subject, forming in their work a mood of increasing disturbance that, in retrospect, is monstrously capped by Les Demoiselles d'Avignon.

It may be only a coincidence, but surely a suggestive coincidence, that this canvas seems to hark back to Manet's Olympia of 1863, in a bald flatness of style, awkward disposition of forms, and the common theme of truly unseductive, naked womanhood displaying itself so sluttishly as to deprive the male appetite of any illusion of being ennobled by the beauty of its object. These pivotal masterpieces of modern art, renowned for their formal innovation, also pinch a most vulnerable nerve in the sexual mores of their societies. For in the Manet and the Picasso, the female subject openly acknowledges and communicates her awareness of her body as an object, an act so impolite as to violate a taboo. In the interval between them appears a number of paintings demonstrating a high incidence of moral conflict in the depiction of the modern nude.

Degas, for example, shows prostitutes nominally as vile bodies. Toulouse-Lautrec records the brothel as tawdry but not vicious, its denizens sympathetic in their wordly fatigue, forgiven in their debauchery. Edvard Munch, never one to flatter the human race, judges woman often as a kind of vampire engaged in a more than equal combat with man, her failing opponent, in a grim war of the sexes. Gauguin invests with an animal stupidity yet also idealizes his Polynesian maidens as a purer and more earthy alternative to the worn-out refinement of Western femininity. And far closer to the Picasso in time, Georges Rouault's Little Olympia, 1906 (Fig. 31), portrays woman, in the words of Leon Bloy, as a "pus-filled goatskin with slimy thighs." With their jowled bodies and gorilla scowls, such creatures, depraved beyond all shame, are mired in what is for Rouault, the filth of Christian sin.

It is, therefore, a pessimistic tradition that Picasso inherited, antierotic even to the extent of chastening the pictorial means themselves into a glowering or bilious vision of the flesh. Behind it, though, lies a current of

31 / ROUAULT: *Little Olympia,* 1906. Watercolor and pastel on cardboard, 21⅞″ x 24¾″.
The Royal Museum of Fine Arts, Copenhagen, the J. Rump Collection.

skeptical realism whose purpose was to strip away the enshrined shams and the genteel lies that in most public media sentimentalized the true relations of the sexes. For nowhere is modern art's protest against bourgeois double standards and the cash nexus of the market place so intimate as in the pictorial theme of the woman who sells herself. Taken overall, it had originated in an assault upon the officially blessed pandering that had produced the covertly prurient Salon nude. Among the painters who had desublimated the theme of sex, the impulse had been to show the subjugation of woman, and perhaps

something of their reaction to it, in its actual horror. In an atmosphere charged with the novels of Zola and the plays of Ibsen, theirs was not simply a revision of an alternate mode of taste but a militant correction of values. But the more they focused on the image of the corrupted woman, the worthier she seemed of stigma or fear rather than pity. The portrayal of unattractive nudes had long been known in European art, particularly that of the north. But their interior qualities and moral authenticity as persons made up for their lack of physical allure (if, indeed, it was a lack to contemporaries). In contrast, the beautiful nudes of antiquity and their descendants were never so personalized. By the late nineteenth century, it was possible to conceive a nude as devoid of "soul" as of seductiveness—a modern touch.

Of course, important exceptions come to mind. Renoir, Rodin, and, later, Matisse were uninhibited celebrants of the joys of sex. Their art was often permeated by a febrile sensuality unreflective of the real tensions and changing social roles that emanated in a pervasive modern lovelessness, or at least the consciousness of it surfacing in waning Victorian mores. But those artists involved with this theme were constrained to expose it by negative example. Under their hands, the representation of women frequently took on a toxic and misogynistic coloring. When earlier nineteenth-century painters showed the plight of the depressed working classes, their programs were clearer largely because coherent stereotypes were available to them and because they themselves could identify with the exploited. But in the fight for the equality of women, the younger men were combatants on the other side. The hostility they projected in their image of women ran parallel to a bourgeois cliché about prostitutes. For while the *filles de joie* were often construed sentimentally (to assuage guilt) as having hearts of gold, society more genuinely felt that they were without minds and spirits, mere mechanisms of sex. Here "heartlessness" was what provoked the greatest scandal over Manet's *Olympia,* accompanied later by the first gleanings that contemporary art would be taking an anti-humanist stand with regard to the figure. The vacant stare and ungraceful posture became signs of modern art's retreat from the sense of the body as an independent organism, animated by the mental and emotional energies of a particular individual. Rouault's whores reveal themselves as fallen women and, as such, still take their meaning from a possible redemption. But Picasso's nudes, surpassing their prototypes in their cruelty and ugliness, are the avenging furies of a new order. In these nominal sex symbols,

all pretense that we are dealing with fellow beings has been blasted away.

But such a unilateral act of destruction had positive goals. For one thing, these *demoiselles,* in their extreme vitality, reverse the peculiar drainage of energy that had earlier marked the theme. Existing outside time and, somehow, above society in their jagged limbo, they radiate an almost aboriginal power. Then, too, we perceive that if it has sacrificed elegance, the subject has been heightened by irony. Already its title (though devised much later by André Salmon), by referring to innocent young maidens, alludes to a sarcasm worked out with supreme pictorial force. While many of its details and proportions derive from African and Catalan Romanesque sources, Picasso's primitive whores are also cast somewhat in the mold of Cézanne's late bathers. The artist, then, effects a sardonic marriage between the arcadian theme of bathers in a landscape—which he savages—and tribal fetishism—which he heroicizes. All the body junctures and crescents seem to hit each other, jostle out and eventually upward, almost flamelike, with an intensity that is quite terrible. Nor is Picasso above commenting upon his own earlier career, whose palette is brought into this implausibly fused scene. The blues and roses that had once underscored the meager condition of a dispossessed couple or a circus vagabond are now combined to mint a chromatic product so evenly tempered that neither the glare nor the freeze of it dominates. Though not heavily saturated, it is a coloration of indescribable freshness— almost genetic in the sense it gives of an art being reborn. And finally, one notices the emotional dissonance of being invited to share Picasso's own antipathy to his disfigured subjects while at the same time he removes them to an otherworldly setting.

Les Demoiselles d'Avignon swept through the subsequent career of Cubism, opening up concepts of treating the human figure that are faintly alarming even though they are psychologically abstracted. Picasso followed up his gains with a number of raw, totemic figure studies that finally subsided in 1909. It was Léger, quite on his own, who next took up the cudgels sensationally against the human body in a large-scale and radical work, *Nudes in the Forest,* finished in 1910 (Fig. 32). This "tussle with volumes," as Léger called it, seems to present an updated version of a well-known Renaissance subject, the battle of the male nudes. To make almost excessively apparent the muscle-bound tensions and the clumsy joints of tubular anatomy, Léger reduced color to a pattern of grayed lavenders and greens. Armored so heavily

32 / LÉGER: *Nudes in the Forest,* 1910. Oil on canvas, 47¼" x 67".
The Rijksmuseum Kröller-Müller, Otterlo, Netherlands.

that they can barely stand up, these "heroic" mannikins creak at every ges-
ture. They are contorted nudes of no particular sex, charging their indetermi-
nate task with a lethargic frenzy. Deeply affected by Cézanne and much
inclined to Henri Rousseau, Léger accentuated the volumes of the one and
emulated the metallic shadings of the other. Yet the new note struck here is
that human being and junglelike environment are made in the same image.
And when Léger's fantasizing temperament, and not merely his historical
derivations, is considered, that image is mechanical. In this painting, for the
first time, human sinew is covered with machinelike surfacing. The rounded
and fanned-out bulk of all these volumes produces a space that would look
much deeper than in the contemporary work of Picasso and Braque were it
not also obsessively cluttered and airless. At this point in his career, we feel

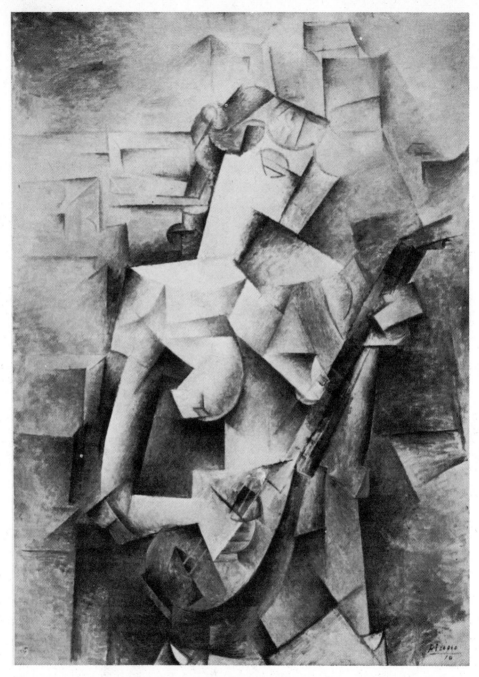

33 / PICASSO: *Girl with a Mandolin,* 1910. Oil on canvas, 39½" x 29".
Private collection, New York.

that not only has his stylistic leaning imposed a mechanomorphic posture on humanoid creatures, but that, also, the transforming process is only half-achieved. One confronts a fantastic vision bent on rationalizing itself.

It must be stressed that Cubism introduces into modern art a specter of beings made neither more nor less interesting or attractive, as if it were a question of the artist's taste, but rather men or women horrifically, ludicrously "other" than ourselves—alter-egos mimicking many of our traits, features, movements, attributes, yet incarnated in a form alien to flesh and blood. Cubism pictures not the transcendence of "soul" over body, but the mutual estrangement of the two. Certain traditional modes are retained—epic, genre scenes, portrait—but it is as if a new, mocking hollowness has entered into them. Bodies are sometimes constructed like edifices, and the matter out of which they are composed is inanimate. Yet their depersonalized, self-alienated appearance is wittily played off against the notion that their behavior and affairs are still normal. They carry on or pose as though nothing had happened. Either the inanimate world has disobeyed, started into life, or every instinctive movement and growth slows before our eyes into paralysis. Cubism assumes that a charade has as much reality and consequence as the way events actually happen.

Questions can be raised as to the legitimacy of such attitudes in the continuance of a figural art. But the affect and volition displayed by the Cubist personage, though strange, cannot be pried loose from the way it functions in a coherent social order. As evidence of this, consider one of the most praised, but surely also one of the most problematical, Cubist figure paintings—Picasso's *Girl with a Mandolin* of 1910 (Fig. 33). No one now judges the anatomical dislocations in this work to be opposed to its elegaic mood. But a literal view of the image could conclude nothing else. To an innocent eye, rarely employed in criticism, the girl is a mutation. Her lower jaw has been reduced to a block, and her right breast has been indented, scooped down, and then harshly extruded to a shingled tip. Contrarily, the graceful, pensive pose, the refined, softly brushed grays, and the delicate activity of strumming the mandolin are extremely sympathetic.

This weird expressive conflict may be interpreted on the basis of Picasso's history as an artist. Could it not be that Picasso reverted to a subject of his Blue Period repertoire at a moment when he was thoroughly engaged in the disassemblings of his early Cubist style? Surely the 1910–1911 mono-

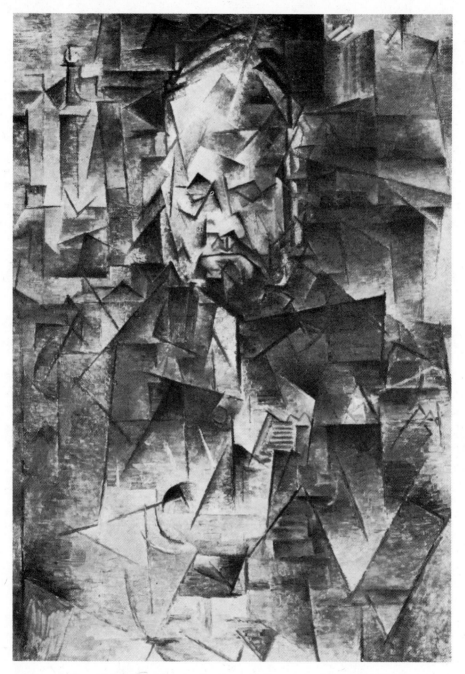

34 / PICASSO: *Portrait of Ambroise Vollard*, 1909–1910. Oil on canvas,
36¼″ x 26⅜″.
The Pushkin Museum, Moscow.

chromes, so frequently thought of as making way, in tone, for facet recession, also owe a great deal to that earlier era of reverie, of which they carry a strong emotional vestige. But to eyes practiced in reading Cubist vocabulary and, therefore, enlightened as to its conventions and metaphors, no discrepancy between form and content exists in this picture. To take this view of the work, however, is to deprive it of the ambiguities inherent in the Cubist principle of treating the figure and its behavior as psychologically viable in the teeth of its inhuman appearance.

The import of *Girl with a Mandolin* perhaps beomes clearer if it is compared with such male contemporary subjects as Picasso's *Portrait of Ambroise Vollard* (Fig. 34). The artist hardly ever creates the image of a woman as portrait—a mode he reserves during this period entirely for men. (The sole earlier exception, the *Portrait of Gertrude Stein,* has in common with the dealer Vollard its depiction of a patron.) In other words, a woman can be typed, shown as a nude body, or abstracted almost beyond recognition, as in *Ma Jolie,* where the gender of the subject hardly plays any role; but she is not accorded the particularity and, it should be added, the dignity of the one-to-one, formalized contact furnished by a portrait. More significant is the fact that Vollard is presented as an individual of phenomenal power and massive, noble presence, while the female type often gangles like a simian, is cantilevered uncomfortably in space, or is given bowed appendages. (A good example is the *Bather* of 1908 [Fig. 35].) All the facets studding the face of Vollard and, to a lesser extent, Picasso's portraits of the dealers Uhde and Kahnweiler express the individuality and confidence of the subject. A similar language only contorts his female subjects with a rictus to which they remain . . . indifferent. The analytic Cubist style confers an emotional tone, honorific or antipathetic as Picasso wills it.

It is fair to say that the other Cubist artists had less stratified and complex attitudes toward the human figure, although they were by no means neutral in their dealings with it. Léger's jocular *The Cardplayers* of 1917 (Fig. 36), in which the male body has been turned into a cross between a congeries of stove pipes, ventilator tubes, and a piece of ordnance, has nothing of the derisive about it. However calculated, its metamorphosis of the French soldier into a clickety-digited machine is not self-conscious, though it does express awareness, as Robert Rosenblum put it, of "a goal of aesthetic order whose lucidity and precision are classical in flavor." In this ponderous card game,

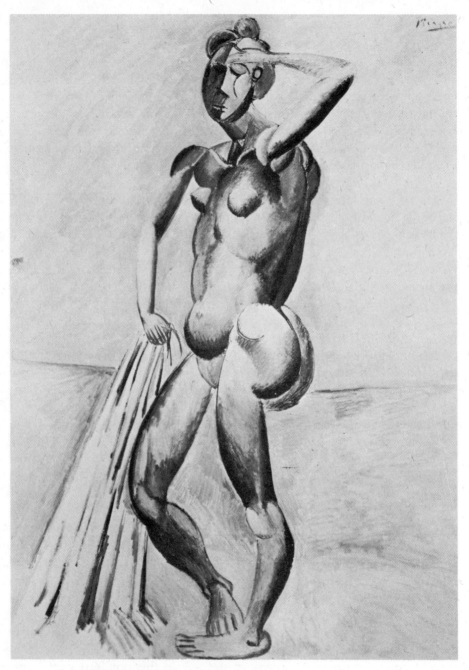

35 / PICASSO: *Bather,* 1908. Oil on canvas, 51¼″ x 38¼″.
Private collection, New York.

36 / LÉGER: *The Cardplayers*, 1917. Oil on canvas, 50¾" x 76".
The Rijksmuseum Kröller-Müller, Otterlo, Netherlands.

recollections of the antique and of the industrial forms of the First World War
are fused with real stridency. But it is an effect that does not compromise the
existence of the figures as accomplished imaginative facts.

One feels quite otherwise about Albert Gleizes's *Man on a Balcony*
of 1912 (Fig. 37), for here it is still implied that the subject has an indepen-
dent reality, aside from the way it is understood by the painter. The figure
has been chipped at, parts of it sliding slyly off plumb, with nice judgment—
but also timidly, in an effort that has stopped far short of any genuine transfor-
mation. Gleizes hesitates, does not complete his possession of the figure, and
is lost. The image is no longer endowed with the weight that could have been
observed and has not been given a plenitude that may be imagined. In many
comparable Cubist figures, the delicate question of how convincing the tie is
between tangible volumes and fantasy content hobbles the artist and nags the
viewer.

With collage and Synthetic Cubism, these issues flatten out. There, all imagery is imparted directly through the method of pictorial construction, so that comic or malign potentialities that may transfigure the human form are inseparable from the means deployed.

Two paintings of busts, Picasso's *Student with a Pipe* (Fig. 38) and Gris's *The Smoker* (Fig. 39), both of 1913, illustrate the point deliciously. The pinhead eyes and the long, equine face of the student are very amusing intimations of mental dimness. But the specifically Cubist device of contrasting the wrinkled paper cap with the schematic head, the real paper and the "abstract" face exchanging roles, enlivens the image far more deeply than would pure caricature. And in giving the pipe hole a pupil, Picasso comments nicely on the student's lack of perception as well as on the supposedly inanimate status of objects. Gris, for his part, presents us with a literal instance of the addleheadedness that modern life may induce, as the head of his gentleman swings metronomically in an arc above the column of its neck. (To judge by the colors—greens, blues, ochers—the artist is also interested in a mad alternation between night and day, interior and outdoors.) Only the illusionistic curl of cigar smoke, defying all contact with the geometrically scrambled face, retains its random liberty of movement.

We can see that collage functioned to disperse the given structure of anatomy far more radically than in the sculptural mode of early Cubism. Our bodies do not respond to a species of cutouts on anywhere near as visceral a level as to depicted volumes. Almost as if in compensation, the collage "view" of the human figure becomes unprecedently ironic—a deft misalliance of "living" geometry and creaturely objects.

Picasso's flashily carnal *Woman in an Armchair* (Fig. 40) is a model of this development. Framed by large sinuous curves, fleshed in tawny hues, her hair moistly streaming, her lingerie crumpled, this paragon of boudoir sex is also disemboweled. Ingres, whom Picasso may be recalling in his melodious contours, conceived the nude as an exquisite, languid animal (Fig. 41); Picasso imagines her as needing pegs to hold up her pendant breasts. In details like this, as well as the bush of the armpit and the roll of the rib cage, he has his exceedingly irreverent way with the ideal of the odalisque, yet makes her more libidinous than ever before. Affinities with a work such as this (although

37 / GLEIZES: *Man on a Balcony,* 1912. Oil on canvas, 77⅛" x 45⅜".
The Philadelphia Museum of Art,
the Louise and Walter Arensberg Collection.

38 / PICASSO: *Student with a Pipe,* 1913–1914. Oil with charcoal, pasted paper, and sand on canvas, 28¾" x 23⅛".
Private collection, New York.

39 / GRIS: *The Smoker,* 1913. Oil on canvas, 28″ x 21½″.
Mr. and Mrs. Armand Bartos, New York.

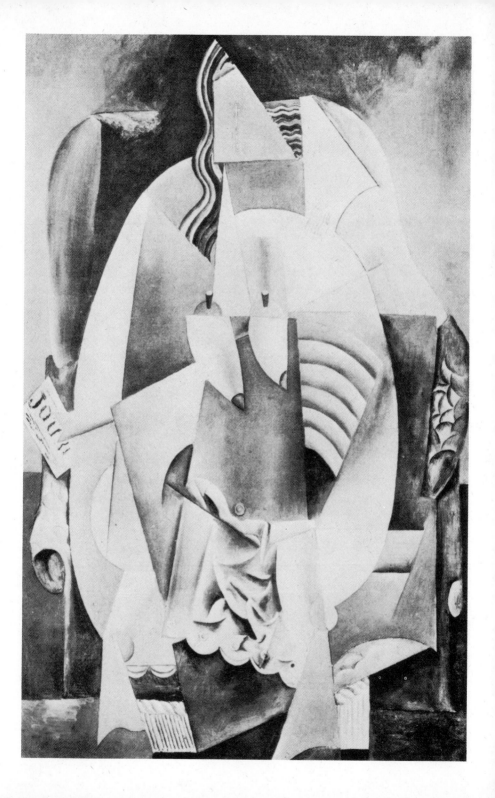

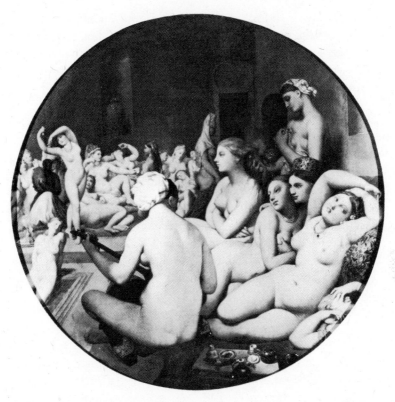

41 / INGRES: *The Turkish Bath*, 1863. Oil on canvas stretched on wood, diameter 43¼".
The Musées Nationaux, Paris.

these are far more explicitly dehumanized) are found in the mechanical nudes of Marcel Duchamp of the preceding year and the sexed apparatus of Francis Picabia of later years. Both these artists enjoy the conceit that machines produce themselves by means of a mating process akin to human sex. In caring for his intellectual apprehensions or his metaphorical gifts more than for what we would call naturalistic psychology, the Cubist artist jolts together our often contradictory motor sensations, physical memories, and fantasies, hostile or otherwise. Facetiously, the dismantling of the figure could be seen as the

40 / PICASSO: *Woman in an Armchair*, 1913. Oil on canvas, 59¼" x 39⅜".
Collection of Mr. and Mrs. Victor Ganz, New York

equivalent of a craft or industrial operation. It was a simile that was bound, also, to conceive of the body as an inorganic assembly of parts—mere anatomical signs, fair game for optional redistribution. To impose a machine metaphor upon human will was one of the more imaginatively disingenuous features of Cubist thinking.

To amalgamate the figure with its surroundings through the most insouciant paradox was another. Several works of the immediately prewar years draw attention to this as a basic motif of Cubism. With his *Woman in Blue* (Fig. 42), Léger obliges us to travel on the outskirts of his large, central blue and white screens in order to perceive human fragments that are themselves constantly interrupted by balustrades, tables, and the like. One feels that all the atmospheric elements, excitingly contrasted as they are, will topple out of an equilibrium that only momentarily sustains the presence of the figure. For in Léger's terms here, the separate identities of bodies and their surrounds are less important than how one can give a sense of modern, ever-fluid sensation through the abridgment, condensation, and interaction of images.

More wickedly gratuitous is Picasso's unstable montage of smoker and interior in *Man with a Pipe* (Fig. 43). The artist salts in a kind of confetti with his clapboard cornices and derbied gentleman, who is nothing but a stuffed man composed of, and no more animate than, the objects of his world. The underlying still-life mentality of the Cubist artist, that since 1909 *conditioned* his treatment of the figure, suddenly appears *illustrated* by the mutant figure itself. And now the very furniture seems to grimace.

In 1916, Picasso was commissioned by Sergei Diaghilev to design the décor and costumes for a ballet called *Parade,* plotted by Jean Cocteau, composed by Erik Satie, and choreographed by Léonide Massine. Though with no previous involvement in theatrical enterprises, he undertook this new challenge very naturally by introducing his Cubist aesthetic directly onto the stage—in context, a radical act. To a ballet planned as a kind of gay and nonsense vaudeville, Cocteau appended the title "réaliste," and Apollinaire, "super-réaliste" or surrealist. For they were aware that the literalism of Cubism—the constant shifting of elements of reality into illusion-making frameworks—would be a powerful antidote to the folkloristic and fabulous produc-

42 / LÉGER: *Woman in Blue,* 1912. Oil on canvas, 76⅜" x 51⅛". The Öffentliche Kunstsammlung, Basel.

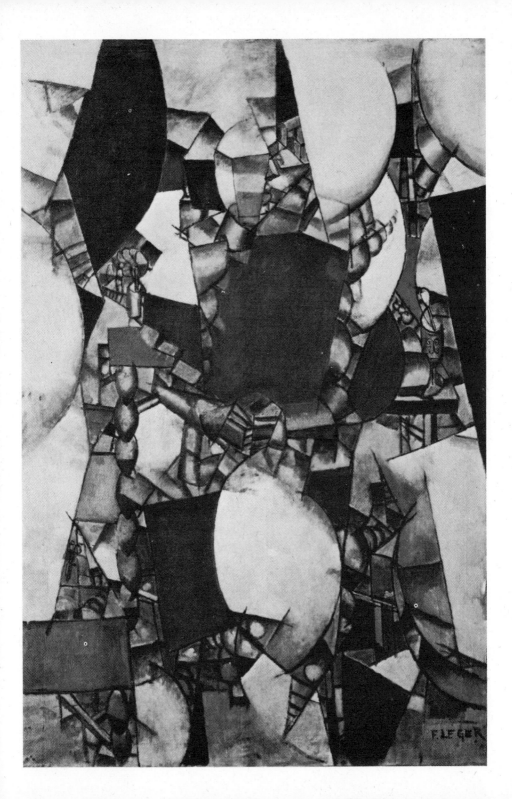

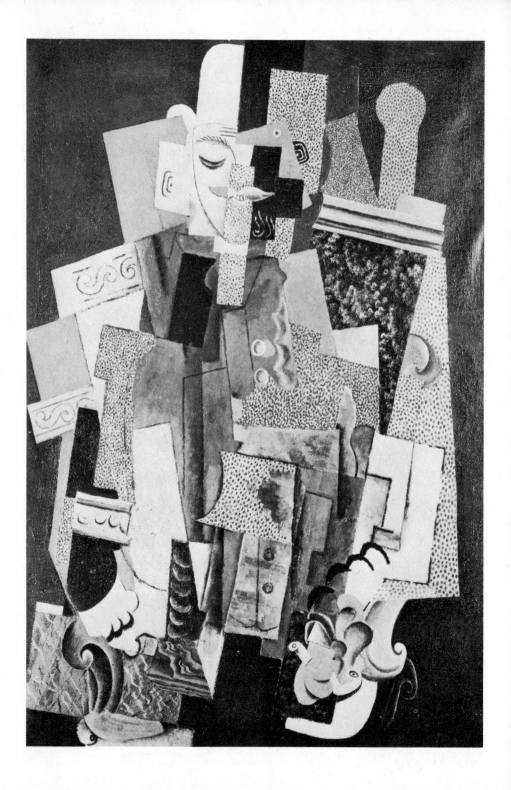

tions that Diaghilev might be expected to produce at the Right Bank showcase, the Théâtre de Châtelet.

Picasso's presence went far to ensure a collagelike aura to the whole affair, which was designed as a ballet farce to be enacted in front of a theater ("parade" referred to the song and dance of performers before the circus tent). Picasso's large curtain, representing a harlequin family with a torreador and a winged horse, opened upon a set mocking the Futurist notion of a big city. The performers begged an imaginary audience to enter a central portal for the main show. A mere "prelude" comprised the entire first act, just as the "real" space of the people introducing the unseen spectacle became the fictional space of characters in a ballet.

Highlighting the cast were Picasso's French and American managers—two ten-foot-high hunks of cardboard Cubist scenery, each occupied by a man who staggered or stamped about, trying to mark time, as if he were a human metronome. The American manager (Fig. 44), attired in skyscrapers and top hat, equipped with a megaphone supported by a false arm, berated the audience for mistaking the parade for the real show. He might also have explained that he was as much part of the décor as a protagonist within it. A great deal of the originality of *Parade* derived, then, from a pictorial conception. But the theatrical requirement, in turn, illuminated an allusion in painting, since it affected a movement only implied by the Cubist figure. Those strange apparitions called "managers" reduced the actual dancers on the stage to puppets, but puppets suddenly, by comparison, made more fleet, supple, and graceful than they had ever seemed before. Hence an entire spectrum of contrasts in gestures, gait, and scaling appeared to levitate and magnetize our urban environment in a new series of clownish rhythms. The ungainly, monolithic managers were neither paintings nor sculptures nor costumes, but an *ad hominem* mix of all three, capable only of a stilted lope. They contrived to illustrate that inhibited and uncanny motion, that special aspect of made objects come alive, incipient in the Cubist vision of the human figure.

If there is any one personage portrayed by the Cubists with distinct favor it is Harlequin, the joker in their stack of brightly decorated cards. They image him in a way similar to the main character in Stravinsky's *Petrouchka*, 1911, as a mannequin briefly and magically animated, a figure

43 / PICASSO: *Man with a Pipe*, 1914. Oil on canvas, 51¾" x 32½".
The Art Institute of Chicago.

44 / PICASSO: The American Manager (from *Parade*), 1917. Destroyed.

stemming from the *Commedia dell' Arte* or the street circus, who acts as a cardboard emblem of disappointed love. Because he is a stand-in for the artist himself—the opposite number to the dissected females of Cubism—and because he is a straw man whose every action is understood as pantomime, Harlequin emits suggestive clues to Cubist psychology. By tradition, the *Commedia dell' Arte* had been countrified or small-town theater, a broad, popular entertainment stereotyped for childlike tastes. The nineteenth-century artistic revival of interest in the theme was suffused by a romantic nostalgia, meaningful as an antidote to the positivism and industrialism of the era. By the First World War, however, when the character reappears in the work of Picasso, Gris, and, later, the Cubist-influenced Gino Severini, he seems to represent that personal expression and authentic feeling—the Romantic ideals par excellence—had been dispossessed, forced to lead a secondary life in mimicry of themselves. This is surely the difference between the Romantic Rose-period harlequins (quite aside from the enormous change in style) and those of a dozen years later.

The diamond-suited specimen given in Picasso's *Harlequin* of 1915 (Fig. 45) typically allows no distinction between the role and the performer. A symbolic incarnation of clownishness, he has changed places with the emotionally huddled-in human being forced to clown and mime for a living. Fronting a sequence of stage-flat "echoes," all of which appear set in arc or pendular motion at different speeds or intervals, this harlequin can be as mobile as a rocking horse. We have already seen such movement in Cubism: jerky, tilted, out of kilter, metronomic, wound up in some peculiar way, as if the image were a clockwork mechanism. But more important is the impression given by this "Harlequin" of having been touched by the artist-puppeteer at some undetermined center of gravity and started off on its own ghostly shuttle. How great a distance separates Léger's muscle-bound automatons from this antihero who can be animated only into the weird, but unencumbered grace of a marionette.

But can the Cubist figure have anything to express of what we call grace, physical or spiritual? In 1900, Henri Bergson's "Essay on Laughter" anticipated such a question in a remarkable way. Concerned with a theory of the comic, he wrote: "The attitudes, gestures and movements of the human body are laughable in exact proportion as that body reminds us of a mere machine." And observing this phenomenon in visual art, he went on:

we shall probably find that it is generally comic in proportion to the clearness, as well as the subtleness, with which it enables us to see a man as a jointed puppet . . . inside the person, we must distinctly perceive . . . a set-up mechanism. But . . . the general appearance of the person . . . must continue to give us the impression of a living being. The more exactly these two images, that of the person and that of the machine, fit into each other, the more striking is the comic effect.

But Bergson takes pains to show how little he approves of this comedy, to be appreciated only through a cold superiority of the onlooker, and, in fact, how much it represented the antithesis of the intelligence, energy, and purpose that are the highest human attributes:

our imagination . . . sees the effort of a soul which is shaping matter, a soul which is infinitely supple and perpetually in motion, subject to no laws of gravitation. This soul imparts a portion of its winged lightness to the body it animates: the immateriality which thus passes into matter is what is called gracefulness. Matter, however, is obstinate and resists. . . . It would . . . immobilize the intelligently varied movements of the body in stupidly contracted grooves, stereotype in permanent grimaces the fleeting expressions of the face. . . . Where matter thus succeeds in dulling the outward life of the soul, in petrifying its movements and thwarting its gracefulness, it achieves, at the expense of the body, an effect that is comic.

Many of Picasso's, Léger's, and Gris's figures seem to get on with matter, even to embody it, under conditions that Bergson would stigmatize as comic. Although the laughable is hardly alien to human behavior, there is, for him, something foreign to sentiment and antagonistic to life itself in that which induces laughter. But though the Cubist figure may often seem ridiculous, it is not ultimately a very risible creation.

Opposed to Bergson on the apparent gracelessness of the mechanical (though he does not deal with the comic) is the German author

45 / PICASSO: *Harlequin,* 1915. Oil on canvas, 72¼" x 41⅜". The Museum of Modern Art, New York, acquired through the Lillie P. Bliss Bequest.

46 / LÉGER: *The City,* 1919. Oil on canvas, 91" x 117½".
The Philadelphia Museum of Art,
the A. E. Gallatin Collection.

Heinrich von Kleist, who, in 1810, wrote an imaginary dialogue with a
dancer who had invented a new kind of puppet theater. Here it is observed
that every movement has its own center of gravity, and that the limbs of a
puppet can be set in motion merely by control of this center. "What advantage
would these puppets have over living dancers? . . . a negative one, namely
that they would always be without affectation. For affectation sets in, you
know, when the soul, the vis motrix, is elsewhere than at the center of gravity
during its movement." When a human being fails in his attempt to imitate a
certain movement, he invokes laughter, for "Only a God," writes von Kleist,

"could measure himself against matter in the field of dance." And he has his narrator say further: "In the organic world we see that grace has greater power and brilliance in proportion as the reasoning powers are dimmer and less active." Nor does he shun the final conclusion of this view: "We shall find [grace] at its purest in a body which is entirely devoid of consciousness or which possesses it in an infinite degree, e.g., in the marionette or the god."

Such proposals may lend insight into the equivocal figure of Cubism. It can never be settled whether this hyphenated human offers a hopeful or deficited vision of social conduct. To be sure, Léger, during and after World War I, can still see man in the city as powerful in his robot status, bravely equal to his modern industrial surroundings (Fig. 46, *The City*, 1919). The harlequin, on the contrary, blends its comic motifs with a tragic tone. *Parade* was deliberately zany, an aesthetic pratfall; the once pathetic harlequin, however, is now rather ominous and makes us uneasy. His eye, beady rather than defiant (as in the *Demoiselles*), stares out too steadily, too unblinkingly to let us rest secure. To move with an ironlike clangor is still to act on one's own. The consciousness of the Picasso harlequin, bereft of soul but glaring with life, is far more problematical. Obeying gravity rather than taking wing against it, incapable of motion except that of a mannikin, he nevertheless seems liberated and superior because his every move is true to his nature. Garbed in the uniform of the vulnerable, he yet has every appearance of the self-sufficient.

It was inevitable that the collage fragmentation of space and the Cubist metamorphosis of the world into a still life should have prepared for this unsettling image of humanity. But to an equal degree, it was the outcome of the psychology behind those icons that are *Les Demoiselles d'Avignon*. On André Breton, the progenitor of Surrealism, the effect of the Cubist figure was quite vivid: "When we were children we had toys that would make us weep with pity and anger today. One day, perhaps, we shall see toys of our whole life, like those of our childhood once more. It was Picasso who gave me this idea—Picasso, creator of tragic toys for adults."

7 / EPILOGUE

As an avant garde, Cubism stumbled into the outrageous. Despite the vagrant farce of Picasso and Braque, it never stooped to produce riddle paintings meant to be unraveled only as a bourgeois pastime. The moral shock it caused at the 1913 Armory show in New York was more the result of a cultural conflict than an artistic stratagem. Rather, Cubism's importance was instantly grasped by a handful of the most advanced aesthetes and poets who saw in it a pictorial counterpart to the wave of invention, scientific discovery, critical thought, and philosophy everywhere transforming men's consciousness of the physical world, its structure, energies, and dimensions.

The social and political context of these phenomena was one of expanding population, ceaseless colonial adventure, and an armed truce politely called the balance of power. England and Germany, for instance, were struggling desperately to gain an advantage over each other in fleets of dreadnoughts, the most powerful weapons known to history. Ever more frequent

strikes and nascent revolution, warnings of the misery of the workers, belied the gilt façade of *la belle époque.*

Within this framework, then, Einstein, Planck, Rutherford, and Russell revealed radical new paradigms in physics and mathematics. Coming to age also were the wireless, the typewriter, the diesel engine, the phonograph, the assembly line and the motor car, the movies, the airplane, the submarine, and electrification of cities. Freud structured the most momentous theory of man's subconscious life in psychoanalysis. Bergson and Husserl wrought provocative theories of time and perception. In music, Stravinsky and Schoenberg brought forth atonal and rhythmic concepts of the most expressive impact, while in architecture, Gropius and Wright made fundamental breakthroughs in design, site, materials, and efficiency. As for literature, one can see in many figures whose works relate on various levels to Cubism—e.g., Joyce, Proust, Gertrude Stein, Apollinaire, Ezra Pound—a basic alteration of poetic sensibility in modern times. Nor would the visual arts ever be the same again after the innumerable innovatons of Duchamp, Matisse, Delaunay, Brancusi, Klee, Mondrian, de Chirico, Kandinsky, Tatlin, and Boccioni.

In impulse, the work of all these cohorts of change was as Faustian and manipulative as its effect was disruptive and euphoric. Cubism became the first movement in painting to be definitely judged—wrongly in terms of literal connection, rightly in the light of a common spirit—as an outgrowth of the theoretical ferment of its time. At a moment when European modernism was gaining a second wind, people seized upon Cubism as a kind of visual seismograph or tangible chart of a reality glimpsed so far only by the mind. What they saw, and what we still continue to see, are immobile forms defying a single conceptual focus.

We may reason about the dual, indeterminate, or reversed function of these forms. Without ever being analyzed, they were often interpreted in Bergson's sense as signs of bodies we feel living and moving within us, in our psychic duration rather than as time-stopped units on various paths in space. But a painting does not operate in time; only our consciousness of it does. In the nature of their art, the Cubists knew they could create only points and locations on a physical surface. The unfamiliar relationships and the unpredictable meanings of their forms require us to invent our own tempo of experiencing them. The more succinct the contradictions in a Cubist can-

vas, the more fugitive are the delays, backups and retakes in the way we apprehend it. Instead of measuring and framing the intervals of our attentiveness, we become immersed in them in an unstructured succession. In Impressionism, incidents always seem to be flowing into each other, becoming each other in one dominant flow. With Cubism, incidents appear to be emerging out of each other, striving to differentiate themselves.

To talk about simultaneity in Cubist painting is redundant. Most paintings, as they are fixed in space, can be taken in with one scan. Their layout and limits are usually given at first sight—unlike, say, a ballet's. But the Cubists, before 1913, worked *against* this by suggesting, through their intuitions of space, that the subject of perception vanishes as soon as it is conveyed. We may see either the convex or the concave aspect of a volume, but we can never experience them simultaneously. The painting, of course, remains always the same—physically static and finite, as are notes of a musical score. Yet maximum encouragement is given to make our "reading" of the picture as evanescent as the hearing of a performance. And we seem to sift and discriminate between the pictorial forms as we are also enabled to navigate through the world, memory and expectation bound up with a whole complex of faculties feeling out the way. Yet here, as in all art, the sensuous reality of the painting is expressive precisely because of the *difference* between what it is and what it encourages or suggests.

Collage realized this expressiveness in bulk. Though dropped relatively early in the career of Cubism, it had the utmost consequences for the history of modern art. For the unity of the picture, as proposed by collage, does not consist of any one style or representational or symbolic technique, but in the willful recombination of any of these elements that transcends their various criteria of finish. Collage epitomizes Cubism as an opportunistic, portmanteau, and self-reflexive art in which disjunction and material artifice are fundamental premises of the creative act.

At each turning point of the Cubist mind, some deeply irrational and contrary decision was involved. To introduce an oil-cloth reproduction of chair caning into the picture was not simply to incorporate an unexpected variable that the artistic organism would assimilate; it was to bring in something from another world and hence change the organism. The willingness to chance this ignited twentieth-century painting and sculpture. But what gave these arts the confidence to continue, establishing enormous credit in the bank

of the imagination, was the Cubists' ability to brazen out their caprice and to materialize strategies that could accommodate their paradoxical choices into a new equilibrium. Homeostasis is defined by the *Random House Dictionary* as "the tendency of a system . . . to maintain internal stability owing to the coordinated response of its parts to any situation or stimulus tending to disturb its normal condition or function." Cubism, not merely in any one of its stages or its productions, but in its overall outlook, was homeostatic in this regard. It was the tension between the way it threatened itself and the search to find resources to combat threat that most fruitfully defines the role it played in the sensibility to follow.

11 / FUTURISM

THE FUTURIST CAMPAIGN: "ART CAN ONLY BE VIOLENCE, CRUELTY, INJUSTICE"

8 /

In October, 1911, three ambitious young Milanese painters, Umberto Boccioni, Carlo Carrà, and Luigi Russolo, made a breakneck trip to Paris. In an earlier series of public manifestoes and (for want of a stronger word) "theatricals," they had, for the last two years, clarioned the word *futurist* as the banner of their violent, ecstatically prophetic new art. Preparing for their crucial French debut that was to take place in February, 1912, at the Bernheim-Jeune gallery, they were anxious to check their progress against that of the Cubists, of whom they had only garbled reports. It was an opportunity to size up the development of advanced painting in the headquarters of Western art at first hand.

Two other personalities aided their reconnaissance: Gino Severini, their Paris-based colleague who first urged the junket and shepherded the painters, and Filippo Tommaso Marinetti, the actual founder of Futurism and financier of the trip, a wealthy poet, editor, avant-garde playwright, and

literary impresario of such stay-awake energy that he had been dubbed "the caffeine of Europe." Within about three weeks, the visitors barnstormed the Paris art scene. We know that they cased the Salon d'Automne, where they saw the work of Metzinger, Gleizes, and Léger, and that they gained entry to the studios of Braque and Picasso. They even managed to get written about by Apollinaire, who found Boccioni's theories about *States of Mind,* a triptych he had in progress back home, "puerile and sentimental."

Despite the ruffle of interest prepared by Marinetti and stimulated by their visit, no one had quite expected the deluge of publicity brought forth by the Bernheim-Jeune show just a few months later, nor the sensationalism of its circuit through the great European centers and capitals: London, Brussels, The Hague, Amsterdam, Berlin, and Munich. *Futurism established itself as the most aggressive artistic phenomenon of its age in the least amount of time and on the widest possible international front.* Most significantly, the Italians had succeeded in demonstrating in their paintings what they had already proclaimed in their manifestoes. For them, the impact of the machine on the twentieth century had dynamited out of all recognition a sequential understanding of space, motion, rhythm, and the temporal succession of events as perceived in visual art. (The machine itself, though, was never assumed to have any exclusiveness or even priority as a modern subject.) Now, after their exhibition had toured the continent and sparked movements everywhere in Europe, the Milanese Futurists returned to Italy. Each of them bent forward to realize forms that Apollinaire, quickly revising himself though still perplexed, thought might "attain the heights of a symphony."

It is still provoking to ask what role that first brief view of Paris played in the Futurist dervish. A miscellaneous, long- or short-term drifting of artists to Paris already had centuries of tradition behind it. A highly organized in-and-out campaign was a thoroughly different and most uncommon affair. We are aware that it immediately chastened the impulsive texturing of works on the easel and sobered the gyrating forms of Boccioni and Carrà. Yet it did not dissolve their pugnacious instinct. The historical interest of the impressions left upon these painters by Cubism is enhanced by controversy.

That their art gained in clarity and control as a result of their exposure to Cubism must be weighed against how much it confirmed the uniqueness of their own experience and program. The Futurists were quick to assault competitors whom they thought all too respectful of a classicist past

and too intellectually detached in their attitude toward form. For example, the Cubists were always discovering stability in a new mode of perception that continually implied a universal disequilibrium to the Futurists. Up-to-the minute phenomena of accelerated sensory change incited intense psychic and emotional responses in the Milanese. They were so moved to crossbreed those feelings that they could never confine themselves to working in the isolated genres of still life and the figure, consistently adhered to by the Cubists. Upon these modes, the Futurists superimposed cityscape and history, a step naturally in accord with their experience as the most committed urbanophiles yet seen in modern art. Joyfully putting themselves under the gun of social events— political struggle and scientific discovery—that lay far beyond art, the Italians dedicated themselves to a spiritual freedom and a primitive innocence which they opposed to any merely "aesthetic" purifying of visual means.

The encounter with Cubism was, indeed, catalytic. It lent pattern and focus to the Futurist obsession with movement. But this turn of events misled many critics to treat Futurism as a vulgar, upstart derivative of Cubism (though it surely affected the work of Robert Delaunay, impressed Léger, and coincided with the researches of Marcel Duchamp, exemplified at that moment by the *Nude Descending a Staircase*). To Parisian critics, Futurist theory seemed wildly exaggerated, newfangled; and even silly—a view that, in retrospect, was an inadvertent tribute to its threat and its modernity. As for Futurist painting, the Cubist apologists stigmatized it rather unreasonably for being too divergent from the Futurist theory they condemned. For their part, Boccioni and Carrà saw the art of their French counterparts as fragmentary and crypto-academic. Anti-rational though their impulses were, they considered their work to be more comprehensive, objective, and progressive than the Cubists'. And more dangerous, too. For latent in the Futurist sense of progress was a will to destroy all moral codes, just as a wish to scandalize the public at large was apparent in their manner of self-advertisement.

From the perspective of the social history of art, few episodes compare with the Futurist incursion through continental Europe. And even outside these immediate Western limits, in czarist Russia, the movement exerted a nerve-wracking effect by unleashing a veritable mania for the new. In 1913, the year before Marinetti actually got to Moscow, Diaghilev could write:

Twenty new schools of art are born within a month. Futurism, Cubism—they are already prehistory. One needs but three days to become *pompier*. Mototism overcomes Automatism, which yields to Trepidism and Vibrism and they in turn to Planism, Serenism, Omnism and Neism. Exhibitions are arranged in palaces and hovels. In garrets lit by three candles, princesses grow ecstatic over paintings by the masters of Neo-airism. Big landowners take private lessons in Metachromism.

In societies that were more industrialized and diffused but less ripe for upheaval, the going proved to be rougher. To lubricate their way, the Futurists devised a carnival of provocation. Traveling shows, foreign newspaper reviews, and dealers' cartels were ordinary-enough features of contemporary art life. The Futurists improved upon them by broadsides and pamphlets, preliminary literary barrages to soften up the intellectual ground, street demonstrations, theater evenings *(serata)*, press conferences and releases, magazine polemics, lectures, and fiery catalogue introductions. Marinetti, the complete promoter, saw to it that no detail of modern public relations—whether it be a night marquee for the Bernheim-Jeune show or photographs of the artists and their works—was neglected in a blitz that appeared to be more commercial and political than artistic.

But this hard-sell style reflected a genuine aspect of Futurist ideology. The artists recruited all media, popular and specialist, in a concerted effort to draw upon potentialities for high-speed diffusion of messages and the most efficient condensation of information. The information that concerned them was perceptual. As the Futurists held that the sensory dynamic of modern life was magnified by endless supplements of new media, transport, and communications, it followed that mixed publicity techniques, no matter how incongruous, were the most appropriate heralds of their expressive aims. The inflammatory means by which these artists launched themselves became a trademark of their vision. Quite aside from attacking the museums as musty temples of dead culture—not a very new accusation in itself—the Futurists considered them obsolete as media. And it was quite clear, too, that they had their reservations about the gallery system as the only means of exposing their art, believing rather that the galleries comprised only one of many alternatives for reaching the public.

From the first, Italian Futurism was never restricted to a single mode of art. Painting may represent its greatest accomplishment, but it was actually born as a literary movement, with Marinetti's famous foundation manifesto of 1909 in the Paris newspaper *Le Figaro*. People from many fields rushed to enlist under its banner. Manifestoes of Futurist sculpture (Boccioni), noise (Russolo), music (Pratella), "Free Words" ("Parole in libertà," Marinetti), photography (A. G. Bragaglia), variety theater, politics, scenography (Prampolini), architecture (Antonio Sant 'Elia), and even cinema abounded into the years just before and during World War I. Unlike the intrinsically pictorial emphasis of Cubism, the Futurist sensibility comprised all the arts. For here was an aesthetic whose statements generally stressed polymorphous appearances, synesthesia, and the interchangeability of materials and perceptions. The switch-hitting Italians, with their broken field and open-frame concepts, took as their domain the whole bewildering flux of industrial and motorized experience rather than the unfolding ambiguities of form or the autonomy of painting.

Though extremely dogmatic, how vague, indeed, was their dogma. It encouraged them to sense each art as a cognate of the next and to think of them as ready to be rejuvenated by the excitement of modern disorder whatever their prior histories or states. Each art form could absorb and be transformed by the consciousness of disjointed feelings and chaotic sensations, understood as the new reality of the present. (One result was that, instead of remaining bottled up within the category of a movement, Futurism contributed directly to the development of all the arts, lending them insights and innovations which still await accurate credit.) "There is no such thing as painting, sculpture, music, or poetry," Boccioni went so far to say, "there is only creation." The proving ground of Futurism was judged to lie in the way it might anticipate the unconfined anxieties to come. For that reason, it was essential that the Futurist effort be of unprecedented scope, a united front establishing as many practical and concrete points of contact with its audience as possible.

Still, it would be hasty to assume that Futurism imagined itself in any sense as a "popular" art, or that there was anything egalitarian about its sentiments. True, at a benefit for the trade unions, the Futurists participated in an open exhibition of "Free Art" in Milan during the spring of 1911, where they invited children, working men, and ordinary citizens to show alongside

themselves. The artists stated that artistic talent was not necessarily limited to those with academic training, and that a fresh and natural vision was likely to rise from the untutored and unspoiled. Far from trying to make more room for neglected professionals, as at the Salon des Indépendants, this was an act that radically "de-defined" the limits of high art. Nor were the Futurists lacking in sympathy for workmen in their status as the human beings most intimate with machines. "One finds today," wrote Marinetti, ". . . men of the people without culture or education, who are nevertheless endowed with what I call the gift of mechanical prophecy, or the flair for metals." Just the same, this avant-garde movement would not altogether befriend masses who could not surmount the most grinding routine.

The Futurists exhibited a certain contempt for the poor and underprivileged partly because they themselves, the ambitious, night-schooled sons of indigent petty bureaucrats, were rushing to transcend their own pauperized class origins. But their social animus was contradicted by a political activism responding to the rebelliousness of a proletariat suffering under conditions of severe exploitation. Not for nothing was Marinetti's "polyphonic surf of revolutions" the central and most meaningful motif of the Futurist painters (until, interestingly enough, their contact with Cubism). For they embraced the spectacle of social conflict as a paramount symbol of their own desire for power. Solidarity with any crowd or mob putting forth its body in a fight for freedom from oppression was their nominal program. But it was, finally, a sympathy for its aggressiveness rather than the human or moral cause of such a manifestation that moved them as artists. Marinetti was quite clear about the real partisanship of Futurism when he affirmed that ". . . art can only be violence, cruelty, injustice." It was in this spirit that the Futurists would inflame the proletariat with visions of a powerful capitalism gone almost bezerk: "the uproar," as Boccioni put it very erotically, "the scientific division of work in the factories, the whistle of the trains, the confusion in the stations, anxiety!, rapidity!, precision! . . . the screaming of the siren . . . the pulsation of the motors . . ." This euphoric vision of life in the factories was not likely to be shared by those who labored in them.

Considering themselves centurions of the twentieth century, the Futurists had a score to settle with the nineteenth century, whose values lived on in the general public, an audience vulnerable to shock and harassment. From the Futurist manifesto of the Variety Theater, 1913, one may pick out

such typically nettlesome suggestions as "spread a powerful glue on some of the seats [of the theater] so that the . . . spectator will stay glued down and make everyone laugh. . . . Sell the same ticket to ten people: traffic jam, bickering and wrangling. . . . Sprinkle the seats with dust to make people itch and sneeze, etc." (quoted from Michael Kirby, "Futurist Performance"). The artists never had to justify thinking of the public as fair game for such tactics precisely because modernity *meant* discomfiture, glutinous, choking, or abrasive as it may be.

It cannot be said that they had a very precise notion of their audience—only a very broad one, loaded with stereotypes. But they derived their psychic income by contending with it on three levels: exalting a demonic future in which the conditions of life are regulated as if by a pressure cooker; sowing bodily confusion and mental alarm in the present; and belaboring and vilifying the cultural geography of the past. None of this was ever carried out as if through mere gratuitous bad manners or spiritless defeatism. On the contrary, the Futurists conducted every negative act with a blooded enthusiasm that seemed to rise only when it got as much as it gave. Harold Rosenberg wrote:

> The creator acts on the assumption that in drawing on all available energies, he is bound to be in tune with the time, that his move is the correct move for the moment in which he acts. His insight into time is embedded in his practice. In contrast, the avant-gardist has an *idea* of the present as a means of transition to the future; instead of communing with the present as the container of the past and the possible, he seeks to use it to fulfil the demands of his system. The rhythm of the avant-garde is the forward drive from a Now defined in terms of science, technology, history. It thins out time to a line leading to a predictable result. It wishes to surpass the moment and shake off or demolish its inherited content.

It might be useful to apply this interesting formula to the Futurists.

Here was a cluster of artists whose sense of profound dislocation only convinced them that this was the universal condition of modern Western man—an environment of perpetual change and ceaseless challenge. They

wanted to tune in all the disparate cultures of Europe to receive their message on the same wave length, an objective which their tour was meant to broadcast. And it was a message of reintegration of bodily instinct under the stress of psychic fragmentation. Their image of the mind agog, yet adapting to the welter of sensations, distinguishes them from the later Russian Constructivists, whose world view was bound up in a vision of crystalline abstract order. Their faith in the limitless dynamic interactions of men and machines contrasts with the totally disabused and mocking attitude held by the Dadaists, who, in other respects, were very influenced by Futurism. Yet, had the Italians possessed a system, they would not have accomplished the drastic modification of every medium with which their restless hands and brains came in touch, and they would not have been goaded to make practice transcend belief. This is what enables us to think of them as creators, making the correct move for the moment in which they act. But on their own terms, it was not enough to be taken seriously as innovating artists; unlike the Cubists, who made no effort to threaten the bourgeois ethos, the Futurists pronounced themselves willing to overthrow all social institutions and to glorify, not merely to intuit, the imminence of war—a fact that indicates the extremity of their conception of being modern men.

For it was hardly enough to score an upset within a relatively small, if sophisticated, intelligentsia. From the Futurist manifestoes dates the upsurge of the avant-garde as a deliberate public disturbance, its hunger to break out of its social ghetto, to repudiate the political ineffectuality of past art, and to play a substantial role on the vaster stage of actual life. Since the decline of officially centralized state patronage of artists in the second half of the nineteenth century, all previous avant-garde gestures had initially addressed themselves to a peer group as a necessary step to eventual wider acceptance. Through polyglot channels, the Futurists worked in reverse. Having spun their theories in advance of their art, they had also attained a powerful drive outside the galleries. Their information-gathering trip to Paris in 1911 was a means of quickening their professional development, an orthodox episode in the furtherance of their careers. It can also be seen as a covering of their programmatic flank.

A surprising logic emerged from this course of events, traceable even in the personal style of these painters. The Cubists were Bohemians who had recently issued from a strong, solid craft background and indirectly

derived some of their continued productivity and freshness from it. They could even playfully exaggerate their workmanlike pride, as when one day, their dealer Kahnweiler reports, "it was at the end of the month, and they were coming to get their money. They arrived, imitating laborers, turning their caps in their hands: 'Boss, we've come for our pay!' " Montmartre and, later, Montparnasse provided congenial lively bases for the development of a radical vision of art. No such stable identity or social anchor benefited the Futurists. Their protean theatrical behavior and shifting masquerades concealed great inner alienation.

In June, 1911, to take some examples, they descended on Florence to administer a beating to the critic Ardengo Soffici, who had just published a very unfavorable review of the Milan "Free Art" show in *La Voce,* an avant-garde periodical. A scuffle was followed by a brawl similar to the riot which was a typical subject of Futurist painting at the time. (Interestingly enough, after this public display of rowdyism, Soffici joined the Futurist group, thus becoming the first art critic converted to a new movement partly through the persuasion of fists!) A little later, on their Paris mission, Apollinaire found Severini and Boccioni to be engagingly dotty types: "These gentlemen wear very comfortable English-type clothes. Severini, a Tuscan, wears low moccasins and socks of different colors. The day I saw him the right sock was of a raspberry tone and the left, bottle green." And finally, at variance even with this, during the time of the Bernheim-Jeune show the Futurists presented themselves indelibly to the world in a well-known group photograph (Fig. 47). With their bowlers, glistening shoes, well-tailored overcoats, and neat cravats, they pose in the guise of an affluent respectability. (The English painter Wyndham Lewis bruited it about, with nice malignance, that the Futurist campaign was supported by ill-gotten gains from the Egyptian brothels of Marinetti's father!) But their dangling cigarettes and their unfriendly, direct gazes—scowls almost—make them more formidable-looking men and radiate a certain arrogance. This conclusive change in self-image, far removed from the stereotype of the artist as a whimsical or picturesque outsider, portrayed the Futurists as very mundane individuals, tycoons of a new order. It is hard to imagine such purposeful (if diminutive) men of affairs —who were actually far greater pariahs than their French competitors— having anything to do with oil paint or turpentine.

Indeed, everything about the Futurists' public presence was cal-

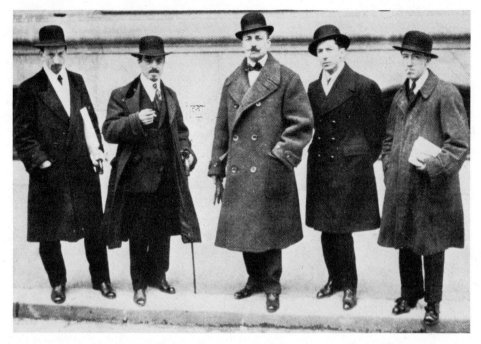

47 / Photograph of the Futurists in Paris, 1912. Left to right: Russolo, Carrà, Marinetti, Boccioni, Severini.

culated to liquidate the mystique of garret penury, café banter, and the lone individual in the studio working with his hands as so many romantic, middle-class clichés about the artist's life. Bohemianism, incomprehensible to workers, was a licenced counterculture tolerated, and even often supported, by respectable society. This was partly because many people longed for the kind of escape from colorless work and repressive convention sustained in the Bohemian code. This longing was no less strongly felt even if it was a conscious daydream. But the Futurists revolted against such a myth.

Though they were romantic fantasists by temperament, they maximized their antisocial program by applauding the progress of business capitalism beyond even the most shameless dreams of the bourgeoisie itself. (The word *capitalism*, however, so far as I am aware, never figured in their statements, public or private.) If the artist ought no longer to be looked upon as

a single artisan using primitive manual and tradition-bound techniques and working on the edge of the market, the bourgeoisie should recognize and embrace the ruthless direction the world's greatest industrial upsurge was taking. Nothing about the middle class bothered the Futurists more than the sluggishness or reluctance with which it contemplated its own worst instincts. Every class, the painters felt, must realize the full potential of its self-interest and play its role without compromise, for only then would the most significant amount of energy be released. *The latent terrorism of the Futurists, their apocalyptic politics, was as sympathetic to the prospect of the lawlessness of the ruling powers as to the subversiveness of anarchist rebels.* In this they were influenced, like the Italian socialist-anarchists in general, by the French writer Georges Sorel. From Sorel's *Reflections on Violence,* published in Italy in 1908, they could have read:

> If . . . the middle class, led astray by the *chatter* of the preachers of ethics and sociology, returns to an *ideal of conservative mediocrity,* seeks to correct the *abuses* of economics, and wishes to break with the barbarism of their predecessors, then one part of the forces which were to further the development of capitalism is employed in hindering it, an arbitrary and irrational element is introduced, and the future of the world becomes completely indeterminate.

It is easy to see how Sorel's inversion of rationalism into irrationalism could have appealed to the Futurists. Yet their belligerence, finally, had no political origin at all but arose from their love of horrendous event and carnal wastage, both seen as aesthetic phenomena. For the first time we have the spectacle of an avant-garde that loathes precisely that element of middle-class liberalism that tolerates radical avant-gardes; for the first time we encounter truly revolutionary artists who were perfectly prepared to attack the bourgeoisie from the right as well as the left—a cardinal reason why they are still so disturbing today. They conceived all politics as vengeance, just as they looked upon all media as interchangeable.

Such attitudes go far to explain, too, the Futurist image of the machine as a destructive rather than a useful instrument—for in utility the bourgeoisie had placed one of its hopes for a more reasoned and harmonious world order. The assault the Futurists launched against liberalism, humanitari-

anism, and parliamentary democracy was motivated by the conviction that these policies delayed the class war by fruitless and niggling concessions and, therefore, postponed the historical destiny of their civilization. If one of their fondest aesthetic goals was "to place the spectator in the center" of their whirling compositions, we may surmise that this meant he must comprehend that destiny for himself.

The theorist Renato Poggioli wrote:

> Fundamentally there is no great difference between the decadent's dream of a new infancy (dear to old age), and the futurists' dream of a new maturity or youth, of a more virginal and stronger world. Degeneration and immaturity equally aspire to transcend the self in a subsequent flourishing; thus the generations that feel themselves decrepit, like those that feel themselves adolescent, are both lost generations par excellence.

That the Futurists actually partook of both moods is suggested by Boccioni's remark: "Our primitivism is the extreme climax of *complexity*, whereas the primitivism of antiquity is the babbling of *simplicity.*" In correctly prophesying the crisis of their age, they guessed how brief would be the period for accomplishing their work. For they imagined rather optimistically that they had ten years before they would be overthrown by "others, younger and more valiant" (Marinetti, 1909).

What interests us is not the truth or sincerity of such remarks, but rather the fact that hyperbole was a necessary condition of existence for these painters and fundamental to their life of high risk. The absolutist rhetoric of their manifestoes became the model for succeeding Utopian movements in the arts. But the Futurists were not Utopians. With their win-or-lose psychology, it was not surprising that they lodged a spectre of extinction within their paean to vitality—the one inevitably keened the other. In one of the Futurist plays *(sintesi)*, published by Marinetti in 1916, it was even fantasied that the Roman Futurist Giacomo Balla, awarded a prize, immediately goes about wrecking all the Futurist painting on exhibition. Nor was it unexpected that their involvement with the downcast and their pride in their independence should eventuate in a worship of repressive strength. With official socialism moving ever closer to accommodation with the centrist governments of the

day, they cried all the more stridently for a recognition of the true sources of power and for a stripping away of what they considered to be the illusions of compromise. Certain young German writers welcomed the war as a rite of purification. But of all the European artists and intellectuals, the Nietzschean Futurists were the only group to become soldiers in the passionate belief that here was a new career and a vibrant identity that could lead to their ultimate triumph as artists and as men. If they sided with the Western bourgeois democracies against the autocratic central European powers, it was because of an invincible aspect of their outlook—the fact that they had been publicly burning Austrian flags for over a year in the name of Italian irredentism. Later, those that survived the trial by arms (it took the lives of Boccioni and Sant'Elia) allowed themselves to become luminaries in the cultural program of Mussolini, whose own development, like theirs, moved in a sinister arc from anarcho-socialism to national socialism—to fascism.

For the Futurists, of course, were violent Italian nationalists. Their kind of patriotism issued from a disgust with the culturally retarded and politically feeble Italy they knew in their childhood, and a wild faith in the modern industrial nation it was giving evidence of becoming as they matured. They hoped to discredit that heritage of the Renaissance that for too long permitted a whole country to languish without a modern national consciousness. With some justice they recognized that the new centers of production were most likely to generate the most daring innovation in the arts and, therefore, to create an entirely new culture, possibly as heroic as the old. In the Milan where they operated, a rising manufacturing civilization, beyond anything yet seen in Italy, altered the urbanscape more abruptly than in other Western European cities where industrial evolution had been more gradual. A large part of their impetus can be attributed to the restlessness of their desire to fill the gap between the familiar signs of technological progress in neighboring Western countries and the still exotic indications of that progress in their homeland. They could breach that gap in their imaginations only by painting a picture of modern life unfamiliar to everyone. Before the spectacle of tramways among mildewed palaces, the Futurists lost all patience. They rushed pell-mell to uphold an equation between Italy's coming of age and the apex of their development as painters. Any discrepancy between the two was anguishing.

With such high stakes, rejecting the past, and yet living remote

from their vision of the future, they subsisted on their nerves. Yet it was not the least of the Futurists' contradictions that they felt geographically as well as temporally uprooted—for all their rabid jingoism. They were excited and repelled by the necessity of placing utmost importance on their Paris opening. This ambivalence can be easily understood. Their profession and their ideology demanded that they be cosmopolitans; their temperaments compelled them to be chauvinists. Most of them knew the French capital briefly from apprentice days. It was now to become a scene of recognition and sales for them. But at all costs they would prevent it from absorbing them. Whole colonies of foreign painters had settled in Paris; others had come obscurely and gone back, hoping to make their names at home. The Futurists were the only provincial group of modern painters who set out to demonstrate that there were vital centers of art other than Paris, *precisely by exhibiting in that city.* They gave a decisive push to the conscious decentralizing of twentieth-century art, though in the process they were obliged to acknowledge the pre-eminence of the French capital. In 1913, Boccioni wrote: "We feel violently the duty of proclaiming loudly the precedence of our efforts. It is the right to Life! Our artistic manifestions never have the 'chance' that is offered by the Paris trademark. . . ." The cachet of being valued by the French and being bought by the English and the Germans was a device to gain greater prestige in Milan and, reciprocally, to elevate the cultural prestige of Italy in the chanceries of the West. More than that, it was designed to encourage a receptivity to experiment among the backward collectors of their native country or, more bluntly, to stimulate its market.

And yet, how necessary was this backwardness—not merely as the butt of Futurist doctrine, but as a condition against which one had to wrestle for one's very identity. The Bernheim-Jeune show, with its accompanying catalogue statement, was an act of marvelous bravado. It stigmatized as *retardataire* everything thought modern, or even ultra-modern up to that point. However, in March, 1912, as the exhibition concluded, Boccioni wrote from Paris to an Italian friend, giving us a different insight into Futurism:

> I confess that at the moment I am a bit worried because I cannot decide whether to settle down in Paris or come back to Italy. I am afraid that Milan would prove unbearable after the period, in fact the parenthesis, I have lived through in Paris—

I think I might be more advanced (though I may be wrong) if all the inner workings of my evolution had taken place in a more favorable climate such as that of Paris. I feel that many times I have lacked daring because of the spiritual isolation in which I lived. . . .

Now I wonder: what would I (perhaps) have done among people who *constantly* encouraged me? What would I have done if I had not always been faced with the fear of being thought a practical joker, a man on the wrong track, a brain that was going up in smoke?

Such then, were the anxieties and prides induced by a trip to Paris. As social adventure, it funneled into an art possessed of its own, highly metaphorical goals. What the Futurists actually created before and after that trip is enhanced by knowing the context of its allusions and values, but is in itself another, and richer, story.

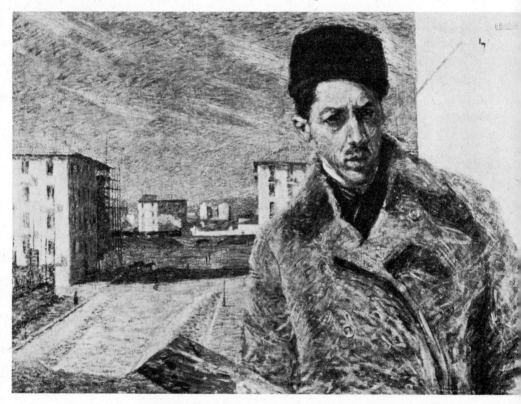

48 / BOCCIONI: *Self-Portrait*, 1908. Oil on canvas, 31⅛″ x 43¼″. The Pinacoteca di Brera, Milan.

FUTURIST ART
AND SLOW MOTION

Boccioni's *Self-Portrait* of 1908 (Fig. 48), though it shows the artist after only a few years as an independent, tentatively introduces us to what will be a central motif of Futurism: the growth of the city. On a bright, chilly morning, he stands on the balcony of his apartment bundled up, facing us, palette in hand, squinting a bit. By implication, the spectator watches from a few short feet away, on that same balcony which overlooks the left-hand landscape. Though Boccioni has his back to it, he seems to be presenting the scene and even leaning over in association with it. One's gaze follows fields that are neither populous nor desolate—no more urban than rural. They are the outskirts of town, the sticks that he has recently called home. New buildings are going up to house the overflow of workers thronging into Milan from all points. These precincts, as Boccioni no doubt accurately sees them, appear quite drab—a kind of no man's land. Only the fur hat he wears, a memento from a trip to Russia two years earlier, lends an exotic note to the tableau.

49 / BALLA: *The Worker's Day,* 1904. Oil on canvas, 39¾" x 54½".
Private collection, Rome.

In Rome, about four years earlier, Giacomo Balla, the one-time teacher of Boccioni and Severini, painted *The Worker's Day* (Fig. 49). The unity attempted within the three subdivisions of this diptych is less of a spatial than a temporal continuum. To each of the compartments, which together conjoin views of two buildings as if, for a misleading moment, they were one, is assigned a time of day. Dawn appears in the upper left and noon in the lower left, while evening occupies the right section of the painting. These, then, are vignettes cut out from the flow of time, which is indicated by the lengthening and shortening of the shadows. Just as the workers are shown at midday lunch and then trudging home in the dusky gloom, so too the sun has passed over in its daily arc and an edifice seems to have grown. Balla, the son of an amateur

photographer, gives us in one glance the discernible passage of several hours as a movie might do in a succession of shots. Indeed, his ensemble is cinematic in the sense that each zone, while representationally complete in itself, makes its point only as it leads us through a luminous narrative delicately shaded by its companions. In the movies, however, we generally experience the literal, if not always the narrative, present as the moment that is happening because it is the only one that is visible out of hundreds, some past, others to come. But Balla disorients us. In painting, everything "occurs" at once so that there can be no real synthesis here between his metaphorical time lapses and the literal breaks in his representational field. And he locks in this disjointed space all the more solidly by framing his images with a simulated brick molding, as if the artist himself were a worker constructing a window (even the wooden strips look like panes) through which a new reality can be glimpsed. Such devices mark this oil as the earliest twentieth-century painting to attempt a visual juxtaposition of *clearly separate* temporal events.

In this picture and in Boccioni's *Self-Portrait* we are dealing with situations in which time is being paced within a human environment about to alter itself radically. Both painters clock that extemporizing urban moment in which it becomes apparent that the streets and their spaces are in reciprocal creation and will never be the same again—and yet the change has by no means taken shape. It is, as they view it—a sad, inhospitable prospect that has reduced the population to homeless specks. Balla's paintings of Rome in the immediately preceding years, in fact, concentrate on such aspects of the city as an alley lamp or a closed, scribbled-over door, looming drastically above or declining beneath the normal line of sight. Without any human presence at all, these dolorous images were meant to evoke the fatigue of workers and a bankrupt's failure, if the artist's terse titles are any indication.

In 1908 Balla painted *Saying Goodbye* (*Salutando,* Fig. 50), almost breathtaking in its illusion of space dropped downward through the stairwell of a walk-up—steps fanning out from diminishing parabolic curves—until the darkened landing of the entranceway is perceived. The artist cantilevers the viewer over a strongly rifled and rather alarming descent that seems to gather speed as it plummets to the bottom of the picture rectangle. One feels that in a trice the smiles of the three women, looking fondly up and back, for an instant, will vanish, leaving only a dizzy void. It was shortly after the execution of this work that Balla, an artist almost forty years old, abandoned various

50 / BALLA: *Saying Goodbye,* 1908. Oil on canvas, 41½″ x 41½″.
Lydia and Harry Lewis Winston (Mrs. Barnett Malbin),
Birmingham, Michigan.

documentary techniques still aligned with Italian art of the last century and
launched himself into that maelstrom soon to be called Futurism.

In speaking of the immediate stylistic background of Futurism,
three sometimes mingled impulses have to be distinguished: a local brand of

nineteenth-century naturalism called "Verismo," Symbolist Art-Nouveau, and Neo-Impressionism. For the Milanese, who recoiled from the academic recording of sense data and in their manifestoes were proud to be "against the moonlight," only Neo-Impressionism appeared to offer certain abstract possibilities from which a liberation into the pictorial future might be contrived. Such little-known turn-of-the-century painters as Giovanni Segantini, Vittore Grubicy, Gaetano Previati, and Giuseppe Pelizza de Volpeda (Fig. 51) had developed an Italian variant of the painting of Georges Seurat and Paul Signac. Compared to these French sources, Lombard "Divisionismo," as it is called, was less concerned with the measured ratios and harmonious contrasts of dotted complementary colors formed into scintillating zones of light and shade, but it more freely manipulated heterogeneous textures and expressive moods. In acclaiming such Italian predecessors in their manifestoes, the Futurists were rehabilitating an art unjustly neglected in their homeland and already considered retrograde in France, especially because of its narrative framework. But what interested the Futurists in the *Divisionisti*

51 / PELIZZA DE VOLPEDA: *The Sun,* 1904. Oil on canvas, 3⅞" x 5⅞". Private collection, Torino.

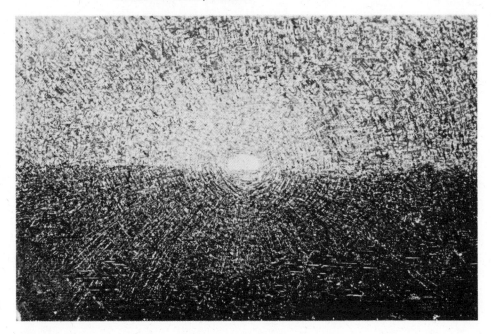

was a potential for energizing the phenomena of color-light, the kinesthetic handling of the picture surface, and the palpitation of all images in luminous currents that could be handled very personally, for all their erstwhile "scientific" rationale. The planes and contours of forms were atomized not to discover the optically pure constituents of color but to activate every perception of the world and to relate that activity to the artist's own emotion. The Futurists were to go further in sensing that matter interpenetrated with the lighted air, and that this was as much a result of the imagination of movement in time as it was of the endless movement of bodies in space. Appearances became a series of impingements and trajectories that dynamically crossed over and through each other and yet could be held in the mind they had set to quiver.

In order to render these episodes, however, the Futurists had recourse to several differing sign systems and experimental metaphors. Their work implied, from 1909 on, so many sensory fusions that the actual pictorial language they used never seemed to catch up. Boccioni's and Carrà's personal diaries and letters were so much haunted by this gap between limited means and unlimited ends that it can almost be thought to represent the Futurist sensation par excellence. Yet, as the historian Joshua Taylor phrased it, "perception [for them], while it responds only to the moment, inevitably brings to that moment an accumulation of experience of various kinds which are not compared with the new experience but are part of it." The Futurists, therefore, had to remember the "past" of all the entangled motions that excited them in order to advance them to any degree.

In Severini's *Spring in Montmartre,* painted in 1909 (Fig. 52), we can observe that none of this has as yet become a problem. Its Neo-Impressionistic green, yellow, and light-blue dabs—comprising the sun-dappled foliage—are sprinkled in orderly planes represented as parallel to that of the picture surface and are marked off by the successive landings of the downward-sloping promenade. It is in the last canvas by an Italian Futurist to depict the city in a guise so uncharacteristic as peacefulness. Carrà's *Leaving the Theater* of 1910–1911 (Fig. 53), on the other hand, shows new disturbance. For it almost seems to heave its scene at the viewer. Muffled figures in browns and blacks flit drunkenly out toward the picture margins amid a nocturnal ocean of snow. Each of these theatergoers is shrouded in a rhythmic irridescence of soft, volume-hugging strokes, and yet the composition does not "add up" to

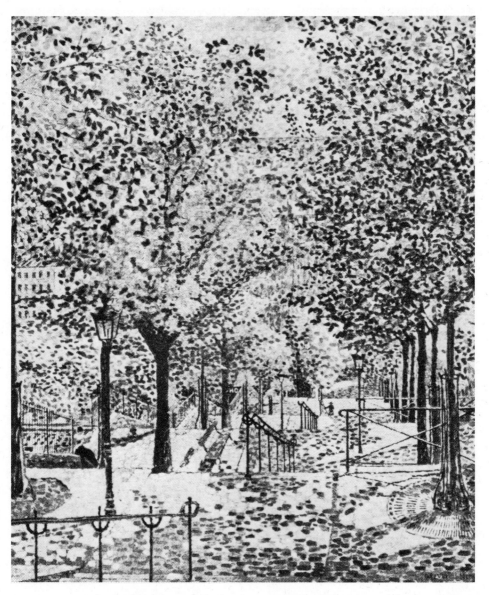

52 / SEVERINI: *Spring in Montmartre*, 1909. Oil on canvas, 28¼″ x 23⅝″.
Private collection, Paris.

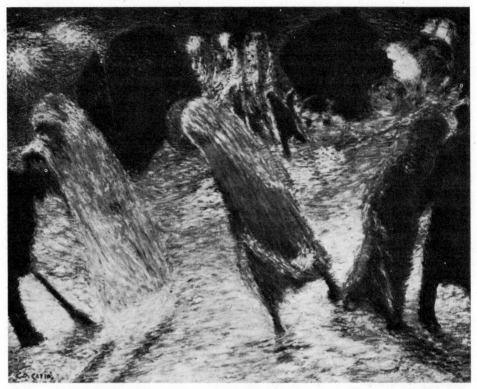

53 / CARRÀ: *Leaving the Theater,* 1910–1911. Oil on canvas, 36⁵⁄₁₆" x 25⁹⁄₁₆".
Mr. and Mrs. Eric Estorick, London.

any larger rhythm unless it be some wayward, tilted escape from the center.

The Futurists quickly came to think of the picture zone as a flickering network of multiple stresses, charged with magnets and electric currents—invisible forces now controlled by man. Later, Marinetti was fond of speaking of "the wireless imagination," and Balla was to show that a street lamp could emit a shower of small blazing chevrons, their wings scissoring open the dark (Fig. 54). This celebration of artificial light, which even dims the moon, had an oracular force, for its wattage emblemized all the harsh,

54 / BALLA: *The Street Light—Study of Light,* 1909. Oil on canvas
68¾" x 45¼".
The Museum of Modern Art, New York,
the Hillman Periodicals Fund.

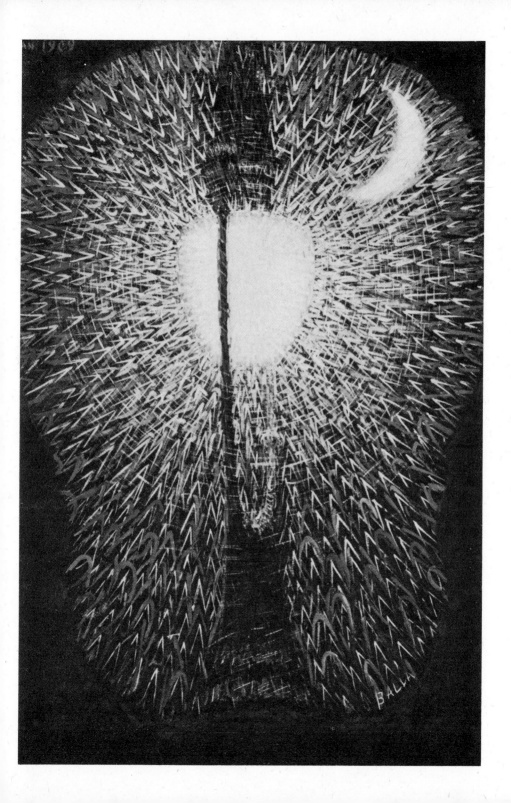

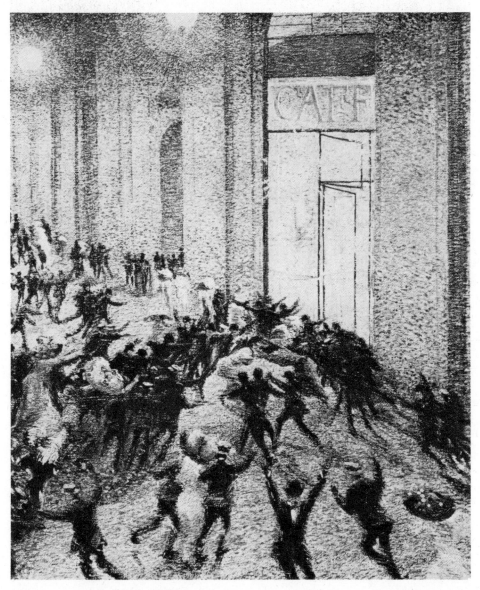

55 / BOCCIONI: *Riot in the Gallery,* 1910. Oil on canvas, 30⅛″ x 25¼″.
Dr. Emilio Jesi, Milan.

unpredictable, and distorting hues that were to turn the Futurist night into a phantasm of violence.

In an interval of only two years, Milan had changed for them—or rather they transformed it—from a place with hardly any community at all into a scene of incessant sweat and fracas, taken over by swirling mobs. And the locale of their concern had switched, too, from the peripheries to the center of the town. Where once they stressed an individual anxiety and solitude, they now focused on the bodily releases of mass action. All this was accompanied by a bolder and more excited sense of form.

Boccioni's *Riot in the Gallery* (Fig. 55) does not yet exhibit this metamorphosis much beyond its subject matter: a horde of fashionable spectators—orange, green, purple, yellow—squirming up to and raveling around two struggling women. But in order to give us a panoramic view of this disorder, Boccioni has sliced his composition into diagonal halves, the top of which, even with its bursting arcade lamps, functions as a rather vacant foil for the churning of the bottom. The atmospheric perceptions of Boccioni are quite complex in their intimately divided color, but he still holds on to modeling and perspective as fairly obvious agents for placing forms in space.

The City Rises of 1910–1911 (Fig. 56), a 6½-by-10-foot painting, reveals him to astonishingly better advantage. (An early related drawing shows that Boccioni toyed with the idea of a triptych with a center stage occupied by a building very much resembling the motifs in Balla's *The Worker's Day*.) In it, what started out as various studies of draft horses hauling loads concentrated later on the one broad-chested equine form whose frenzied lunge seems almost to be powering the city into existence. The intent is unmistakably symbolic. Far from portraying one particular incident, the artist shows an overall hysteria of effort that laces through both men and animals, materializing, in Boccioni's words, "the fatal striving of the crowds of workers." Light rays needle into the smoke and construction and may ricochet over a muzzle and a fist. And everywhere the images are fine-combed and whisked to let in the light and make them vibrate like a buzz saw. As for color, buoyant red in the horse (the color of proletarian insurgence), blue-black (its yoke), yellow, and milky whites precipitate out of the sun-shocked hazy morning.

Such are a few of the *impressions* given by this apotheosis of muscular energy. What is particularly surprising, however, is that neither density nor weight coexists with bulk and action. The men who almost col-

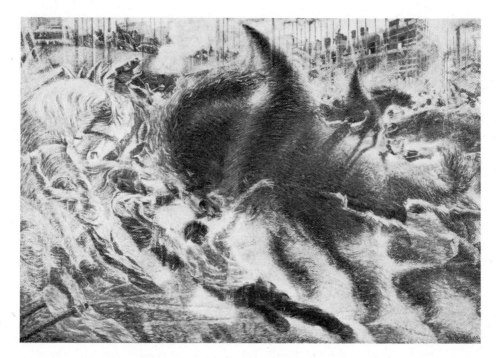

56 / BOCCIONI: *The City Rises,* 1910–1911. Oil on canvas, 78½″ x 118½″.
The Museum of Modern Art, New York,
Mrs. Simon Guggenheim Fund.

lapse with the strain of pulling their burden and the beasts who lunge with all their might are as light as chiffon. But if we analyze these impressions we understand that Boccioni does not want to depict brute force as such, but rather to convey the optical phenomena of movement to which it gives rise. The identity of all images is, therefore, subordinate to a stippled froth that extends them slightly in space, as if they are being seen at two very close instants in time. To borrow a term from photography, Boccioni "shot" the event with a shade too slow a shutter speed. He catches physicality itself off guard, even in this heroic context. That is why the indistinct and contradictory spaces, the sudden bleachings, and the blurry gestures appear simultaneously authentic and fantastic. They invoke certain split, distracted moments of unfocused visual consciousness. Instinctively crystallizing information from

sense data, the human brain condenses such moments, ejects them from mind. But Boccioni wants to edit perception differently and to recollect precisely such interchronic occasions not with the small nuances of an Impressionist, but as a reflex of sheer animal stress. His presences, whose last traceable contours dissolve in a new abstraction, have a ghostly fury. Beyond this, divisionism alone could not take him.

For his competitive part, Carrà set out to create a large, monumental history-painting, as heroic as Boccioni's. His *Funeral of the Anarchist Galli* (Fig. 57)—the top portion of which was repainted in preparation for the Bernheim-Jeune show—shows an incident during the Milanese workers' strike of 1904. At the burial of Galli, a strike victim, wedges of mounted

57 / CARRÀ: *Funeral of the Anarchist Galli,* 1911–1912. Oil on canvas, 78¼" x 102".
The Museum of Modern Art, New York,
acquired through the Lillie P. Bliss Bequest.

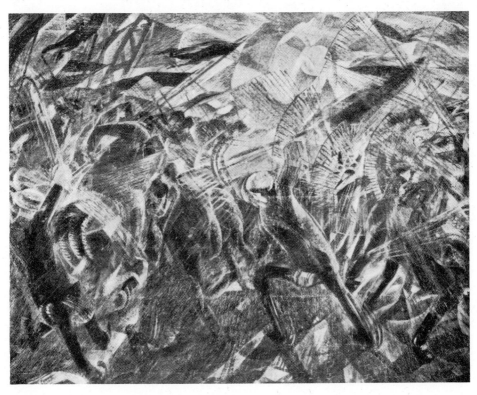

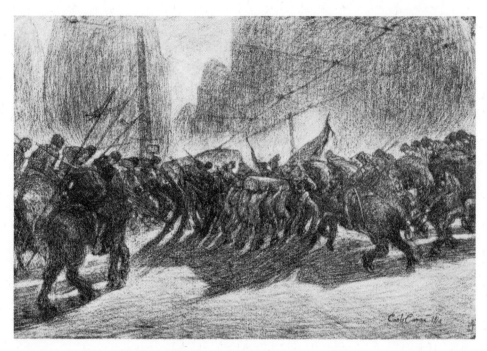

58 / CARRÀ: Drawing for the *Funeral of the Anarchist Galli*, 1910.
Pastel on canvas, 22⅞" x 34¼".
Galleria Annunciata, Milan.

police, lances at the ready, charged the pallbearing cortege, almost jostling
its carnation-covered coffin to the ground. Carrà was there, "in the midst of
the fray," and he recorded the event in a tonal sketch (Fig. 58) which shows
horsemen moving in from the left toward mourners in the center ground,
tramwires and a gridded support tower above, and the dim, blocky profiles
of large trees in the background. In the painting, though, he has brought the
tumult up front and transformed it into a blackened nocturne, heightened
with red and brown, where desperate, weighted figures collide with each
other on an upended, indeterminate ground. Accentuating the infinite shoves
and tremors in this climactic moment, Carrà indicates a series of rotary mo-
tions over and through his agitated, shadowed masses, by spoked linear curves
—"lines of force," the Futurists were to call them. If light can streak, it may

be reasoned, gesture can sputter. The residues and emergence of their actions are as important as the bodies themselves. Carrà has created a field in which diagonal thrusts of tone are countered by arched lattices of line. The conflict between the police and the workers is paralleled by the tension between the narrative and the schematic elements of the painting. In the roughage of his textures, Carrà gains a new drama, for himself and for Futurism in general.

It would be difficult to say which of these exciting paintings, Boccioni's or Carrà's, renders the more vivid sensation of dynamic energy. One painter marries that energy to light and makes of it a fireworks display articulated with delicacy; the other identifies it with the empathetic capacity of our own muscles to tauten at a spectacle of furious human struggle. Both works, in any event, exalt motion as an absolute. Not only is the subject in continuous, intoxicated motion, but the activity engulfs the spectator, forcing him to recognize the ever-restless momentum of perception itself.

In their technical manifesto of April 11, 1910, the Futurists proclaimed:

> The gesture which we would reproduce on the canvas shall no longer be a fixed *moment* in universal dynamism. It shall simply be the dynamic sensation itself [made eternal]. . . .
>
> Indeed, all things move, all things run, all things are rapidly changing. . . .
>
> A profile is never motionless before our eyes, but it constantly appears and disappears. On account of the persistence of an image upon the retina, moving objects constantly multiply themselves. . . . Thus a running horse has not four legs, but twenty, and their movements are triangular! . . . To paint a human figure you must not paint it; you must paint the whole of its surrounding atmosphere. . . . Our bodies penetrate the sofas upon which we sit, and the sofas penetrate our bodies. The motor-bus rushes into the houses which it passes. . . . Painters have shown us the objects and the people placed before us. We shall henceforward put the spectator in the center of the picture.

Many of the images conjured in this manifesto were to be depicted in Futurist canvases of the next year. It is significant that the Futurists

first conceived their subjects and then tried to incorporate them into the "dynamic sensation" itself, rather than modifying an intuitive principle of form with a subject as the Cubists had. These basically antithetical approaches were responsible for the different syntax used by the French and the Italians in their solutions to such mutual problems as the multiplication of forms and the interpenetration of voids and solids. The Cubists were likely to consider the motif as a network of braces, some observed, some invented. The Futurists had a greater tendency to view the object as the vehicle of a very swift passage observed at different points in time. The constants in a Cubist painting are the facets and other geometrical elements, flexed with infinite variation. The only constant for the Futurists, however, was a generally "given" velocity of some thing or things whose course was unique. Both schools were convinced of the essential fluidity and relativity of perception. For Picasso and Braque, these qualities emerged in the process of manipulating half-standardized lines, shadows, and shapes, into wholes made up of embroidered hesitation. In Futurism, on the contrary, matter and movement perceived are an intrinsic and immediate product of bodily experience, which has to be translated with fresh pictorial equivalents every time a new phenomenon is studied.

That is why the Futurists evolved very discontinuously and short-windedly, changing styles when they changed subjects, and still remained Futurist. In his *Funeral of the Anarchist Galli,* Carrà portrays one event, but several instants of time within that event. There is no way of determining the physical or temporal origin of his force lines. Stimulus and response are dislocated or exchanged. Although Carrà composes in a very purposeful way (reminiscent of the battle pieces of the Renaissance painter Paolo Uccello, in whom interest was just then being revived), the mobile aspects of what he shows and how he wants to show them make the action very approximate. He gives us to understand that our vision is in motion, too, and strives for a generally elusive synthesis of "pictorial" and spectator action.

From this point until 1915, Futurism presents two essential metaphors of this synthesis. One was to stop-watch transient activity itself, marking off "stations" of any one path or flight by closely successive time intervals in the manner of multi-exposure, stroboscopic photography. By this procedure, the artist could confer a rather friezelike rhythmic momentum upon any movement; he could "hold on" to it and graph the history of spatial switch even if it was completed in a split second. The other metaphor surrenders to

the coexistence of several movements in time, so that we cannot be sure from which angle we view them or how long they last. Here, one's attention has to jump from one narrative possibility to another, filling in the tenses of the action at will.

The first metaphor, which was to be exemplified by Balla, highlights what we may *know* of bodily movement at the expense of what we can literally see of it. The second approach, best noticed in Severini, conveys a great deal more of our *sense* of motion in the world while contradicting our knowledge of the things that have moved. Between these colleagues in Rome and Paris, the Milanese Futurists struggled for more immediate and, yet, even more ambitious solutions to the problem of time versus space in painting.

Regardless of their different expedients, however, the Futurist artists were united by one major principle. They wanted to sensitize the viewer to the appearances of speed, not by "accelerating" but by breaking them down and, ultimately, by *detaining* them. To explain this, it may be useful, once again, to refer back to the camera analogy.

Images projected on our retinas are channeled through the pupil, an aperture that responds to the available light by opening or constricting itself. Cameras come equipped with adjustable apertures, too, but since they are to deposit one shot on light-sensitive film, they have a shutter speed required to time and terminate the exposure. In painting, one has to imagine that there is generally a figurative shutter speed as well, designed to frame or freeze motion where motion is implied. The conventions of pictorial art are such that we tend to read this frozen quality as a stopped frame or still shot of continuous action. The painter, concerned with simulating the reality of movement, must conceive devices that make us discount the actual immobility of his images. He may do this by obscuring contours and precise location with many fine transitions or colored light and shade. Or he may suggest, by various qualities of overt gesture, the quickening of his own performance. Playing a subtle game of mingling these two conditions, the Impressionists were the first modern painters who might be said to have lengthened the "moment" of their paintings. (Indeed, to some of its earliest hostile critics, Impressionism looked too high-keyed, as if, we would now say, it had been overexposed.)

Futurism took pictorial analysis much further by evoking—and this is conceivable only in the twentieth century, when a mechanical model

was available in movies—a positively *slow motion* art. If, in fact, it never gives us this feeling, it is because painting, unlike the cinema, is exclusively a spatial medium. Arrested images in space have nowhere to "go" in time. Whereas thousands of images exist consecutively on a strip of film, Futurism piles scores of them up to be synthesized in one glance. Filmed activity takes up time, as does real activity. But Futurism gives us many visual moments in one temporal moment. Slow-motion cinema, by breaking down visual moments in far greater detail than they are actually perceived, mechanically distends the travel of images. They appear delayed in a thick medium that withholds their destinations. *By insinuating this kind of optical gearing in painting, however, the artist produces exactly the opposite effect.* Instead of painfully anticipating the action, we feel frustratingly "behind" it. Because incidents are literally impacted in the viewing space, we must accelerate the way we receive pictorial events in our viewing time. Despite appearances to the contrary, that is why we do not tend to interpret forms as disjointed in Futurism, whereas disjunction is very much to the point in Cubism.

Yet insofar as this effect evolves out of certain schemata worked out on a mechanistic level, there is nothing to identify it with the creation of art. Indeed, previous visual attempts to record or represent locomotion in time belonged traditionally to the realm of the comic, as in the work of certain nineteenth-century caricaturists, or the scientific, in the chronophotographs of Eadweard Muybridge and Étienne-Jules Marey. But the Futurists discerned in the motion of objects traversing space in time a sheer excitement that was poetic as much as it was physical. They dedicated painting to compound that excitement from the refined Impressionist nuance. In the process, they enriched the meaning of complex forms—a very artistic result indeed.

10 / FUTURIST STATES OF MIND

Russolo's *Memories of a Night* (Fig. 59) is a montage of faces and figures, in near space and far, whose storytelling intent is more confused than its silhouetted forms and haloed lights. We cannot tell if these are the memories of the artist or of one of his subjects; nor do we know if this ambiguity was intentional. Further, this jerry-built reverie is remote from immediate perception. No one of his images inhabits the same environment as any other, the whole being a colloquy of incidents brought together out of heterogeneous time and place. Lacking a specific setting, the women, horse, male heads, and passers-by are, however, placed in a dreamlike context. Obviously, it was not enough for the Futurists to dramatize a heightened pace of physical events. Many of their works, before and after the Russolo, have little to do with this. Their larger aim was to show how we react to and remember events, what new consciousness is generated by them, and what they might symbolically mean to us.

59 / RUSSOLO: *Memories of a Night*, 1911. Oil on canvas, 39¾″ x 39⅜″.
Miss Barbara Jane Slifka, New York.

Russolo's taste for symbolic groupings soon took striking emblematic form in *The Revolt* (Fig. 60), where a phalanx of rioters, swerving upward at a 45-degree angle, seems to lift the city off its hinges and down upon the crowd. Large chevrons—symbolic shock waves—advance leftward, ahead of the collective action. While they structure the drama, they have

nothing to do with the observation of movement. The excitement is strictly abstract; it produces a succinct and yet unrealized composition—a kind of posteresque Futurism.

Severini, a short time earlier in his *The Boulevard* of 1910 (Fig. 61), offered a very hybrid work, inadvertently close to Russolo in its closed-off forms and simplified color areas though too consistently shattered for its patterns to drive home any one perspective. Severini was later to occupy himself throughout his prewar years with a characteristically heel-kicking Parisian subject matter—those dance halls and night clubs with which Lautrec and Seurat had been so taken. And his palette, too—chiefly reds and blues on a white ground—became so French as almost to recall the tricolor. His was the only Futurist intellect detached enough to imagine elegant and comic possibilities in the dynamic sensation. *The Boulevard* resembles a kind of fairground made into a jigsaw puzzle, where various derbied strollers dressed in black seem to pop up between the green, lavender, orange, and pink

60 / RUSSOLO: *The Revolt*, 1911. Oil on canvas, 59″ x 90½″.
The Haags Gemeentemuseum,
The Hague, Netherlands.

61 / SEVERINI: *The Boulevard,* 1910. Oil on canvas, 25⅛" x 36⅛".
Mr. and Mrs. Eric Estorick, London.

"pieces" that first clutter up the foreground and rush diagonally back from
the sides to be inlaid in the triangular forms and "hills" of the horizon.
Movement does not belong to any depicted action but emerges out of the
staccato rhythms caused by the gerrymandering of flat cut shapes and figures.
In this playful, decorative scatter, the viewer cannot pick up any single episode
and transfer it to another without trying to "unlock" his gaze from the
relentless interwedging of the shapes. It is synthetic Cubism before the fact,
and yet punctuated with the spritely points of Neo-Impressionism, whose
concern for color complementaries are freely mimed.

 With such of his own work and that of his Cubist friends in mind,
Severini sought to draw the Milanese Futurists into the crucible of advanced
Parisian painting. But even with a comparable subject, Boccioni's demon

62 / BOCCIONI: *Forces of a Street,* 1911. Oil on canvas, 38⅝″ x 30¾″.
Private collection, Liechtenstein.
Photograph by Hinz, Basel.

evoked in him a very disquieting and even alien response. His *Forces of a Street* of 1911 (Fig. 62), one of about four canvases created hurriedly between his two visits to Paris, is a nocturne in which the passage up a city street is like a gauntlet of dark purple, blue, and green levels striped with long, jagged black shadows that seem to angle them off the ground, and is skewered down from above by the inverted-V rays of lamplight. A tramcar careens from its tracks directly at us in the foreground, as passers-by, carts, and cabs flow backward, sucked by the quake-frought channel. Night, for Boccioni, brings shaded menace to gravity and space, upsetting all basic faculties of orientation. But he represents these essentially appalling phenomena by new means of control. The various objects and people, askew in the street, are materialized by transparent spectral superimpositions upon the night-camouflaged zones of the thoroughfare. And meanwhile, the pyramidal structure of the scene has a staggered apex, echoed with such variations in the field as to activate all its perimeters with a maximum tension. The forces to which the title refers, very awkwardly and schematically analyzed in a preparatory drawing (Fig. 63), enter into dialogue with each other. The economy of its structure shows the influence of that Cubism Boccioni had assimilated at the time, but it stops well short of containing the energy of his vision.

To indicate the path along which he was urging his art, it is only necessary to compare this painting with a canvas Boccioni executed just a few months earlier. It is supposed that *The Noise of the Street Penetrates the House* (Fig. 64) reveals Boccioni's riposte to a black-and-white photograph of a recent Delaunay shown to him in the summer of 1911 by Severini. Certainly its deformations, the sense of a whole city buckling and caving in onto the foreground balcony, recalls that painter's Eiffel Towers (which led Gertrude Stein to speak of a "catastrophic school"). It is an important work in that it displays the mutually wrenching effect of close and distant, rising and falling, forms and of public and private experience on a mind aghast in the modern city. But as a demolition of what might be called stable conditions of seeing, it is too literally jarring, as if Boccioni were grinding his pictorial gears. Tiny laborers look like they are crawling up on stakes impaled in his mother's shoulders. The effect is cacaphonous enough. Modeling and volume, independent of the hot yellows and purples, tends to dissolve, and the syntax has not yet been crystallized in the fierce sign language, the Cubist overdrive of *Forces of a Street.*

63 / BOCCIONI: Drawing for *Forces of a Street*, 1911. Pencil on cardboard, 17¼" x 14⅝".
The Civiche Raccolte d'Arte,
Gabinetto dei Disegni, Castello Sforzesco, Milan.

Meanwhile, Carrà's problems during this hectic interval of the encounter with Cubism are made evident by his *What the Streetcar Told Me* (Fig. 65). More visceral in temperament than any of his friends, he sought to compensate by avid control of his structures. Here the rectangular armature of the streetcar frame and the schematized profiles of horses and pedestrians strive to attain focus against the patchy and mottled brushwork. A preceding

64 / BOCCIONI: *The Noise of the Street Penetrates the House,* 1911.
Oil on canvas, 39⅜″ x 39⅝″.
The Niedersächsisches Landesmuseum, Hannover.

65 / CARRÀ: *What the Streetcar Told Me,* 1911. Oil on canvas, 20½″ x 27″.
Dr. Giuseppe Bergamini, Milan.

painting, *Jolts of a Cab,* had been a whirlwind of chaotic and fuzzy forms, and though he was to persist in making the very paint seem to stammer, as if to act out the lurches of both the passengers and the viewer, his planning of rhythms now began to take on the function of a shock absorber, while the side view of the images blocks obvious "entrance" into the scene. These, of course, are matters of strategy. The *effect* to which he aspired and failed to achieve may be suggested in the 1912 Bernheim-Jeune catalogue preface: "We must show the invisible which stirs and lives beyond intervening obstacles, what we have on our right, on the left, and behind us, and not merely

66 / BOCCIONI: *States of Mind I: The Farewells*, 1911–1912. Oil on canvas, 27⅞" x 37¾".
Private collection, New York.

the little square of life artificially compressed, as it were, by the wings of a stage."

The most psychologically ambitious and conceptually programmatic work in the evolution of Futurism is Boccioni's *States of Mind* (*Stati d'animo*, Figs. 66–68), a triptych, with separate right and left wings, that sums up and synthesizes the principles that had obsessed the artist since the first painters' manifesto. It consists of three compositions, all the same medium size, entitled: *The Farewells, Those Who Go,* and *Those Who Stay.* This apotheosis of twentieth-century travel by rail dates from the spring of 1911 to the winter of 1912, when it was shown in Paris. Between October and January,

Boccioni had in some areas decisively reworked the first version of the theme, which he had sketched out before he had come in contact with Cubism. Now, the Bernheim-Jeune preface, with likely reference to *States of Mind,* was to remark:

> We have declared in our manifesto that what must be rendered is the dynamic *sensation* . . . the particular rhythm of each object, its inclination, its movement, or, to put it more exactly, its interior forces. . . . What is overlooked is that all inanimate objects display, by their lines, calmness or frenzy, sadness or gaiety. These various tendencies lend to the lines of which they are formed a sense and character of weighty stability or of aerial lightness. Every object reveals by its lines how it would resolve itself were it to follow

67 / BOCCIONI: *States of Mind II: Those Who Go,* 1911–1912. Oil on canvas, 27⅞″ x 37¾″.
Private collection, New York.

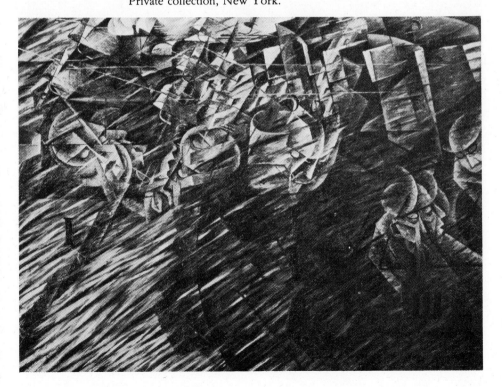

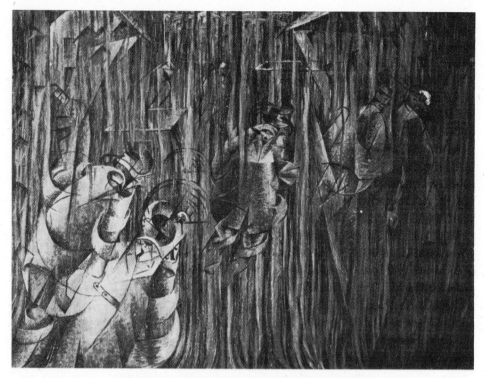

68 / BOCCIONI: *States of Mind III: Those Who Stay,* 1911–1912,
Oil on canvas, 27¾" x 37¾".
Private collection, New York.

the tendencies of its forces. This decomposition is not governed
by fixed laws but it varies according to the characteristic personal-
ity of the object and the emotions of the onlooker.

As the dominant author of these words, Boccioni understood that we cannot
witness the movement of bodies without experiencing emotional conse-
quences that can by symbolized in painting. Hopefully attaching objective
meanings to abstract elements in painting was by no means new in itself, but
establishing a vocabulary of such meaning for observed motion was an en-

tirely different matter. The problem he faced in the triptych was how to make this symbolism explicitly intelligible in all its intense conflicts without sacrificing the volatility of sensation.

To the physical exchange between the interior density of things and the atmosphere that surrounds them he would fuse less tangible empathies of resistance and submission, assuming that each image was struggling to have its own affective destiny within the viewer. His program appealed to the viewer's capacity to intuit space as a thickened, refractory medium, passage through which takes its toll of energy and nerves. And in order to embody this program, he had recourse to a segmented narrative centering upon what, for the Futurists, was one of the most poignant human events, that of leave-taking.

Some confusion exists as to the sequence in which these paintings should be "read." That Boccioni was concerned with the tides of experience and extreme feeling set in motion by train journey is clear enough. But if *The Farewells,* by virtue of its monumentality, is rightly considered the visual center of the ensemble, it must compromise the temporal references of the subordinate wings. That is, one hesitates to place *Those Who Go* before—to the left of—*The Farewells* because its subjects could not have departed prior to farewell; while *Those Who Stay* cannot logically "begin" the narrative either, because it is also defined by the preceding, subtracting event of the train having gone off.

In other words, the powerful architectural rationale of the series contradicts its "plot," if by plot we mean its narrative sequence. But it is plausible that Boccioni might have conceived of this ambiguity as the essence of his statement. For it is difficult to escape the sensation that past and future are reversible, open reflections of each other, that we anticipate and remember by means of the same fluid process. The artist could very well have called his painting *Those Who Say Farewell,* in accord with the grammar and sense of the two companion pictures. If he chose, rather, to say *The Farewells,* he distinguishes something done from the repercussions of the event on those caught up with it. The two wings of *States of Mind,* the active and the passive, are simultaneous flashback and flash forward, crossing laterally with each other as they take their bearing from the incontrovertible fact of farewell. One can appreciate how intimately bound is Boccioni's symbolism with the unique, perplexing relatedness of these paintings. Their separateness points to the fact

that people are being taken from each other; their thematic links call to mind the possibility of traveling in spirit.

But how do we come to terms with the actual phenomena present in each of these canvases—that is, the intricate language by which what we may know and what we may perceive are blended together in a pictorial unity? That problem is usually approached by conceiving a construct called style—or, put differently, the manner by which an artist willfully predisposes his forms as a reflex of his personality and in response to the history of his art. On this level, it is easy to discern Boccioni's style.

His exposure to Cubism of 1911, for instance, seems to have affected *States of Mind* rather like a decompression chamber, lending weight and solid torsion to images that, in the early studies, had been virtually macerated by the downpour or radiation of force lines. The figures in his first sketches for the triptych were all too easily swayed by the wind storm and withered by its force. In the finished version, they have tensility enough to have folded and creased, allowing them to grip into the surround no matter how threatened their mooring. *The Farewells* contains hints of a Cubist grid, displays a prominent number motif, bristles with overlapping, shingled planes, and is replete with profile and frontal views of the locomotive. It is additionally organized by large, convulsed arabesques and executed in sputtering strokes, conveying a feverish agitation of images in rapid movement. The same stylistic duality characterizes, in different degrees, the other two paintings of the group. In sum, the pictorial language of *States of Mind* emerges as a kind of Esperanto, composed of known Cubist and Futurist roots. Indeed, Boccioni stipulated, "We must combine analysis of color (the Divisionism of Seurat and Signac), with the analysis of form (the Cubism of Picasso and Braque)."

Yet etymology is one thing; insight into current usage quite another. What is signified in this triptych, and how is it signified? With Gleizes's *The Football Players* (Fig. 69), the many elements that cannot be associated with anatomy or landscape must be interpreted as abstract presences in a re-created world. They are conceived by the painter as devices to energize his composition through a kind of tectonic contrast rather than as aspects of his subject. This procedure lends to *The Football Players* a general and synthetic character, in which the activity of the game is rigidified in a scheme of broad, patterned foils, subordinating human and muscular conflict. *The Farewells*, on

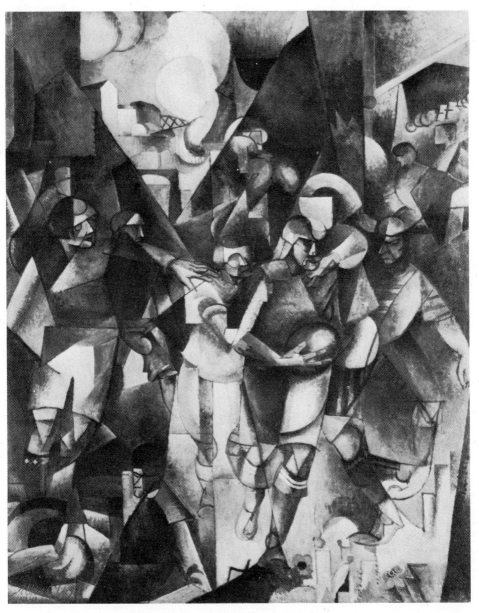

69 / GLEIZES: *The Football Players,* 1912–1913. Oil on canvas, 89″ x 72″.
The National Gallery of Art,
the Ailsa Mellon Bruce Fund, Washington, D.C.

the other hand, has an expressive system in which the dominant green forms, clenching or struggling free from each other, are imbued with a frenzy of their own. And not only does their mass flail as if stoked by the heat of the train's boiler, but it has to be interpreted as a flow of linked figures whose writhing cannot be rationalized as part of an actual activity. Instead, it embodies an anguished stream of consciousness. So, *States of Mind* is at once more instinctively concrete and particular than any comparable Cubist work, but also more disparate and fantastic as an ensemble. Boccioni charges his art with metaphors that require us to view his scene as a montage of emotions and to judge images as visualizations of the inner stimuli and responses that comprise his true subject. He combines various levels of reality not in order to compare change with stability, as if this were a problem of rearranging formal emphases, but to surprise us with the shivers kindled by what might be our own rapid and multiple, physical and spiritual, jolts at departure.

It was necessary, then, that his forms comport themselves all the more clearly in order to bear their essentially ambiguous load. For example, the mass of contorted figures in *The Farewells* is colored green not only to provide the complementary contrast to the red cinders wind-whipped from the engine, but to double-function as foliage for the train to plunge into and pass by. Or, as another instance, in the personage of *Those Who Stay* (Fig. 68), Boccioni very plainly describes the back-belt buttoning and cutaway shirt collar as existing on the same plane, thus suggesting a psychological tug that for the Cubists, on the contrary, would have ramified the volumes suggested by counterposed marks. In *Those Who Go,* the purpose of the force lines is clearly to peel away or streak over the features of the masks, but their literal meaning is not apparent. The Cubists had been united in the emphasis they gave to the dissection of appearances for the purpose of imposing a new structural order on painting. Boccioni's Futurism, by contrast, is perfectly explicit where it deals with volumes, lights, and masses, but its visual structure serves above all to heighten the emotional stresses of its subject. Think merely of the spaces in the triptych to apprehend that they juxtapose depth illusion and flatness as emotive realms that coexist simultaneously in the memory rather than behave like the deliberately evasive modulations of Cubism.

The enigma of *States of Mind* represents a new phase of Futurism, achieved only after much trial and error. In *Memories of a Night* (Fig. 59) Russolo's miscellaneous and illustrative treatment of a mental state suffers

because it is literally additive in its approach to its material. A more formidable precedent is Boccioni's own *Mourning* of 1910, animated by a rhythmic dishevelment of grief. The heads of the women mourners, their wrinkles and hair electrified by the intensity of their emotion, seem almost to wander off from their bodies in despair. This work foreshadows Boccioni's interest in grotesque physiognomy, which resulted in a number of drawings and some sculpture of faces distorted by fanciful interactions with the environment. It presages as well the dissociated heads in *Those Who Go*. The artist sees an analogous stress in the experience of grief and travel, especially in their collective traces which may be summarized by the "state of mind" concept. In the almost two years which separate these paintings, however, he had learned how a form "would resolve itself were it to follow the tendencies of its forces." These tendencies conflict and intermingle with more solid masses so that the artist must weave skeins of ever-more-complex impulses, inducing and precipitating unseen trajectories, the more to correspond with the vagrant tracks of movement's infinite disturbance.

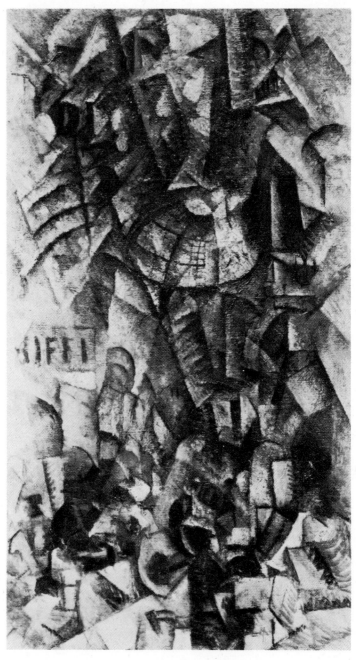

70 / CARRÀ: *The Galleria in Milan*, 1912. Oil on canvas,
35⅞" x 20¼". Gianni Mattioli, Milan.

11 / THE FUTURIST CONTRIBUTIONS OF BALLA

One need not deny the success of Boccioni's *States of Mind* to demonstrate how thoroughly it is embroiled in contradictions. We have, on one hand, an expressively climactic work, based on polarities of what are best called force patterns, accentuating opposing levels of being. Yet its context is of ongoing time, which specifically conditions events but does not isolate, define, or locate them. To put it another way, the work is rife with a certain Romanticism, all its energies visibly constricting to express the pitch of a unique, intense experience, while those energies seem fluid, archetypal, and reminiscent of a Symbolist eternity. Additionally, the work freely combines a system of schematic writing, derived from Cubism with the spatial and narrative apparatus requisite for portraying a scene. The succeeding works of Boccioni showed how precarious was this fusion of opposing motifs, and how it exasperated him to focus now on one, now on the other of their terms as he tried to resolve his elusive goals.

Carrà felt this pressure too but, under its weight, relapsed, if that is the word, into an animated, excellent Cubism, quite thoroughly enlisting the French formal vocabulary in the service of Futurist simultaneity (e.g., *The Galleria in Milan*, Fig. 70). The last few canvases Russolo was to paint before engaging in his prophetic noisemaker *(intonerumori)* experiments revealed him to be a bright, uncomplicated, and uninhibited patternmaking artist who reduced "the dynamic sensation" to concentric zones of radiating light, as, for example, in *The Solidity of Fog* (Fig. 71).

This luminous energy, which seems to terrace nonexistent planes, is symbolically animistic in a way reminiscent of Balla's earlier study of the effect of a street lamp (Fig. 54). Balla, who had not shown in Paris and who had no more been affected by Cubism than Russolo, developed a mature, personal style in 1912. It is perhaps strange to speak of an almost scientific objectivity as "personal," but in the context of Futurism detached study of one motif, without editorial comment or heroic inflection, must be considered idiosyncratic. This Roman artist had not yet shown any interest in the turmoil of human life induced by modern machines. Nor was he in conflict about the demands of memory and observation. Even further, the Futurist states of mind were still matters beyond his concern.

Rather, his Futurism consisted of presenting one fragmented episode in a continuum of motion. He concentrated on how a dachshund scurries, a violinist plays, and a girl runs. His curiosity about such things led him to articulate intelligible *units* of progression to convey these particular activities. Such units are so built up as to correspond to those lighted afterimages that sometimes seem to replace each other a trifle slowly in the brain as it processes the image on the retina.

His impulse, then, was to be acutely analytic, and for such a purpose the most appropriate formats were repeated, overlapping, and cyclical patterns of motor activity. To make them more readable, he employed a fresh understanding of Divisionism, embodied in palpable meshes, nets, and weaves. In addition, he abandoned the neutral-shaped color-dot as a vehicle for energizing his textures in favor of rather striated or minced units. It is a far more sensory approach than an intellectual or emotional one to the problem of portraying force lines, a convention of Futurism that Balla had not really accepted.

In a large polyptych representing Rome's Borghese Park, a very

71 / RUSSOLO: *The Solidity of Fog*, 1912. Oil on canvas,
39⅜″ x 25⅝″. Gianni Mattioli, Milan.

72 / BALLA: *Borghese Park* (detail), 1910. Oil on canvas,
overall dimensions 76⅜″ x 152⅜″.
The Galleria Nazionale d'Arte Moderna, Rome.

un-Futuristic work of 1910 (Fig. 72), he imagined light to have crystallized
incessantly into myriad rings of color, as if he could actually draw the radiation
of molecules in the sky. The dot-dash of the *Dog on a Leash* (Fig. 73) provides
a quite differently liberated example of this code in action. The ground
virtually seems to flow through the frantic, skittering footwork of the animal
and the couple tethered together by a chain whose rotary movement mimes
the arcs of their own, more comic locomotion. The wit of the painting consists
in the resemblance between the gait of the mistress and that of her toylike
dog, and also in the extravagant propulsion of their stroll. The extreme finesse
of the design contrasts with the naïve many-footedness of Balla's images.
There exists a contemporary photograph by the Futurist photographer A. G.

Bragaglia of Balla posing before this canvas. The fact that he deliberately moved during the long exposure serves as a charming document of his expressive aims.

Indeed, it is not surprising that experimental chronophotography played an influential role in the development of such art. The French photographer Marey, very evidently known to the Italians, had already employed terms reminiscent of Futurist aesthetics in titling some of his studies: "Trajectory of a flying apparatus describing a sinuous curve in the air," "Alternating images for multiplying the number of positions," etc.

Possibly in the spirit of Marey but with altogether more lyricism, Balla offered the complex, quivering gestures of the musician's left hand,

73 / BALLA: *Dog on a Leash,* 1912. Oil on canvas, 35⅜" x 43¼".
George F. Goodyear and
the Buffalo Fine Arts Academy.

74 / BALLA: *Rhythm of a Violinist,* 1912. Oil on canvas, 20⅝″ x 29⅝″. Mr. and Mrs. Eric Estorick, London.

plucking and pressing his strings, in the quasi fan-shaped *Rhythm of a Violinist* (Fig. 74). It is almost as if the viewer himself holds the bow, visible in the lower part of the composition. Here the artist no longer contents himself with ruffling the contours of figures or reiterating their appendages to simulate activity. He is concerned less with things than with the sensations given by things—sensations vibrating, no doubt, like the evanescent, dissolving pizzicati of the violin itself. In lieu of the decorative schematisms of the *Dog on a Leash,* which implied at least the stability of blue-black masses relieved against the cream-colored ground, a polychrome, unbounded mass is formed out of the movement itself. Moreover, Balla no longer conceives additively by simply placing the outlines of objects marching in advance of one another.

His restrained filaments—ocher, dark green, pink—are each expressive of contour and action simultaneously. They seem to etch into time. For in this picture, Balla's imaginative re-creation of violin playing seems to pack more variegated incident within the same few seconds than in *Dog on a Leash*. The intervals between the successive "stops" appear longer, but the syncopated rhythms in space are far more flexible and porous, as, for example, in the ingenious handling of the opening and closing of the fist. Consider, too, how Balla propels a gathering force upward and out from the narrow base of the frame so that the delicate scything through location reaches a crescendo at the pronglike finger farthest to the left. Because it is the point of clearest definition, we are also meant to experience this passage as the most recent occurrence in time. This correspondence of metaphors is dazzling in its conviction.

Balla could have consolidated his gains and executed a number of works in the manner of this adroit and refined dynamicism. Instead, he threw himself—if that verb applies to one so cautious, studious, and self-critical—into the dissonant, color-popping pyrotechnics of the friezelike *Girl Running on a Balcony* (Fig. 75). Though it obviously sacrifices the more detailed passages of *Rhythm of a Violinist,* it is, however, very much in the line with his then current studies of how light dematerializes bodies in action. The relatively large, flat green, orange, red, but primarily blue blocks that palpitate over the surface appear as a coarse, loosely set mosaic. And their movement first comes almost exclusively from their sensory "on and off" interaction of hue and value. But shortly afterward, we pick up the insinuated, repeated fragments of heads, legs, railing, even whirling skirts, that signal the rightward, light-dazed rush of the girl (though they have nothing evidently to do with the mosaic itself). So obtrusive are the pulsations of his color blocks that they absorb his analyses of the positions of the girl's sprint, which regains meaning only by virtue of Balla's new vision of space.

Everything in this scene occurs simultaneously; there are no distinctions between past and present—between the beginning and the end of an action. Yet the entire field of sight is occupied with the career of an activity that must have taken several seconds to complete. The result is a generalized space, neither illusively deep nor palpably flat, lacking planes yet avoiding openness. Balla planned with characteristically thorough efficiency on fusing the figure and ground into one optically percussive fabric. It may not be accidental that the emotional effect of *Girl Running on a Balcony* verges on the

75 / BALLA: *Girl Running on a Balcony,* 1912. Oil on canvas, 49⅛″ x 49⅛″.
The Civica Galleria d'Arte Moderna,
Raccolta C. Grassi, Milan.

euphoric. The gay sputtering off of its patches seems to complement our own earthbound and densely laden movements by fizzing through time and light.

Taken together, these three remarkable paintings can be viewed as a primer of Futurist theory on the movement through time as well as space, strained through a very dispassionate intelligence. That they answer more to Balla's interpretation of that theory than to the exigencies of his emotion keeps them, though, from being a record of his personal stylistic development. Balla proceeds from depicting movement as a vibration along the contours of images to a concept of movement as a vibration of the entire painting. He rethinks the issue of color, from seeing it as a local quality of hue inherent in single motifs to a participation of most of the separate hues of the spectrum in any one passage. In other words, these works mark a voyage from the particular to the abstract, in which the longer a motion appears spun out in time, the more integrated is the pictorial language required to render it. The means are extremely lucid and clear-cut. If his progress is thought of in musical terms, the change registered is from monophonic to polyphonic, canonic to fugal, without the sudden shifts in key, the tonal thickening and texturing of the other Futurists. Additionally, if Balla starts out from a far more detached and circumscribed approach to the mechanics of organic movement than the Milanese, his series concludes by accepting what almost amounts to an ecstatic mood. By and large, this was accomplished by that indivisibility of statement in which part can no longer be separated from the pictorial whole. For Balla's art ignited at the question of what structure various motions may finally have in common with each other rather than in what ways they differ from the viewpoint of dramatic expressiveness.

During 1912 and 1913, the Futurists were often accused of being both photographic and literary—each term seemingly implying the other. Against such criticism, the Milanese, in particular, took active measures. Their indignation was aroused by the suggestion that stroboscopic photography, as a technical achievement, superseded their vision. They leveled against photography the stigma of materialism, belittling its numb recording of fact, even fact that the eye was too distracted or the brain too slow to perceive. (X rays, on the other hand, elicited great approval precisely because they penetrated matter, made light of it.)

But in many technical respects the Futurists had learned much

from photographic phenomena. In Boccioni's *Materia*, 1912, the heavily distorted, outward looming, locked hands of the figure correspond to the way a wide-angle lens would exaggerate the foreshortening of certain protrusions. Indeed, Carrà and Boccioni were extremely sensitive to those quizzical stoppages, capricious superimpositions, and unreal, equivocal tones with which photography, cinematic or still, is invested.

Though Balla also was indebted to photography, for example, in his sense of cropping or his slanted and sudden vantages, he chiefly rationalized its potential for analyzing motion. Where his friends tended to accept the accidents of uncorrected vision (within their otherwise very willful compositional themes), he wanted to prune optical data of all inconsistency. For the other Futurists it is always implied that the spectator and subject are in simultaneous action. For Balla, the spectator is stationary. But his reductions offer such fresh patterns of interlace and fusion that through them he was able to construct a harmony that transcended appearances altogether.

That is the import of a large series of *Irridescent Interpenetrations* he realized in 1912 (Fig. 76), the first totally abstract works of the Futurist movement. This series of paintings seems symbolic, musical, and decorative in almost equal measure. Their spindly, thin-pointed wedges with their constant interfaces appear to dilate and constrict themselves on a geometric basis, imbuing their pale color with a prismatic salience. They were unique in Futurism in their uniform and flat surfaces and their linear, closed design. While they were hardly static, Balla had discovered a principle of equilibrium in these aerial, yet strangely taut, stalactites of light. Once again he could have pursued this new train of thought into those momentous issues of abstraction characteristic of much twentieth-century art. But he drew back—as did Delaunay and Severini in 1914 at a comparable point—happy enough, perhaps, to gain a heightened clarity but reluctant to part ways with the tangible velocities with which displacements occurred in the real world.

The immediately succeeding work of Balla, though no less fruitful, is more orthodox from a Futurist point of view. *The Swifts: Paths of Movement + Dynamic Sequences* of 1913 (Fig. 77), one of the loveliest and most graceful paintings of the era, is like an oscilloscope record of wave motions superimposed upon the repeated, fluttering wing beats of the birds, whose imperceptible gyrations become floating funnels of movement. (It takes a moment to discover that Balla has confined himself exclusively to plan views

76 / BALLA: *Irridescent Interpenetration No. 1*, 1912.
Oil on canvas, 39⅜" x 23⅝".
Lydia and Harry Lewis Winston (Mrs. Barnett Malbin),
Birmingham, Michigan.

77 / BALLA: *The Swifts: Paths of Movement + Dynamic Sequences*, 1913.
Oil on canvas, 38½" x 47½".
The Museum of Modern Art, New York.

of the birds.) Our eyes seem to operate as tracking stations of the incessant flapping activity, until, at mid-point, the direction of flight seems to reverse itself and flow back to the left, while the crossover volumes and sudden dips of the total whirl skitter away from impending tangents. So fluid are these patterns that we take them in before realizing how triangled is the grouping of forces behind the arabesques and how discreet are the multiple pressures they exert against the straight edges of the frame. So orchestrated are its transparencies, so complexly harmonious are its pinks, umbers, blacks, and whites that his work of the previous year looks *a cappella* by contrast.

In his subsequent studies of high-speed dynamics—those occupied with the "ballistics" of an automobile—the paintings gain structure through the overt conflict of triangular and spiral forms, where the vehicle itself resembles a projectile opening multiple arrowheaded swaths and trailing wheel-like eddies in the resistant air.

12 / THE SYNTHESES OF SEVERINI

If Balla was the furthest removed from Cubism, Severini was the Futurist artist most closely associated with it. As an important participant in the avant-garde of Paris, Severini did more than keep open his lines of communication with his Italian brethren. The job of judging and assimilating the compatible elements of the two movements without compromise to a distinctive personality fell to his capable brush. And because his work evinced great sympathy with Cubism in its ironic tone, its acknowledgment of artifice, and the ambiguous clarities of its craft and form, its Futurist allegiances stand out the more by contrast.

Soffici, a critical liaison between the French and the Italian scenes, wrote in 1913 that his confreres were drawn to Cubism by the "sober consistency of the bodies and objects, the weight, the gravitation of the masses, the balance of the planes and volumes," virtues that, he asserted, were traditionally Italian. And even Boccioni was half-inclined to appropriate Picasso into

such tradition because that artist's mother was of Genoese extraction! We can see that nationalistic stereotypes and farfetched ethnocentrism had more to do with such remarks than a just appraisal of conceptual affinities. The Italians could imply that the Cubists fundamentally shared with the Futurists a response to the common Mediterranean heritage that the Futurists themselves were supposed to have disavowed. Yet one can hardly gain credit by attacking one's opponents on the basis of their resemblance to oneself.

In fact, the Futurists had precedence in their concern with the dynamic motion of forms and considerable independence from the Cubists in their concepts of dissolution and dismemberment of objects. In France these were factored through the demands of the open grid, and in Italy deduced from the catching of perception on the wing. Then, too, the Futurists had a unique understanding of "simultaneity." The Puteaux Cubists identified this term with successive visual juxtapositions, corresponding to our motor and tactile responses to objects. More extensively for the Italians, the word meant, as Joshua Taylor suggests, "the co-existence and indivisibility of the inner and outer, the interpenetration of solid and void, sound and sight, memory and perception." Cubist geometries provided various syntactic supports for Futurist commitments and unquestionably gave them terrific aesthetic sanction, but the aims of the two groups led to quite divergent results.

For an intimate understanding of these crosscurrents, let us compare Severini's *Portrait of Mme. M. S.* of 1912 (Fig. 78) with the later Juan Gris *Self-Portrait* (Fig. 79) of 1916. These two paintings offer startling parallels in their naturalistic treatment of the eye, whose calm, fixed stare is isolated amidst seemingly chaotic, abstract forms, where it is riveted with a beleaguered humanity. Both artists have excised their diagrammatic pictorial codes when painting this highly expressive feature. The eye, organ of visual perception, becomes the still point about which shuffle and revolve the scallops, angles, and scrolls of bodily displacement. It is as if each artist had dealt us a hand of mixed cards whose royal cutouts we scrutinize to discover a possible suit. As we sort the relatedness of the forms, we reassemble, now slowly, now more quickly, the scrambled aspects of one human figure. It is an innately Cubist experience.

Gris invokes this experience on three levels. The brown-red, yellow, and green sections that slice through the face work against the integrity of the head shape, though they form a brilliant harmony with the black

78 / SEVERINI: *Portrait of Mme. M. S.*, 1912. Oil on canvas, 36¼″ x 25½″.
Sam and Ayala Zacks, Toronto.

hair, lavender shoulders, and ocher wainscotting surrounding it. Meanwhile, the flat, wood-grained hair and the "metallic' shading of the chin area and left eye cavity violently contradict the glisten of the open pupil on the right. Finally, Gris sets up a slipping "y" structure in the relationship of the bust to the head and neck, in which every slope to the left is recovered and compensated to the right and vice versa, so that there is an assured center of gravity from which everything hangs, like a delicately poised counterweight.

Severini, on the contrary, obscures the gravitational main point— or rather, establishes many, located at the meetings of diagonal lines that act like sweeping second hands whose outside arcs describe multiple centrifugal currents. Crucial details—ringlets of hair, open fingers with a cigarette— garnish the various intersected pivots and huddle within or dangle down from them. In the Gris, a coherent process of staggering organizes all the tipped zones into a pattern of regained stability. The Severini, on the other hand, never allows this stability to take shape, with the result that clothing and coiffure seem to loom and withdraw unexplainably. One has no sense of a reconstituted body at all, as in the Gris, but rather, of contradictory, congealed, fragmented memories of a body's various active and nervous positions. Memory contributes to the view of the Gris, too—memory that compares the different locations of anatomy. But in the Severini, there is nothing firmly enough established in the present to relate to a remembered past, nothing normal to measure against the abnormal. One has to accept flux itself as the norm. The visual effect of Severini's portrait is initially much more confusing than the Spanish painter's, but nevertheless a certain logic of double exposure and retinal persistence makes it credible in the mind.

And the artist underlines this logic by his simple color scheme of ocher, blue, creams, and pinks, which provide a tight decorative framework. He introduces a kind of visual rhyme that makes the most disparate features —the flounces of a blouse, tresses of hair, the palm of a hand, the flower of a hat, the ears of a dog—seem compounded of the same repertory of starched and cupped forms. Only the sequined brooch, floating free in the center, is alien to the sharp discipline, if not the droll spirit, of the painting.

Floridly patterned sequins, painted maroon and gray-green, deep mauve and light scarlet, scintillate in the ambitious *Dynamic Hieroglyphic of the Bal Tabarin* (Fig. 80), Severini's Futurist version of the dance scenes of Lautrec and Seurat. Influenced by a discussion with Apollinaire about the

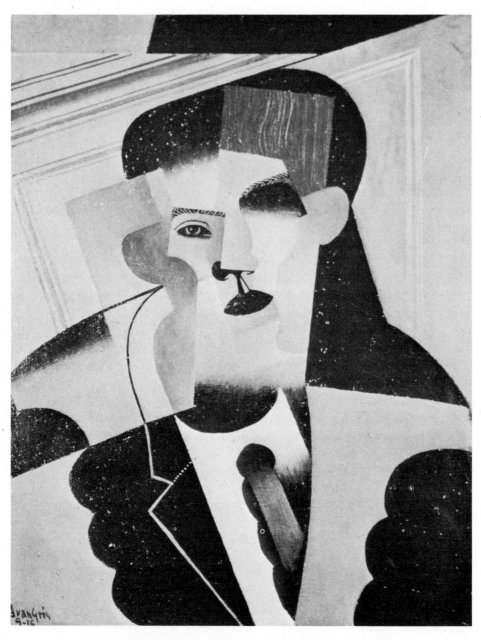

79 / GRIS: *Self-Portrait,* 1916. Oil on canvas, 24⅞″ x 19⅛″.
Joseph Pulitzer, Jr., Saint Louis.

embossing and accretion of real objects in Italian fourteenth-century painting, the artist here accommodates a literal glitter to his pictorial dazzlement. Like the various words ("bowling" and "polka") that are scattered among the kicked heels and laughter of the dance, the sequins are simultaneously scraps that actually could have existed in the cabaret and elements that affirm the surface as against depicted depth. Indeed, the whole tableau oscillates between abstraction and figuration far more radically than we have yet seen in his work. It is impossible to look at any shard or ribbon of color, in its seeming free fall, without recognizing it as pictographic shorthand of a thing seen as well as a rhythmic foil abutting or eliding with countless others. Hence the word "hieroglyphic" in the title. Because everything is seen through the mad gaiety of tossing maroon petticoats, this is also a "dynamic hieroglyphic."

Severini synthesizes (it was a word found frequently in his writings of the period) the energies of the Bal Tabarin on two connected levels. One of his procedures is montage, whose more ingenuous appearance we have already seen in Russolo's *Memories of a Night*. Only one year later, however, Severini understood that the act of making a plausible composite from superimposed and juxtaposed elements required a system of analogues with a spatio-temporal conviction of their own. For instance, it is vital to read the location of objects figuratively and not literally. We associate Severini's images much more readily with each other than we do Russolo's, if only because the dance-hall scene is a fantasy of perception, not capricious memory (though Severini executed it far away from Paris, in a small Italian town). Still, the details of the Bal Tabarin have no definite location from a representational point of view. For expressive reasons, these specifics are impromptu settlements of motifs that can have no one final place on the surface. Yet, as soon as this is *comprehended,* we discern their structural necessity: the rationale of the larger foreground presences—the two (or is it just the one dancer in two places?), contrasted with the wee background figures and flags at that triangular apex that has all the while been shrewdly prepared at the climactic top of the canvas.

All this is tactically Cubist but strategically Futurist. A Cubist might have conceived the general ensemble, but not the Rococo windiness of its feeling nor the daring leaps of its associations. A Cubist might break up and stagger verbal inscriptions, but would not suggest this as an aural entanglement of a setting. No Cubist would have construed the noise of bowling

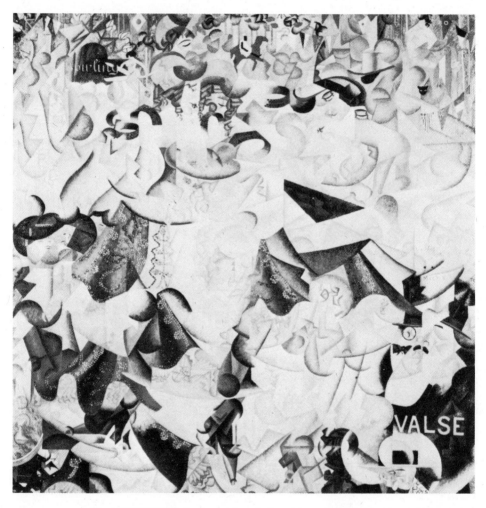

80 / SEVERINI: *Dynamic Hieroglyphic of the Bal Tabarin*, 1912. Oil on canvas, 63⅜″ x 61½″.
The Museum of Modern Art, New York,
acquired through the Lillie P. Bliss Bequest.

to be swallowed up in the cacophonous blare of a combined polka and waltz. Severini may have taken his stylized curlicues and ruffles from advanced work in the Parisian milieu, but he did not learn there how to turn them loose over pale-blue and white vacancies, with their rondures modeled by conflicting light sources. Léger's *Nudes in the Forest* (Fig. 32) and Picabia's *Procession in Seville,* both estimable pictures, are ponderous and monolithic by comparison. And even Boccioni's much-revised *The Laugh* (Fig. 81), an earlier painting on a rather similar theme, seems overly forced in contrast. In this work, with its sour red and green disharmonies, rotund echoes of an uncontrolled hilarity are tightened in by means of systematic grids and planes. But the effect is contrived and at cross-purposes, evoking a lugubrious glamour far removed from the synthetic ease and levity of the Severini. The assurance of this

81 / BOCCIONI: *The Laugh,* 1911. Oil on canvas, 43⅜" x 57¼".
The Museum of Modern Art, New York,
gift of Herbert and Nanette Rothschild.

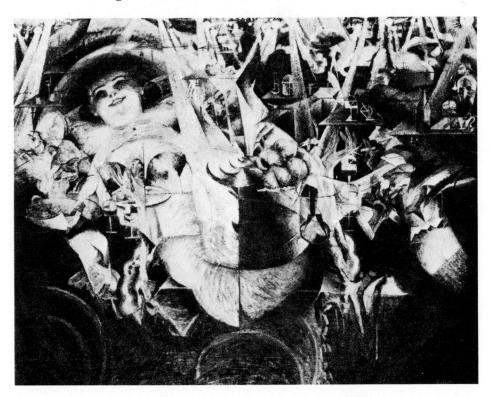

Parisian Futurist was a little whimsical. He could show a tiny nude riding an open scissors. It is an erotic touch insouciantly associated with the resemblance of the tableau to a stiff paper roll uncoiling and cascading down while bunching as if after every wicked snip.

For Severini, the remembrance of matter in conflict with the experience of movement suggested the character of a pictorial mass. Henceforth, he concerned himself with a relentless transposition of terms, justifying the process rather vaguely as a universal propensity of the human mind. In an unpublished manifesto of 1913, he wrote:

> We wish to enclose the universe in the work of art. Objects no longer exist. One must forget the exterior reality and the knowledge we have of it in order to *create new dimensions* which our sensibilities will organize into a system. . . . We shall in this way express plastic emotions which are not only relative to an emotional environment but which are linked to the universe, because matter, considered in its action, encloses it in a vast circle of analogies that begin with the infinities or resemblances and end with the contraries or specific differences . . . only the memory of an emotion remains and not the memory of a cause which produced it. Memory will act, therefore, in the work of art as an *element of plastic intensification* and even as the true cause of emotion, which is independent of any unity of time and place. . . . The spiral forms and the beautiful contrasts of blue and yellow . . . which were discovered one evening, while living the action of the ballerina, may be reperceived *later . . . in the concentric flights of an airplane or in the fleeting vision of an express train driven at full speed.*

Needless to say, the realization of such sentiments imposed a difficult task on static painting. For they not only violate unities of time and place, they imply a totally gratuitous and random act of association. It was too strenuous a concept for representation, yet too dependent on observation to serve as a coherent prop for an abstract art. Still, it was characteristic of the Futurists, in their zeal to achieve ends before they had settled the question of the proper pictorial means, to have conceived for painting a hyper-textured, multi-layered symbolism, and to have prophesied a kind of cinematic montage more than a decade before it was achieved cinematically by Sergei Eisenstein.

Of course, the main difficulty of Severini's or, for that matter, Carrà's goals (in the latter's manifesto of sound, noise, and odor painting) was the hammering out of suitable conventions with which to suggest them.

Marinetti's poetry, for example, extending the device of onomatopoeia, encouraged the reader orthographically to pronounce words as if they were cries or shrieks (e.g. "Mon Amiiiii"). "Our lyrical exaltation," he wrote, " . . . must freely deform, remould, cut, lengthen and reinforce the center or the extremities of words; it must be free, also, to increase or diminish the number of vowels or consonants. . . . It is of little importance that the deformed word becomes equivocal. It will wed itself to the onomatopoeic harmonies or the summaries of sounds, and we will thus quickly attain . . . the sonorous, but abstract, expression of an emotion or a pure thought." It was Marinetti's ambition that poetry should aspire to the visual discourse of painting (in its orthography and placement on the page), foregoing verbal communication if need be, and that painting should assimilate the syntactic liberation of Futurist poetry. Quite obviously the success of this compound enterprise would depend on the credibility and intelligibility of the artistic signs employed. It is an indication of the stress put on these signs that they were required to be self-standingly pure and yet loaded with widely varying, and even conflicting, information drawn from the outer world.

The only way to expand the capacities of the medium was, then, to do violence to it, even if this was to introduce unnatural expressive burdens, to hobble "grammatical" structure, and to provoke continual misdirections and misreadings. Where the Cubists, by 1912, had come to realize that they had prompted too many contradictions within the buttresswork of their façades, the Futurists, at the same time, charged their work with ever greater blends of unsorted signals. The exfoliating collage corresponded to no theory of appearances or states of mind, for the collage mode was a kind of promiscuous "carrying on," accountable only, but crucially, to their sense of formal rightness. To the Futurists, though, each admixture of new materials theoretically affirmed a particular moment of perception but had *no inherent structural role.* The difference between ideal Futurist doctrine and its less-than-ideal practice can be seen in Severini's output of 1913 and in Balla's after 1914. For in both these artists generalized arabesques, while having no trouble in holding together the forces of the composition, lose their forensic way among the far-flung analogies of intended significance.

13 / BOCCIONI'S SCULPTURE

With the ultra-serious, self-demanding, agonistic Boccioni, however, events took a different course. He was the sort of obstacle-prone artist who had to wrestle into synthesis every wayward clash of a fertile brain with the prior habits of resourceful hands. Before examining the work that most absorbed him after the *States of Mind,* it is best to pause over the theory with which it was to be justified, the "Manifesto of Futurist Sculpture" (April, 1912), a landmark in the history of that medium.

Inspired by the backlog of innovation it had already accomplished in painting, Futurism wanted to wreak its will on sculpture. Braque's and Picasso's collages of 1912 probably hastened Boccioni's thinking on the problem as well. And once again, where the Cubists initiated in collage a kind of philosophical caprice which they then rechanneled into a newly clarified canon of pictorial and assembled forms, Boccioni saw sculpture itself as a necessarily limitless composite of heterogeneous matter, whose densities and

"forces" would attack the very notion of form—in the sense that form implied a discrete separation of sculptural object from environment (although he hardly realized any of these objectives in actual work).

In his manifesto he begins, then, by condemning the concept of the nude in sculpture—that is, "the construction of dummies"—because it has kept the plastic mode isolated from all those advances gained by painting in the study of the less tangible properties and influences of landscape and atmosphere. It was not that Boccioni had any prejudice against the figure as such, but rather against the refusal to treat the sculptural figure, with which the spectator most often identifies, as affected by its physical context. For precedent of the kind of expression he was considering, Boccioni remarks on the Italian turn-of-the-century sculptor, Medardo Rosso, whose indistinct and smudged high and low reliefs seem to be in constant metamorphosis because they resist being construed by the light as having definite volume, solidity, or shape (Fig. 84). But Rosso's virtues, to Boccioni, were mainly those of the Impressionist. Here was a sculpture of spontaneity, fugitive in the handling of masses, but restricted to the optical, and devoted too much to a self-contained world.

Futurism demanded, on the contrary, a "systematic" and "definitive" style of movement (a key phrase) that would imbue the work with a character of "universal creation." This was to be approached in concrete terms by a "translation into plaster, bronze, glass, wood, and any other material, of those atmospheric planes that link and intersect things . . . by making their extension in space palpable . . . since no one can any longer believe that an object ends where another begins." It therefore followed that the sculptural block must contain within itself elements of the affected environment, which reciprocally receives from the interior of the work extended intimations of the piece's own structure. Boccioni proclaimed the abolition of definite lines and closed forms through a continual merging of the disparate identities and locations of things. Since, finally, these things could be classed as both ideally organic and mechanical, the new sculpture would be a composite where "the opening and closing of a valve creates a rhythm just as beautiful . . . [as] the blinking of an animal eyelid."

The force of these principles, many of them already familiar from earlier manifestoes, consists in the application of Futurist dynamism to a downright static and tangible medium, regardless of its prior animistic con-

ventions. This document forecast not only techniques independent of traditional carving or modeling and the release of its appendages from the tyrannical monolith, but the advent of light and kinetic sculpture as well. (Balla's stage setting of 1917 for Stravinsky's *Feux d'artifice* ["Fireworks"] was, however, the only visual Futurist work to have utilized literal movement and light.)

Just as important was Boccioni's very early critique of vitalist thinking. The latter implied a belief that the three-dimensional, inert mass could be imagined brimming with heroic life. Now this had to be amended to include the presence of a mechanical input within sculptural creation. On one hand, he intensified the metaphor of incipient animal growth in sculpture, a vision he called "physical transcendentalism," while on the other, he conceived of a passive reversion to the thingness and numbness of brute or fabricated material. Vitalism highlighted the personifying idea that, in essence, the created body was imprisoned in the inchoate block, waiting to be hacked out and thus liberated by the sculptor. In contrast to this Renaissance notion, Boccioni's was an intrinsically twentieth-century regard for geometrics and occlusions in the repeated or standardized formation inspired by modern industrialism. Boccioni eventually imposed a new architectural metaphor upon an organic one. To reconcile the interplay of sculptural core and periphery within the symbiosis of "living" and machined shapes was the task to which he now addressed himself in actual sculpture.

Characteristically, he seems to have attacked the almost insoluble problems first—that is, the challenge of such composite imagery that might illustrate, as he put it, "how your lamp spins a web of plaster rays between one house and another." It was already an indication of difficulties encountered by the Futurists in this context of metaphor that their titles underlined accretion rather than synthesis—as for example in Severini's *Dancer = Sea + Vase of Flowers* or Boccioni's own sculpture, *Head + House + Light* (Fig. 82). Compounded of iron, wood, plaster, and glass, this lost work, loosely based on his painting *Materia,* seems to have drawn brickbats magnetically to its fancifully fluted "armor."

Another piece created around this time might, however, at first appear to be a retrenchment from the theories of the sculpture manifesto. The bronze *Development of a Bottle in Space* (Fig. 83) is composed of a single traditional sculptural medium and is also a still-life subject with many closed

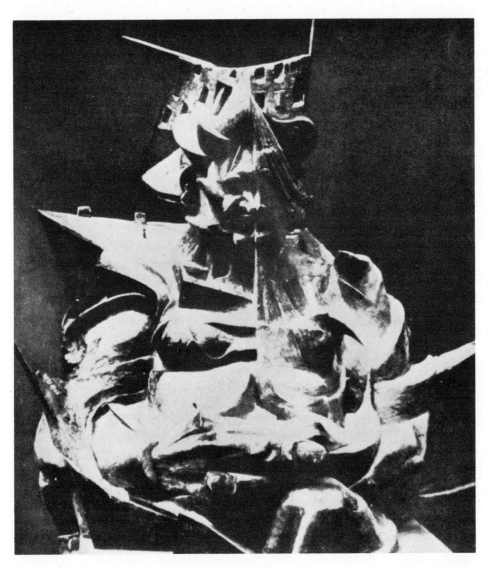

82 / BOCCIONI: *Head + House + Light*, 1912. Various materials, Destroyed.

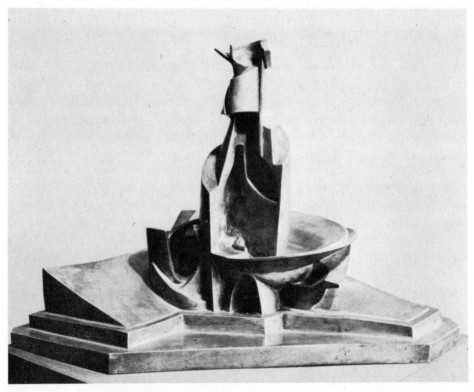

83 / BOCCIONI: *Development of a Bottle in Space,* 1912. Silvered bronze,
15″ x 12⅞″ x 23¾″.
The Museum of Modern Art, New York,
Artistide Maillol Fund.

and clear contours that do not express that transcendental energy championed
by Boccioni in doctrine. It consists of a 15-inch-high cylindrical bottle form
that has been sliced vertically down the "shoulder" to reveal elliptical cham-
bers within. All this, in turn, has a two-tiered base, the first being a "dish"
cantilevered to swing out in a wider arc around the bottle and, beneath it, the
second, a double-stepped, upended parapet, forming strong horizontal wing
plinths in anchoring support of the vertical cylinder. But in an important
sense, it is a mistake to view this composition as fundamentally right-angle.

For Boccioni has seen to it that vertical axiality works only to orient a helical, counterclockwise movement that spins arabesques into the cavity of the bottle while also developing them "sympathetically" just beyond it. These rotations seem to dissolve cleavages between external and internal substance, for the whole sequence is just as much an extension as it is a cutaway of the basic solid form. Though his contours are absolutely precise, Boccioni's invention "disestablishes" their correspondence to real contours.

A glance at Rosso's *Conversation in a Garden* (Fig. 84) shows that Boccioni obviously preferred a kind of mental tremulousness to an optical one. But for all that, he was sensitive to the entrapment of, and stereometric molding by, light as a dramatic agent with which to reveal form. (We might also conclude that Boccioni's is a draftsmanly sculpture, too, for it was very

84 / ROSSO: *Conversation in a Garden,* 1893. Wax over plaster, 17″ high. Gianni Mattioli, Milan.

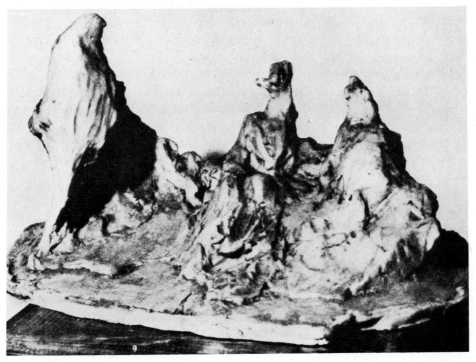

possible for him to have arrived at his plan through drawing, as, in fact, a related study indicates—an approach Rosso would never have taken.) Just the same, Boccioni's sculpture is faintly reminiscent of Rosso's theme of a single, dominant hooded figure. Indeed, though a nominal still life, this bottle rises up to command its space very much as a figure would.

A cylinder has neither a front nor back, and although there are several intriguing points from which to view it, the bottle very definitely confronts us at the maximum intersection of its curves. And it is precisely here, too, that one realizes the sculpture to be essentially architectural, if only because the words needed to describe the work in detail—platforms, entrances, balconies, plan, elevation—also refer to an edifice. How rich is the ambiguity of a piece that has the scale of a still life but the bearing of a figure and the features of a building.

It is illuminating to compare such a formulation of a sculptural statement with Picasso's painted bronze of 1914, *Glass of Absinthe* (Fig. 85). Despite the convoluted peelings off its cone, the *Glass* is an outright still life, with both a literal element (the real spoon) and an ostentatious pictorial motif (the painted spots) coexisting within the object's actual scale. Picasso could accommodate these disjunctions in the enjoyable spirit of a game, offering their differing levels of reality, their reciprocal subversions, as an index of his re-creative process. Such an attitude would be inconceivable to Boccioni. For him, the discord of heterogeneous materials in sculpture remains discord unless he succeeds in convincing the viewer that they function other than as finite objects in a world that strangely denies tangibility itself, if not the properties of tangible things. Thus, the *development* of a bottle—the stress on what the object is becoming as opposed to the perception of the decisions involved in its contrivance. Boccioni's work was meant to be a demonstration not of the acute intellectual distinctions with which a work could be put together, but of the absorption and dissolution of material distinctions into a universal continuity.

The thrust with which Boccioni wanted to invoke this sense of flow is represented by his *Unique Forms of Continuity in Space* of 1913 (Fig. 86). Culminating the extensive researches of two now-lost plaster studies on the same theme, the broad chest, trunk, and thighs of this slightly more than half-life-size figure seem to churn space even as they aerodynamically stride through it. The Futurist scholar Marianne Martin writes of this work as being

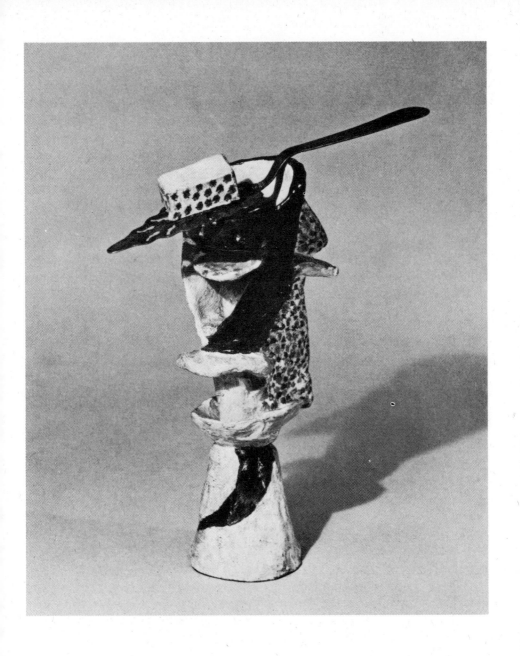

85 / PICASSO: *Glass of Absinthe,* 1914. Painted bronze with silver spoon,
8½" x 6½".
The Museum of Modern Art, New York,
gift of Mrs. Bertram Smith.

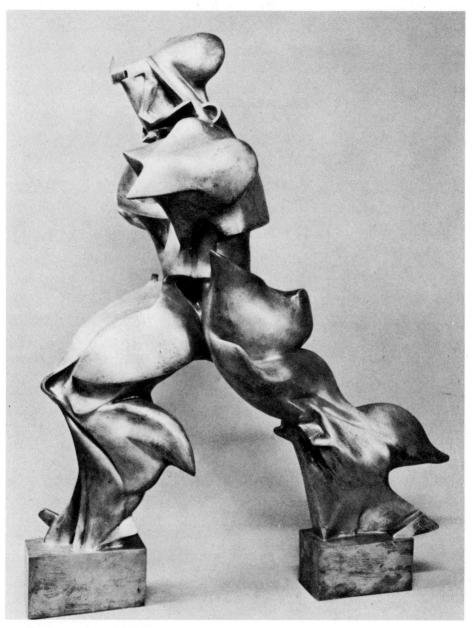

86 / BOCCIONI: *Unique Forms of Continuity in Space*, 1913. Bronze, 43⅞" x 34⅞" x 15¾".
The Museum of Modern Art, New York, acquired through the Lillie P. Bliss Fund.

a "new savage who was not to conflict with nature, but be in total harmony with its forces . . . perhaps the most exalted statement of the cathartic and resuscitative aims of Futurism, which demanded not only a new world with new values, but a new man as well." The incontrovertible power and grace of its effect does, indeed, convey an exhilaration that appears to reflect something of the artist's self-image as well. As to why his response to the technological demiurge should be embodied in an image at once so emotionally aggressive and yet ambiguous in the identity of its parts we already know from Boccioni's earlier career. There is summed up for us a glamorous vision of supple, masculine, pitiless brutality, bulging with animal energy yet at many extremities fined into flesh-piercing metal points, fins, and blades. It is as if "anatomy" has been rippled and stretched into this formidable array of tips, not at all capriciously but in emulation of the various past and present fluid patterns arising out of its action.

Boccioni's concept is naturally alien to the primitive or aboriginal. These would represent an anti-rationalism, to be sure, but one associated with *pre-logical,* non-Western societies. Rather, he imagines and identifies with a primitivism of a surmised, *post-logical future*—a return to instinct through the exhaustion of logic. Still, he does relate to one pre-industrial model, the Greek *Victory of Samothrace,* not only to challenge one of the monuments of classic tradition (specifically denigrated by Marinetti's "Foundation Manifesto"), but to insist, too, that with its head-on view like that of a ship's prow (Fig. 87), *his* is the victory figure of the twentieth century. And he envisages it as a kind of gladiator, the head protected by a sword hilt or visor and the left shoulder transfigured into a species of natural shield.

But there exists another level of symbolism in the work that lends it a prophetic concision as a discovery in sculptural form. While exhibiting the piece in Paris in 1913, Boccioni wrote a further statement of principle from which we read: "My spiral, architectonic construction . . . creates before the spectator a continuity of form-force released by the *real* form, a new, closed line, delineating the body in its material movements. The form-force, with its centrifugal direction, is the potentiality of the real form." One is struck by the cogency of the word "released" as a means of interpreting such matters as the inner pressures that seem to swell the figure's contours and the flanges that hook out from its mass. Effective in this light, too, is the strategy of insisting on the primal independence of the profile, back, and front vantages, yet

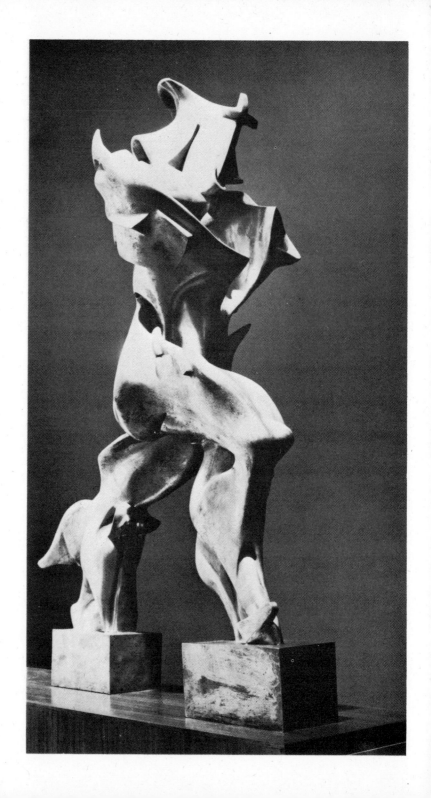

containing them all in a rhythmic design that makes them continuously suggestive of each other though still very surprising (Fig. 86). It may be that the main directions and proportions are all that remain of an original figure under the stress of innumerable "releases," or that the ensemble is a sequence of unspecified mutations that take on new meaning as potentialized movement because they kindle our own bodily empathies. In any event, Boccioni substituted for the provisional, individualized, and always organic intimation of movement in past sculpture, qualities of fixed, ruthless, mechanistic will, flaring up within a convincing metaphor of abstract growth that went far to put modern sculpture into orbit.

The difference between his progress along these paths in a three-dimensional mode and his comparable breakthroughs in painting is of extreme importance. Several contemporary drawings and a few strong canvases indicate that Boccioni was constantly analyzing ever more effective means to construct emblems of pumped, gyratory, and muscular input. In *Dynamism of a Cyclist* from 1913 (Fig. 88), the center of the field appears to buckle and bulk into various turned folds, which are slashed through with diagonal lines amid a froth of broken strokes. Whether high- or low-keyed in expressionist color, works like this have so far extruded the event sequence of a body in motion that only its hypothetical "form-forces" remain. To convey the lyrical excitement of such situations, the paint medium provided an ideal malleability. Its optical properties could be so exploited as to obtain a field of vanishing junctures and a space entirely free of the necessity of specific location. That such a possibility benefitted those Futurists interested in the pure or "absolute" vibrations of physical activity can be seen in Severini's painting of 1914, *The Spherical Expansion of Light* (Fig. 89). (Examples of comparable moments of abstraction in the works of Delaunay, Picabia, Léger, Kupka, Hartley, Marc, and Balla show that this was a pervasive tendency in advanced Western painting during the two years.)

As his pictorial work demonstrates, however, Boccioni could not forsake volume as a prime expressive ingredient of his notion of dynamism. And here the trouble with painting was that the porous suggestiveness and ephemeralness of its readings were no compensation for his urge to see real

87 / BOCCIONI: *Unique Forms of Continuity in Space* (another view), 1913.
Bronze, 43⅞" x 34⅞" x 15¾".
The Museum of Modern Art, New York,
acquired through the Lillie P. Bliss Fund.

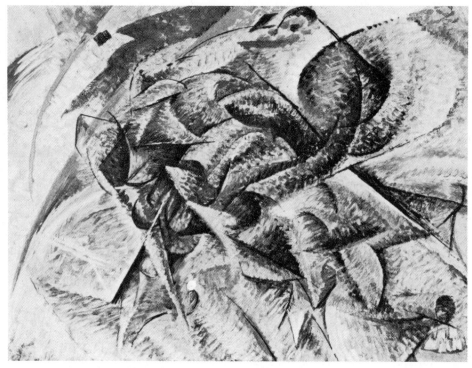

88 / BOCCIONI: *Dynamism of a Cyclist*, 1913. Oil on canvas, 27½" x 37⅜". Gianni Mattioli, Milan.

volumes taking foot in spectator space. There had been sculptural implications in Boccioni's painting for about three years, but they had invariably been shunted away in pictorial conventions that denied his work access to any physical encounter with the viewer. If the Futurists could reiterate time and again that they wanted to draw the viewer into the center of their pictures, it was because they had established new levels of credulity for painting, which, in a structural sense, was what their innovations were all about. But this figurative beckoning was ultimately a passive element within an artistic theory that wanted to engage the widest spectrum of sensory assault. Though sculpture had its own decorum—a more self-conscious and evident immobility than painting's—it occupied the same space as the viewer and could influence him

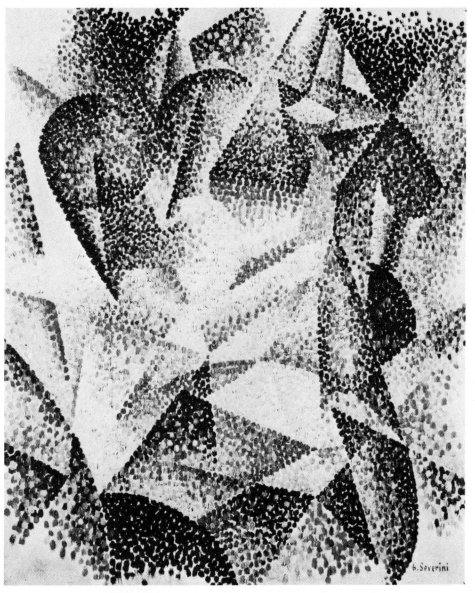

89 / SEVERINI: *Spherical Expansion of Light,* 1914. Oil on canvas,
24⅜" x 19⅝".
Dr. Riccardo Jucker, Milan.

unpredictably as a free-standing peer with its particular integrity, reach, and weight. In backing the spectator away, sculpture could take the emotional offensive. It had no transparency with which to superimpose forms or equipment that could allude to their interpenetration. The euphorically lightweight and fanciful complexities of painting were beyond it. Yet it could offer a distinctly more precise, tempered, and concrete parallel to them. And for Boccioni, at a moment when he was foreshortening all the pressures of his eventful career, the incitement to impose an actual transgression of the world rather than remaining within a virtual one had to be successfully met.

14 / PAINTINGS, SOUNDS, AND WORDS

It can be said, then, that before the war the Futurists made deliberate trouble for themselves as artists by their militant refusal to stabilize any advance as long as there were new risks to be taken. Without this disregard for aesthetic safety, their enthusiasm for armed conflict would have lacked moral substance. As that disaster impended, they welcomed it with riots, but, in visual art, most memorably with Carrà's "free-word" painting, *Patriotic Celebration* (Fig. 90), illustrated in the August 1, 1914, number of *Lacerba,* the Florentine periodical in which the Futurists published much of their doctrine.

 This work was expressly designed to exacerbate the volatile political climate of an Italy internally vacillating between the adversaries in a war known to be almost imminent. Given these conditions, the official attitude was one of thorough neutrality. Italian Socialist opinion, at first confused, gradually sensed that the national mood was against Germany and Austria but hesitated to take overt action because of a sympathy for the proletariat of those

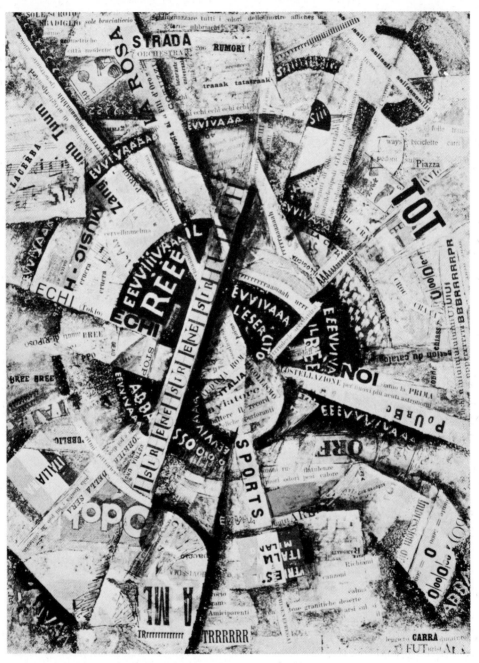

90 / CARRÀ: *Patriotic Celebration*, 1914. Collage on cartoon,
15½" x 11¾".
Gianni Mattioli, Milan.

countries. Having no such party alliances, the Futurists, led by Marinetti, beat the drum in favor of intervention on the side of the Allies. Carrà's picture, then, was a spark in a flammable atmosphere, for its celebration of war was an outright cry against his country's policies.

Though very small in scale, it is perhaps the most comprehensive and archetypal treatment of Futurist themes. It almost seems a living manifesto, a linguistic *summa* of the movement. As befits its outright political aims, it is posteresque in disposition. Its basic motif is a vortex, reminiscent of the prop wash or wing insignia of a British or French airplane, that seems to unwind centrifugally to spew forth incessant printed militancies in several languages. Technically, the work is a collage whose tempera-painted passages and pasted papers are intercalated so intimately that it is impossible to sort them out or even to assign them differing status—as, no doubt, Carrà intended. A centrifuge sifts and separates the binding elements of a compound. But here, concentric form, radiating spokes, and verbal expletives mutually ramify each other. A vivid attempt is made to equate the emotional associations of the colors—predominantly the red, white, and green of the Italian flag —with the way its whirring legends demand to be cried or shrieked. Even the staccato, painterly touches and atomized bursts of pigment show that the tactile and sonic impact of the work are reflexes of each other.

To achieve such a tour de force of complex allusion, more was needed than pictorial acumen. In fact, Carrà had available theoretical prescriptions from his own, Russolo's, and Marinetti's writings that went far to lay the groundwork for "free-word" painting. In his manifesto on "The Painting of Sounds, Noises and Smells" of 1913, Carrà already foretells the basis of a grand synesthesia: "sounds, noises, and smells are nothing other than different forms and intensities of vibrations; . . . We Futurist painters declare that sounds, noises, and smells can be incorporated into the expression of lines, volumes, and colors in the same way as lines, volumes, and colors can be incorporated into the architecture of a musical work. Our canvases will express, therefore . . . the plastic equivalents of the sounds . . . of the theatre, of the music hall, of the cinema, of the brothel, of the garage, etc."

Obviously the literary aspects of Futurism could be inserted into Carrà's theory of equivalents on a different, though related, level. Marinetti prided himself on his typographic and orthographic revolution, in which the color and styles of various scripts, combined with the rhythmic or shaped

distribution of words and phrases, enacted an expressive drama that was as much performed as read and, therefore, as temporal as it was spatial. *Onomatopoeia, as conceived in Futurist poetry, treated words to that same syllabic elongation, that same record of momentum, that Futurist painting conferred on forms.* "The infinitive," wrote Marinetti, "is round, and like a wheel it may be applied to all the cars of the analogical train: by making stops impossible it provides style with speed. Moods and tenses are triangular, square, or oval. The infinitive alone is circular." Marinetti was giving a visual-temporal symbolism to the combination, not of specific word meanings, but of grammatical forms—a startlingly original, if not a really demonstrable idea. On a more pragmatic level, Russolo, in his "The Art of Noises," stated that: "EVERY NOISE HAS A TONE, SOMETIMES EVEN A CHORD, THAT DOMINATES OVER THE WHOLE OF ITS IRREGULAR VIBRATIONS. . . . Now, the existence of this predominant characteristic tone gives us the practical possibility of scoring noises . . . of giving to a noise not only one tone, but a certain variety of tones without losing its characteristic. . . . Thus certain noises obtained through a *rotating* [italics added] movement [of an instrument] can give us a complete ascending or descending chromatic scale by speeding up or slowing down the movement."

With these relevant theories in mind, it is not too farfetched, therefore, to think of the pictorial ground in Carrà's small collage partly in grammatical, partly in musical terms. The images are substantives to which the words are modifiers, while the roundels act as the causative change in pitch of those signaled noises and expressions that function as tones. And because of their scale, color, placement, and distance from each other, these "word sounds" conjure an environment and a history that relates to the experience of listening to an accelerated phonograph, say, as previous Futurist painting related to film. For there is a disjunction between the normal speed-rate of spoken language and the way it is invoked here—in space—just as appearances seem speeded up by painters who had broken down the phenomena of motion.

What Carrà achieved in this work may be further elucidated by comparing it with the most affecting example of sound invocation in earlier modern painting, Edvard Munch's *The Cry* (Fig. 91). Where the Norwegian artist amplified by his landscape arabesques a scream, or more likely, moan, issuing from one oval mouth, Carrà's whirlpool is the agent for "noises" that

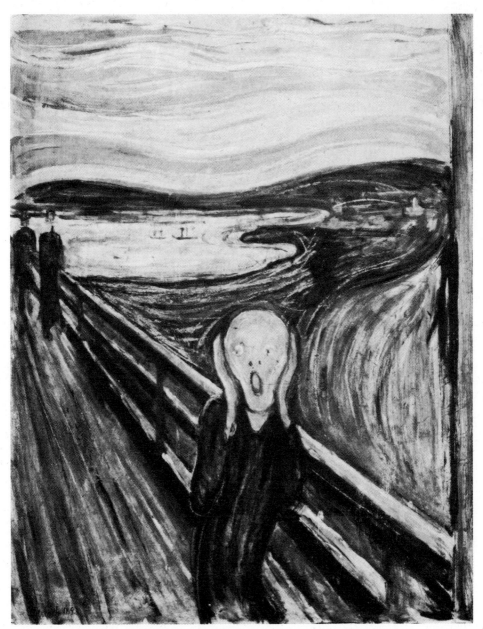

91 / MUNCH: *The Cry*, 1893. Oil on cardboard, 35⅞″ x 29″.
The Nasjonalgalleriet, Oslo.

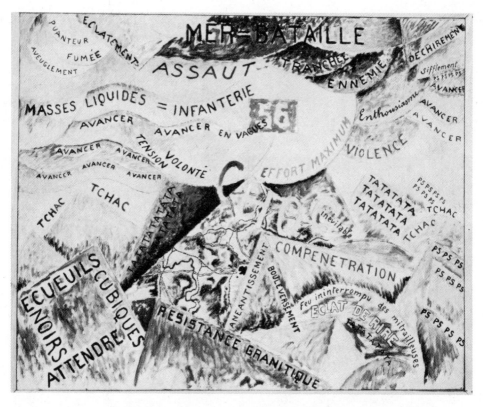

92 / SEVERINI: *Sea=Battle*, 1915. Oil on canvas, 19½" x 25¾".
Sam and Ayala Zacks, Toronto.

chop at angles through a thicket of streamers ricocheting off the center. (It is not clear whether they are flaring outward or homing in.) If Munch wanted to sweep up the universe in the holistic grip of the pathos of his subject, Carrà engages our rationalizing faculties—the way we relate spaces, decode symbols, and read signs—in order, paradoxically, to release us from intellectual systems. And since it scrambles many direct and indirect modes of involvement, the work produces its own emotive resonance, which is a bit similar to the feeling one gets when one is unable to tune in one station on the radio waveband.

That we can handle this tumultuous stew at all is due to Carrà's acute formal and poetic judgment. Severini's sound painting *Sea = Battle* (Fig. 92) has its felicities, but it continually loses tension by its abstract, undulant waves, even as it ludicrously imitates machine-gun fire with such inscriptions as "TATATA." The strewings of Futurist poetry have similar drawbacks, partly, one suspects, because they lack the "scoring" necessary to raise the human voice above the level of the phonetic mimicry quite naïvely thought to engender a new, modern music in verse. Carrà, however, provides a kind of visual scoring that does not have to be voiced—trilled or screeched—does not require audibility, to come into existence.

It is enough for him to stimulate a wild range of tongue or larynx movements within the web of the verbal material offered in the painting. The act of reading not only furthers the temporal dimension of his work but bespeaks a polyglot world of events and sensations completely in accord with his maelstrom view of himself and his situation.

Though Carrà provides more than a hint of his program with words like "incidente" (chance) and "accidente," he does emphasize a basic "argument" between the Italian principle "EEvviiivaaa il Rèèè, Evvivaaa L'Esercito" (long live the king, long live the army) and the German word "TOT" (dead), in headline newsprint. "Taie volontà di Edison" (by the will of Edison) is the technological opposite of "sole bruciaticcio" (scorching sun). For the rest, under the phrase "città moderne" can be clustered the "rumori," "odori," and "calore" (heats), and modes of transport—trains, bicycles, etc. —to which the onomatopoeic and pictorial features of the field allude. If the artist has not established these meaning structures in any one sequence, *Patriotic Celebration* is obviously not so free as to be chaotic. Though it rotates away from the visual cues of right- or left-handedness, or even conventional equilibrium, it reads as well upside down as right side up. "Noi siamo la prima" (we are the first), announces one clipping, and, as if to underline the real mood of this marvelous work, the artist signs it "leggiero CARRÀ duraturo FUTuristA" (lighthearted Carrà durable Futurist).

15 / TO LEGISLATE THE EVANESCENT

It is an historical fact that these lighthearted and strong-willed painters ceased to be innovators soon after the war for which they had chafed became a reality. For all the craft that went into what Carrà called "guerrapittura" (warpainting) and Severini's generalized battle pieces, nothing was added to the surge of discovery that had marked their careers before the war. Even if we can only speculate about the reasons for this dissolution of impulse, they are clearly signficant in evaluating Futurism's contribution to modern culture.

By 1914, it can be assumed that the Futurists had arrived at a state of extreme exhaustion as artists. Indeed, their whole course had been to overcharge the allusive capacities of painting. Futurism was permeated through and through with a rabid dissatisfaction with pictorial materials and, even more, with the orthodox properties of all media as vehicles with which to respond to the sensations of life in the twentieth century. Their metaphors had been pushed to the point of such complexity that they could be rescued

only by a reductive or schematic abstraction foreign to their image of themselves as political activists. Their momentum and faith in the new were so depleted that Carrà and Boccioni reverted to ideals of disciplined stability—apostate goals in a Futurist context. Later, in 1916, Boccioni allowed that "I shall leave this existence with a contempt for all that is not art. All that I see at present is play compared to a well-drawn brushstroke." But this disillusionment occurred at the very end of his life and has the ring almost of recantation.

When the war broke out, however, the Futurists either had to risk shifting priority to non-military distractions, as if nothing of utmost consequence had happened, or focus propagandistically and simplistically on aspects of campaigns too specific in reference and too solicitous of a mass audience to escape becoming exalted illustrators. When they did pick up their palettes during those years, it was in a quasi-propagandist spirit. The big change that occurred in them psychologically was brought on by the war. Marinetti had spoken of warfare in general as "the world's only hygiene." Previously, in a Europe that was still at peace, they had been artists of yearning and celebrants of violence, operating within a movement that was breaking up under the terrific stress of internal disputes. Actual combat, which they welcomed with a maniacal innocence, afforded them the cathartic release of becoming men who *were* violent; it legitimized a conversion of means to ends and, consequently, took the steam out of their quest for artistic originality.

The Futurist consciousness introduces an antagonism to art in one of its most characteristically twentieth-century stances. The manifest origin of this attitude lies in an awful impatience with the sublimations of art when compared to action. The avant-garde hypothesis presumed that art would initiate a drive to comprehend and convey a moment of history. But the Futurists wanted literally to partake of history, which entailed the risk of losing themselves within it. Earlier rebels in art had always stood at some distance from events in order to perceive what was happening to them and because their art demanded time out from reality in order to achieve itself. For the Futurists, however, historic time and the dream of art converged radically. They enjoyed a priceless engagement with the stuff of changing perception but little or no pause to concentrate and magnify what they could learn from the experience of modernity. They compensated by claiming that such experience possessed an intrinsically aesthetic character, to which the artifacts they created had a subordinate relation.

In other words, they imagined the absorption of art into life, which negated, but also paradoxically glorified, the value of their own work. To them, the revolutionary act itself embodied a Futurist conception of art.

All this followed from their intolerable judgment of themselves as outsiders cut off rather than aswim in the undifferentiated whole of social flux. These were virulent feelings passed on by the Futurists to later avant-garde movements. We can attribute to such a continuing psychology not merely an implicit defeatism, but an explicit, positive diffusion of energy. The experience of the war induced this ambivalence of values—this overpowering tension between ideas of worthlessness and transcendence in the modern artist. Art itself would be expendable if it could lead some exemplary life either in the subversion or the reconstruction of society. Brought to an extreme posture of nihilistic irony in Dadaism—that is, to the deprecating of all action as absurd—art became an inverted, random attitude of mind in which any object, even one ready-made, could be appropriated by the artist and rendered purposeless (that is, aesthetic). Compared to this outlook of withdrawal and disdain, the Russian Constructivists conceived of rationalizing the artistic impulse, first in would-be service to the abstract ideals and then in response to the worldly needs, of a revolutionary nation-state. As precursor of these attitudes—the skepticism of one and the heroism of the other—Futurism worked as an early-warning sensibility, oscillating between them so that the anti-art potential within it was remarkably suggestive, open-ended, and undirected.

Much of this state of affairs is suggested by the Futurist manifestoes. But it is far more vividly demonstrated by the individual development of painters whose staggered, yet hasty, evolution had never been seen before in modern art. On the surface, the closely associated, intensely beleaguered, and mutually competitive artists behaved in stereotypical accord with preceding avant-garde movements. That is, the terms of discourse were framed within a special, self-referring language whose modifications by practice incited in each of the creative actors a breakthrough mentality. They, and they alone, were in possession of insights that advanced along an uneven front where gains were made by those bold enough to see the further consequences of common strategy. Thus Carrà was inspired by Boccioni's *States of Mind* to produce like-minded Futurist visions of the Cubism that had stimulated them both in 1912. Thus Balla suddenly switched in 1913 from his *Irridescent*

Interpenetrations to an idiom briefly aligned with the propulsive Boccionis of that year. Decisions as to the importance of any move were legitimized by the particular model of exploration in which the group believed, and were then abetted by the momentum to which its members felt exclusively committed. Though extremely simplified, this sketch does indicate the *normal* outlines of that highly charged interior accountability with which avant-garde artists played their freely innovating roles.

What was abnormal was the extremely short-term aspect of the communicative signals the Futurists gave each other. Instead of building a comprehensive conceptual structure whose variables could accommodate a range of successively more probing work, they tended to assign separate concepts to each major production. Compared to their hypertensive alertness, the development of other contemporary avant-gardes, even the most mobile, looked sedated. Alternative fittings of key notions in Futurism—such as force lines—reveal themselves, but we do not see noticeable transitions between the progressive stances assumed by each painter. Though small clusters of paintings may relate very closely to each other, Futurist art seems to have leapfrogged from resolutions to new difficulties. The most astonishing example of this kind of gaping fluidity is Balla's record of 1912, in which four important, consecutive paintings evince four resoundingly different codes of operation that indicate a line of thought but are not cumulative in the realization of it.

How opposed this is to the attitude of the Cubists. For them, the point of any new pictorial syntax is utterance and workability. One does not undergo the creative strain of inventing a language, with all its initially unfamiliar rules and elements, and then deny oneself the pleasure of speaking it—or rather, playing with it. The Cubists, happening upon a new principle, racked up scores of works to afford themselves the satisfaction of a dialogue with the innumerable possibilities and combinations that it allowed. No doubt they felt a pleasurable curiosity akin to that of the grand masters who develop fresh moves and gambits in chess. Histories of Cubism constantly distinguish between its innovating and logical follow-up steps, between experimental ploy and conclusive results. But to produce large inventories of high quality and to consolidate imaginative advantage—procedures that seem natural to us—were alien to the Futurist mind, which admiringly judged all experience as provisional.

For the Italian ideal of process was not that of structural permutation within a familial class of forms. Rather, it was one of transfiguration of dynamic impulse, to which individual paintings could bear only fragmentary witness. Studded with prime works without sequence, the history of Futurism wreaks havoc with the idea of *genus* in art. Among the Futurists, one discerns relatively few "runs" or "sets." When these do appear in overall context, they give an uncharacteristic impression of drag or hesitation. It is as if their ambition carried the Futurists into a limbo devoid of a past—even the immediate past represented by their own newly completed work. Their purpose constrained them to be self-starters, at every stage abandoning or departing from the knowledge that would enable them to proceed. They took almost too seriously the condition that any moment lived in the present instantly becomes an event of the past. There is a solid promissory quality suffused in the development of Cubist art. In contrast, one feels mostly a worried anticipation when following the precarious footing of the Futurists. In Paris, artists acted upon material as if nothing were more suited to metaphysics; whereas, for the Futurists, immaterial phenomena in a hundred different bothered guises became fugitive motifs of concretion.

To check in at any point of their careers is to see it as one of no return instead of a coherently located representation, having its own intrinsic logic within an output of consecutive and interdependent aims. The Futurists refused to stabilize their art by means of craftsmanly elaboration (though their execution could be very exciting) and stylistic continuity (though they were very knowing about style as a mode of artistic identification), and, consequently, diminished their importance. They would no more deny their sources than their seriousness, but at the same time they did not assume that the production of art was self-justifying merely because it had a long tradition that celebrated the joys of sense. Art, for them, would be revelation or it would be nothing. To revert to our metaphor of signals, the Futurists seem to have conceived their works rather like flares that cast a delirious and ecstatic glow over a terrain before guttering out.

Of course, this is a poetic description of a didactic movement. Individual Futurist works of art were narrowed and expanded as demonstrations of theoretical points. What had been conceivable in words and thought the artists would render visually in paint or in three dimensions. One confronts, therefore, the rather startling phenomenon of artists for whom words

initially offered less resistance than their own medium. Words cast into the form of proposals and manifestoes acted as the first actual sketches for a painting program. The exchanges between doctrine and art (most significant in the study of Futurism) were often neither so direct nor so apparent as this suggests, but it is fair to say that once the artists thought they had achieved a substantive match of idea and realization of idea, they were no longer motivated to perpetuate the specific idiom in which it was embodied. Manifestoes were the feasibility studies that the Futurists used to "get into position" for their new works (as well as rallying cries of self-support).

This goes far to account for the unprecedented deluge of theoretical statement in Futurism—a phenomenon also caused by the increasing unwillingness of each artist to forego his sovereignty by allowing others to speak for or, as he thought, upstage him. Considering the disagreements between the Milanese painters and their gradually more conservative Florentine allies at the editorial offices of *Lacerba,* and in light of the varying disputes all these had with the farfetched Marinetti, who rarely embroiled himself with the exigencies of visual art in practice, Futurism became a terribly divisive movement, frantically attempting to codify itself. Such tensions did a great deal to give Futurism its manic, burlesque character and its crazy calendar of cause and effect.

But they were also in accord with an aesthetic that blended entirely with the personalities at issue—personalities striving so much to outdo each other as well as most advanced concepts of modern art. As the rhetoric of their theories swelled with words like *total, absolute, synthetic,* and *transcendental,* the irreconcilable differences among them were brought to a head. (Carrà, for instance, dropped all interest in noise and became one of the quietest painters of the age, along with de Chirico, in the "Scuola Metafisica," while Severini turned into a synthetic Cubist.) But even as they were constantly losing traction between ideal and realization, before the war they never descended into comforting clichés about journeys into the unknown or settled for using painting as a dry testing ground for verbal *Diktat.* Rather than doctrinaires with ulterior motives, they were vulnerable, idealistic pioneers, essentially in conflict between a love of the experience of motion and a zest for the conveying of it. They valued insurgence for its own sake.

In the end, Futurism might be judged a movement that set up and then mediated, with a precision it could not have forecast, some of the major

contradictions of twentieth-century art. The Futurists' craze for novelty was strangely enough hedged, for, if anything, they were more up on horseback with their sentiments than in the rapidly outmoded automobile flivvers of their time. The lengths to which they went to give a mechanistic view of the conditions of living cast no aspersion on human energy at all, but rather implied a heightened capacity of the psyche to relate to modernity. (How much more ambiguous were the Italians than either the Cubists or the Dadaists on the question of the anthropomorphism of inanimate things.) Yet, for all their self-consciousness, they did not engender among themselves a cult of the personality. And for all their physical investigations of heterodox media, they taught how replaceable were objects and how imperishable was thought. They dramatized with great pride those pathogenic features, those anticipations and fears of failure that were to mark the rest of the century, at the same time that they demonstrated that rigorous art, even imaginative rebirth, could be generated under such moods. Yet, their notions of accelerated movement within time and space gave a necessary stutter to the heightened fluidity of their forms. They displayed as acutely as the Cubists an idea of what art had to look like in remodeling the perception of the world just before the war. But their picture of that world was much more inclusive. The Cubists were more particular and authoritive even in their deft incompletions (or because of them). The Futurists were far more daringly general, despite their specifics. The exchange between the two movements, the works and ideas they produced, bestowed on their successors a challenging view of the future that would be held in Western art for sixty years.

SELECTED BIBLIOGRAPHY OF WORKS IN ENGLISH

JOHN GOLDING. *Cubism: A History and Analysis, 1907–1914.* New York, 1959.

ROBERT ROSENBLUM. *Cubism and Twentieth-Century Art.* New York, 1966.

EDWARD F. FRY. *Cubism.* New York, 1966.

JOHN BERGER. *The Moment of Cubism and Other Essays.* London, 1969.

DOUGLAS COOPER. *The Cubist Epoch.* Los Angeles and New York, 1970.

DANIEL-HENRY KAHNWEILER and FRANCIS CRÉMIEUX. *My Galleries and Painters.* New York, 1971.

WILLIAM RUBIN. *Picasso in the Collection of the Museum of Modern Art.* New York, 1972.

JOSHUA C. TAYLOR. *Futurism.* New York, 1961.

RAFFAELE CARRIERI. *Futurism.* Milan, 1963.

221 /

MARIANNE W. MARTIN. *Futurist Art and Theory, 1909–1915.* Oxford, 1968.
MICHAEL KIRBY. *Futurist Performance.* New York, 1971.
R. W. FLINT, ed. *Marinetti: Selected Writings.* New York, 1972.

INDEX

Boldface type indicates page numbers of art reproductions.

style of, 5, 148
Bréton, André, on Picasso, 109
Brücke, Die, 20

Cardplayers, The (Léger), 93
 analysis of, 91, 93
Carrà, Carlo, 219
 Cubism and, 118, 119
 manifestoes of
 "The Painting of Sounds, Noises, and Smells" (1913), 209
 paintings of
 Funeral of the Anarchist Galli, 145, 146, 147, 148
 The Galleria in Milan, 168, 170
 Jolts of a Cab, 158–59
 Leaving the Theater, 138, 140
 Patriotic Celebration, 207, **208**, 209, 210, 212–13
 What the Streetcar Told Me, 158, **159**
 Parisian début of, 117–18
Cézanne, Paul
 bathers of, 80, 86
 color-modulation of, 26
 Cubism and, 21, 23
 exhibition of (1907), 15
 Fauvism and, 16
 Léger and, 87
 Merleau-Ponty on, 26
 paintings of
 Lac d'Annecy, **25**, 26
 Trees Forming an Arch, **27**, 28
 perceptual approach of, 24, 26, 28
 Picasso on, 23, 28
 Rousseau compared with, 23
 style of, 66
Chirico, Giorgio de, 111, 219
Chronophotography and Futurism, 150, 173
City, The (Léger), **108**
 analysis of, 109
City Rises, The (Boccioni), 144

analysis of, 143–45
Cityscapes
 in Futurism, 119, 133–35, 138
 in Léger's work, 40, 43
Clarinet, The (Braque), **68**
 analysis of, 68–69
Cocteau, Jean, 100
Collage
 Boccioni and, 192
 Cubism and, 63–76, 112, 191
 figures and, 95
 Futurism and, 209–10
 as sculpture, 72–73
 as still lifes, 68
 Wadley on, 66
Color
 Balla's use of, 177
 Cézanne's use of, 26
 in Cubism, 61
 Fauves' use of, 15–16
 form and, 26, 28
 in Futurism, 137–38
 Picasso's use of, 80, 86
 Seurat's use of, 5
Commedia dell'Arte, 105
Commoedia Illustré (journal), 43
Constructivism, 4, 6, 77, 124, 216
Contrast of Forms (Léger), 40
 analysis of, 38
Conversation in a Garden (Rosso), 197
Courbet, Gustave, 9, 23
Creation artistic, Cubists on, 11–12
Criticism of Cubism, 3–13, 57–58
Cry, The (Munch), **211**
 analysis of, 210, 212
Cubism
 analytic, 57–58
 antecedents of, 14–28
 artists on, 11–13
 Berger on, 6
 Braque on, 11, 33

ABOUT THE AUTHOR

Max Kozloff, an associate editor of ARTFORUM, has been writing art criticism for eleven years. His work has appeared in a regular column in the *Nation* throughout the sixties, in the majority of the art periodicals, and in several literary reviews. Trained as an art historian at the University of Chicago and the Institute of Fine Arts, New York University, he has devoted as much attention to modern art of the past as to art in process. His two previous books are *Jasper Johns* (New York: Harry N. Abrams, 1969) and *Renderings; Critical Essays on a Century of Modern Art* (New York: Simon and Schuster, 1969).

Icon Editions